D1536521

AFTER MODERN SCULPTURE

MANCHESTER
UNIVERSITY PRESS

THE BARBER INSTITUTE'S
CRITICAL PERSPECTIVES
IN ART HISTORY SERIES

SERIES EDITORS
Tim Barringer, Nicola Bown
and Shearer West

EDITORIAL CONSULTANTS
John House, John Onians,
Marcia Pointon and Alan Wallach

After
modern sculpture

Art in the United States and Europe
1965–70

RICHARD J. WILLIAMS

Manchester University Press
Manchester and New York

distributed exclusively in the USA by St. Martin's Press

Copyright © Richard J. Williams 2000

The right of Richard J. Williams to be identified as the author of this work
has been asserted by him in accordance with the
Copyright, Designs and Patents Act 1988.

Published by Manchester University Press
Oxford Road, Manchester M13 9NR, UK
and Room 400, 175 Fifth Avenue, New York, NY 10010, USA
http://www.man.ac.uk/mup

Distributed exclusively in the USA by
St. Martin's Press, Inc., 175 Fifth Avenue, New York,
NY 10010, USA

Distributed exclusively in the Canada by
UBC Press, University of British Columbia, 6344 Memorial Road,
Vancouver, BC, Canada V6T 1Z2

British Library Cataloguing-in-Publication Data
A catalogue record for this book is available from the British Library

Library of Congress Calaloguing-in-Publication Data applied for

ISBN 0 7190 5650 0 *hardback*
 0 7190 5651 9 *paperback*

First published 2000

07 06 05 04 03 02 01 00 10 9 8 7 6 5 4 3 2 1

———

Typeset by
D R Bungay Associates, Burghfield, Berks

Printed in Great Britain
by Bell & Bain Ltd, Glasgow

N
6512
.W55
2000

Contents

List of illustrations *page* vii

Acknowledgements ix

1 After modern sculpture 1

2 Form and Anti Form 18

3 A new subjectivity 39

4 'The vacant, all-embracing stare' 59

5 Dematerialization 81

6 Space 100

7 Earth 118

8 Revolution 139

Bibliography 162

Index 175

List of illustrations

1 Richard Serra, *Splashing*, 1968. Courtesy of the artist. Photo: Peter Moore. *page* 10

2 Anthony Caro, *Prairie*, 1967. Courtesy Annely Juda Fine Art. 18

3 Robert Morris, *Untitled* (*254 Pieces of Felt*), 1967. Courtesy Solomon R. Guggenheim Museum, © ARS, New York and DACS, London, 2000. 19

4 David Smith, *Home of the Welder*, 1945, Tate Gallery, © Estate of David Smith/VAGA, New York/DACS, London, 2000. 23

5 Anthony Caro, *Midday*, 1961. Courtesy Annely Juda Fine Art. 25

6 Anthony Caro, *Sculpture Seven*, 1961. Courtesy Annely Juda Fine Art. 26

7 Carl Andre, *Equivalent VIII*, 1966. Tate Gallery, © Carl Andre/VAGA, New York/DACS, London, 2000. 27

8 Robert Morris, *Untitled* (*Tangle*), 1967. Courtesy Solomon R. Guggenheim Museum, © ARS, New York and DACS, London, 2000. 32

9 Richard Serra, *Belts*, 1967. Courtesy of the artist. Photo: Peter Moore. 33

10 Fischbach Gallery, *Eccentric Abstraction*, September 1966. Photo: Rudolf Burkhardt. 41

11 Eva Hesse, *Metronomic Irregularity*, 1966. Courtesy Rudolf Burckhardt, © Estate of Eva Hesse. 42

12 Keith Sonnier, *Untitled*, 1966. Courtesy of the artist. 42

13 Bruce Nauman, *Cast of the Space Underneath My Chair*, 1967. Courtesy Kroller-Müller Museum. 50

14 Eva Hesse, *Area*, 1968. Collection Wexner Center for the Arts, Ohio State University, purchased in part with designated funds from Helen Hesse Charash, © Estate of Eve Hesse. 51

15 Robert Morris, *Untitled* (*Threadwaste*), 1968. Courtesy Solomon R. Guggenheim Museum, © ARS, New York and DACS, London, 2000. 63

16 Barry Le Va, *Continuous and Related Activities Discontinued by the Art of Dropping*, 1967. Courtesy Sonnabend Gallery. 64

17 Barry Le Va, *Untitled*, 1966. Courtesy Sonnabend Gallery. 64

18 Richard Serra, *Scatter Piece*, 1968. Courtesy of the artist. Photo: Shunk-Kender. 65

19 Robert Smithson, *Mirror Trail*, 1968. Courtesy John Weber, © Estate of Robert Smithson/VAGA, New York/DACS London, 2000. Photo: William C. Lipke. 65

20 Robert Smithson, *Fountain Monument* from *The Monuments of Passaic*, 1967. Courtesy John Weber, © Estate of Robert Smithson/VAGA, New York/DACS London, 2000. 67

21-6 Robert Morris, *Continuous Project Altered Daily*, 1969. Courtesy Solomon R.
 Guggenheim Museum, © ARS, New York and DACS, London, 2000. 74–5
 27 Robert Smithson, *Asphalt Rundown*, 1969. Courtesy John Weber,
 © Estate of Robert Smithson/VAGA, New York/DACS London, 2000. 76
 28 Robert Smithson, *Glue Pour*, 1970. Courtesy John Weber, © Estate of Robert
 Smithson/VAGA, New York/DACS London, 2000. 76
 29 Richard Serra, *Casting*, 1969. Courtesy of the artist. Photo: Peter Moore. 84
30-1 Leo Castelli Gallery, *Nine at Leo Castelli*, December 1968. Photo:
 Harry Shunk. 85
 32 Eva Hesse, *Aught*, 1968. University of California, Berkeley Art Museum,
 Gift of Mrs Helen Charash, © Estate of Eve Hesse. Photo: Benjamin Blackwell. 87
 33 Keith Sonnier, *Mustee*, 1968. Courtesy of the artist. Photo: Peter Moore. 87
 34 Keith Sonnier, *Untitled* (*Neon and Cloth*), 1968. Courtesy of the artist.
 Photo: Peter Moore. 88
 35 The former Leo Castelli warehouse at 103 West 108 St., New York, in 1996.
 Photo: Richard J. Williams. 105
 36 Allan Kaprow, *Yard*, 1961. Courtesy Getty Foundation. 109
 37 Robert Morris, *Dirt*, 1968. Courtesy Solomon R. Guggenheim Museum,
 © ARS, New York and DACS, London, 2000. 127
 38 Robert Smithson, *Rock Salt and Mirror Square*, 1969. Courtesy John Weber,
 © Estate of Robert Smithson/VAGA, New York/DACS London, 2000. 132
 39 Giovanni Anselmo, *Structure that Eats Salad*, 1968. Courtesy Sonnabend
 Gallery. 145
 40 Mario Merz, *Cone*, 1967. Courtesy Tate Gallery. 146
 41 Giovanni Anselmo, *Le Cotton Blanc qui Mange l'Eau*, from the exhibition
 Op Losse Schroeven, 1968. Courtesy Stedelijk Gallery, Amsterdam. 149
 42 Mario Merz, *Città Irreale*, from the exhibition *Op Losse Schroeven*, 1968.
 Courtesy Stedelijk Gallery, Amsterdam. 150
 43 Mario Merz, *Overzicht Tent*, from the exhibition *Op Losse Schroeven*, 1968.
 Courtesy Stedelijk Gallery, Amsterdam. 150
 44 Robert Morris, *Amsterdam Piece*, from the exhibition *Op Losse Schroeven*,
 1968. Courtesy Stedelijk Gallery, Amsterdam. 151
 45 Gilberto Zorio, *Lampe avec Amianto*, from the exhibition *Op Losse Schroeven*,
 1968. Courtesy Stedelijk Gallery, Amsterdam. 151

Acknowledgements

This book started out life as doctoral research at the University of Manchester, and I must begin by thanking my many friends and former colleagues there, in particular Andrew Causey, who supervised the original project. At Manchester University Press I must thank Vanessa Graham and Louise Edwards. John Moores University has been generous in support of the book's production, for which I am grateful to Colin Fallows. Rudolf Burckhardt, the Leo Castelli Gallery, John Gibson, Charles Harrison, Nancy Holt, Jon Ippolito, Philip Leider, Barry Le Va, Lucy Lippard, Ilene Z. Magaras, the Robert Miller Gallery, James Monte, Robert Morris, Richard Serra, Willoughby Sharp, the Sonnabend Gallery, Keith Sonnier, Marcia Tucker, and the John Weber Gallery all provided valuable material, in the form of interviews, letters, conversations, permission to use archives or images, or sometimes all of these things. My conversations with Suzaan Boettger, Mark Crinson, David Lomas, David Peters Corbett, Fiona Russell, Brandon Taylor, and Marcus Verhagen were all extremely pertinent, even if they didn't realise it at the time. David, Jane and Alan Williams provided all kinds of support throughout the research and writing, while the very early stages could not have been done without the support of Teresa Sanz. Most of all I would like to thank my wife Stacy Boldrick, who has lived through the whole process almost as vividly as I have.

1

After modern sculpture

This book is about the end of modern sculpture. Its title presupposes such an end, and indicates the promise of something different beyond. In absolute terms the idea that sculpture 'ends' in this way is of course a fiction, as any number of artists, curators, arts administrators, and very probably dentists, would be able to tell you. In the United Kingdom in 1999, where and when this book was written, such people could easily point out the enthusiasm with which sculpture is taught in art schools, the hundreds of sculptors they produce every year, the private and public agencies funding sculptural research, not to mention the critical and commercial success that sculptors such as Rachel Whiteread have had. What I mean therefore is something much less grand than 'the end of modern sculpture': I really mean the idea of the end of modern sculpture. For a small, committed public, say the few thousand regular readers of the New York-based journal *Artforum*, such an idea was fact in the 1960s. They believed that they had seen the replacement of one dominant aesthetic mode by another, the replacement of a sculpture of useless, three-dimensional, gallery objects with another, in which the concern for the object was no longer important. This is no more than an idea, but a highly pervasive one nevertheless. It appeared first in the art criticism of the 1960s, and its influence is clearly legible in the work of sculptors, especially British ones, working in the 1990s.

The evidence is such concepts as Anti Form, Arte Povera, dematerialization, and eccentric abstraction, all of which appeared in the form of polemical articles in the international art press between 1965 and 1970. All were widely read in the art world, and all were the focus of debate. They all sought to put the discipline of sculpture in question, or indeed put it in doubt altogether. The questions these concepts posed were fundamental ones: what is sculpture? Should sculpture concern itself with the making of objects? Can sculpture effect political change? Can sculpture effect perceptual change? Why make sculpture at all? All artists and critics concerned with these questions felt that art, as long as it was concerned with the production and consumption of objects, was in danger of becoming, as the American sculptor Tony Smith put it, 'an art of postage stamps' – an insignificant practice in other words, one with little meaning in the wider world.[1] The impulse behind these ideas was therefore to make sculpture more important by redefining it. But its redefinition was radical, such that at the end of the process, sculpture was

no longer necessarily a practice connected with material objects, as it had tradition-ally been. By 1970, sculpture could certainly still be a three-dimensional composi-tion in metal, with some vestigial resemblance to the human figure. But it could also be a temporary array of debris in an old warehouse, a trench dug in a remote desert, an object found on the street and declared to be sculpture, or a film of an artist rub-bing his testicles. As Rosalind Krauss famously put it, sculpture now operated in 'the expanded field'.[2]

The narrative that underpins this book is therefore one of profound change, a shift in the values of sculpture such that it ceases to be exclusively a material practice, and becomes open to a much wider range of activity. There are many texts that tell this story already. It is the subject of Lucy Lippard's dense and fascinating annotated bibliography, *Six Years: The Dematerialization of the Art Object from 1966 to 1972*, published as long ago as 1973.[3] It is the subject too of much of Krauss's work, and her book *Passages in Modern Sculpture* (1977) and the essay 'Sculpture in the Expanded Field' are essential reading in this context, as indeed is *October*, the journal she helped found after leaving *Artforum*.[4] I would also mention exhibitions such as *Gravity and Grace: The Changing Condition of Sculpture 1965–1975* held at the Hayward Gallery, London, which made sure that any future histories of the field took proper account of European ideas, Arte Povera especially. Jon Thompson's introduction to that exhibition in the catalogue, 'New Times, New Thoughts, New Sculpture', is an excellent, concise commentary on the subject.[5]

This book is similar to those existing texts in one respect. I accept, more or less, the story of a discursive shift as it appears in Lippard, Krauss, Thompson, and elsewhere, and I discuss a lot of the same material. I have not, for example, discov-ered new artists who were somehow omitted from earlier versions of the story. However, there are three ways in which the book is quite different, and these differ-ences make it a 'critical perspective'. First, my focus is the later 1960s, and the art that was produced in reponse to *both* Modernist sculpture (exemplified by Anthony Caro and David Smith) and Minimal Art (exemplified by Donald Judd and early Morris). My use of the word 'modern' in the title refers therefore to both of these tendencies, a usage that some readers may find problematical given the extensive literature on Minimal Art as an anti-Modernist strategy, Hal Foster's essay 'The Crux of Minimalism' perhaps being the best example of this.[6] My rea-sons for employing this different usage of 'modern' are partly pragmatic and partly historical. They are pragmatic in that so far concepts such as 'Anti Form' have had surprisingly little historical treatment, whereas Minimal Art has; they are histor-ical in that the opposition of Modernist and Minimalist sculpture is a relatively recent one. When we look at historical texts such as Gregory Battcock's 1968 anthology, *Minimal Art: A Critical Anthology*, or the 1967 exhibition *American Sculpture of the Sixties*, we find much more inclusive versions of both concepts.[7] I want to recover some of that inclusivity in order to foreground the crises around the sculptural object that occur in the later 1960s. Such crises otherwise tend to be lost in discussions of Minimal Art.

This book is different, secondly, in that it is about ideas more than it is about sculpture. The ideas, the manifestos or articles, published in *Artforum* and elsewhere are not treated as supplements to the sculpture. In many respects they are the sculpture. This is not to say that there is no discussion of material objects (there is, a lot), but that it is the competing ideas that matter. I say this because I believe that the form of the debate is quite separate from the sculpture that it purports to define. This position is one that is underwritten by a structuralist understanding of how texts work, the arbitrariness of language vis-à-vis its referent, and so on. But it also derives from empirical research. In 1967 for example, Robert Morris, Gilberto Zorio, Barry Flanagan, Joseph Beuys, and Eva Hesse were all making sculptures that were abstract, flexible, temporary; all were about the same size, and all sat on the floor as opposed to on a plinth. The works were formally similar, yet the critical discourse around each was utterly distinct, ranging from formalism, to expressionism, to a kind of apology for the artist as shaman.

Thirdly, I write about these discourses of sculpture in a way that shows they are grounded in a social reality. They are interlinked in a social sense, evidencing communication through the medium of art magazines, dealers, galleries, artist's studios, the street, and the bar. This explains some of the exclusions from this project, Beuys, for example, whose participation in sculptural debate on these terms is only distant (I say more about this later on). The book therefore does a lot of textual analysis. I am interested in what artists and critics write and say to and about each other. I am interested in what they are reading, how far they understand that reading, what use they make of it, and how they communicate it to others. I am interested too in events, the sites of social discourse: exhibitions, openings, and other social occasions.

Before I say more about the precise concerns of the book, let me try to describe in what ways sculpture was under pressure in the later 1960s. An efficient way of doing this is to describe an exhibition and the critical discourse around it. The event, *American Sculpture of the Sixties*, had great prestige, but it was a critical failure among the public that mattered. Its failure explains, albeit partially, why modern sculpture should appear to dissolve at the time (it also provides a historical rationale for my very inclusive definition of 'modern sculpture'). *American Sculpture of the Sixties* opened on 28 April 1967 at the Los Angeles County Museum of Art, and ran until 5 June, whereupon it transferred to Philadelphia.[8] It was, according to its curator, Maurice Tuchman, 'an anthology of the most ambitious and interesting sculpture of the present decade'. This was a highly ambitious claim – more so when one considered that the 'sixties' were barely two-thirds over – which was matched by the physical scale of the exhibition. Tuchman originally envisaged a relatively modest show, representing about eight major sculptors, but the end product represented the work of almost eleven times this number.[9] All accounts of the exhibition made some statement about its colossal size: showing 166 works, it was the largest event of the art season, bigger even than

the *Whitney Annual Exhibition 1966* which had shown 148.[10] The costs involved were huge: the catalogue alone cost $35,000 to produce, while the cost of transporting the work that originated in New York alone was $15,000 one way; even this did not include the twenty-five works which were built on site. It was very probably the most expensive single exhibition ever.[11] The quantity of the work was not the only matter of scale the critics noted, as the work itself was in many cases extremely large. Tony Smith's *Cigarette*, for example, built on site by the New York-based artist Richard Tuttle was 26 ft in height, while David von Schlegell produced a sculpture 42 ft long. These were not unusually large works in a show in which many works had at least one axis of around 20 ft. Other works were technically ambitious, such as Kenneth Snelson's *Cantilever*, an intervention on the exterior of the gallery, comprising an aluminium and steel framework projecting horizontally some 30 ft into space; or Robert Grosvenor's *Still No Title*, a huge yellow piece that appeared to hover improbably above the sculpture plaza. Meanwhile other works made use of new industrial processes or materials. One critic noted that Antonakos's light sculpture was accompanied by seven pages of installation instructions.[12]

The museum, recently completed to a design by William Pereira Associates at a cost of $11.5 million, comprised three large buildings and an outdoor sculpture court (The Norton Simon Sculpture Plaza) surrounded by a moat. *American Sculpture of the Sixties* occupied all of it. Meanwhile the catalogue, of which 36,500 copies were printed, was larger and more sophisticated than anything produced by any other museum at the time. It included ten essays, ran to 259 pages, and included photographs of virtually all of the works in the show, some of which were, unusually for such catalogues, in colour.

The catalogue's content was similarly ambitious. Its ten contributions came from Lawrence Alloway, Wayne Andersen, Dore Ashton, John Coplans, Clement Greenberg, Max Kozloff, Lucy Lippard, James Monte, Barbara Rose, and Irving Sandler, which is to say it was an index of contemporary American sculptural criticism. Coplans, Kozloff, Monte, and Rose were all contributing editors to *Artforum*, which although only founded in 1963 had already become a journal of immense significance for sculpture. Lippard was a regular contributor to *Art International*, another important site of debate, and well known in New York. The British critic Alloway, associated with the Independent Group in the 1950s, curated the 1966 exhibition *Systemic Painting* at the Guggenheim Museum. Ashton, Greenberg, and Sandler were, it barely needs to be said, extremely distinguished critics.

It was an ambitious show, indicative of both the aims of the museum, with its recently completed building, and its curator Tuchman. The fact that Tuchman was able to increase the size of the exhibition from eight artists to eighty-eight is indicative of his ambitions for the project, and the museum's willingness, and ability, to pay for them. The exhibition was as much about the condition of American sculpture, as giving the Los Angeles County Museum and the recently arrived Tuchman a national presence. Philip Leider referred to these facts when he wrote: 'Tuchman

has established himself as the most energetic curator in the country, and the exhibitions schedule of the Los Angeles County Museum of Art has gone unmatched.'[13]

The scale of the exhibition, and the size of the work, indicate a certain triumph of organisation, and there is no doubt that the exhibition was a landmark event for both Tuchman and the Los Angeles County Museum. Reviews by Hilton Kramer ('A Stunning Display of Radical Changes') and by Frederick Tuten were productive of such a sense of triumph. But the reviews in the two journals most sympathetic to contemporary sculpture, *Artforum* and *Art International*, were both harshly critical, especially Philip Leider's review in the former. It is curious that Leider's remarks should be so hostile. *Artforum* had supported Tuchman on the occasion of two of his exhibitions at the museum, *The New York School* and the present one, by publishing special issues on subjects related to them, and Leider was named in Tuchman's catalogue remarks as having had an impact on the development of the show. The following describes his review, and Kurt Von Meier's equally interesting piece for *Art International*, and speculates as to what such hostility meant. The conclusion, previewed at the beginning of the chapter, is that it is at exhibitions like the one at Los Angeles that Minimal Art revealed its exhaustion as a critical practice, the hostile reviews being indicative. 'The major drama of the exhibition', wrote Leider,

> lies in the tension of hatred that is generated between the work and the building, most especially that considerable part of the exhibition that is installed outdoors on the 'Norton Simon Sculpture Plaza'. No work escapes the tearing involvement with the kitsch fountains, loony lamp-posts, plastic-domed walkways, concrete railings, the whole unstructured jumble of senseless frills that make up the design of the museum buildings. The sculpture is an insult to the building, but the building is an insult to the sculpture too, and finally drags the latter down to is own miserable level so that the entire installation becomes an offence.[14]

He went on to criticise the exhibition point by point using categories established in *Artforum*'s own 'Handbook of Museumship', published in 1963: (1) lack of clarity of purpose, as seen in the conflicting aims of presenting a survey at the same time as promoting the 'most ambitious and interesting' sculpture of the time; (2) the selection of artists, on the grounds that Tuchman's decision to exclude sculptors who were also painters had prevented the inclusion of Barnett Newman, Larry Rivers, Roy Lichtenstein, and others; (3) fundamental defects in the idea of the survey exhibition, given the proliferation of art magazines and opportunities to see art, even outside of New York;[15] and (4) a series of problems with the installation itself, mainly resulting from the crowded nature of the installation. 'It is nothing short of maddening', wrote Leider,

> to try to take part in, for example, the monumental three-part Bladen when it is involved with reflections from a Chryssa neon-light box nearby, a massive tin house from a Tony Berlant in front of it, a piece by Lloyd Hamrol scuttling

beneath it, a multi-colored George Sugarman undulating alongside it, three Robert Hudson polychromed sculptures taking up the rear and a shiny steel George Rickey wriggling away above it.[16]

Leider concluded: '*American Sculpture of the Sixties*, if its lessons are absorbed, should be the last of the survey exhibitions; they are obsolete, like dinosaurs, non-functional, like college outline books, misleading, like *Time* magazine, deficient in quality like department stores, and expensive, like parades.'[17] This statement formed part of a special issue on sculpture, published to coincide with the exhibition, but beyond that its importance was emphasised by the fact that Leider, the editor, wrote the piece (a relatively rare occurrence by 1967), that it was positioned at the beginning of the journal, and that it was long and well illustrated. It read as a statement of the journal's position, rather than Leider's personal view. It was as if *Artforum* was pitted against the exhibition.

Leider was not alone in criticising Pereira's building. Hilton Kramer's otherwise positive account of the exhibition described the (in his view, high-quality) work as functioning as an effective critique of the structure: '*American Sculpture of the Sixties* is the most devastating criticism we have had of this new and already antique monster', he wrote.[18] Implicit in Kramer's remarks was the idea that the sculpture had somehow managed to 'defeat' the building, in spite of overwhelming odds. Kurt Von Meier wrote that 'the only way to get even would have been to install a Boeing 727 in place of the silly little fountain out front, and one of those giant yellow earth movers in the Simon Sculpture Plaza'.[19]

The building was at issue in most of the criticism, whatever the final assessment, but in Leider's case, the problem of the building seemed to take on greater significance. All of the captions to the illustrations made some reference to the battle between the building and the work: Tony Smith's *Cigarette* was evidence of a 'fight to a draw'; Gabriel Kohn's piece was described as 'holding its own'; the Lyman Kipp was 'about to be absorbed into the architecture'; Caro's two works were captioned '(two sculptures), lamp-post, squares, rail and plant'. Why did Leider situate *Artforum* in opposition to *American Sculpture of the Sixties*, an exhibition we might reasonably expect it to support? And why was its opposition defined so closely in terms of the building?

Perhaps Leider and Tuchman had had some private disagreement, although I have found no evidence of this.[20] No – what Leider's opposition signifies is a critical debate over the meaning of sculpture. His position, articulated through his journal, was essentially modernist: sculpture in this scheme was an austere, self-conscious, self-critical practice, concerned above all with self-definition. The work *Artforum* favoured at this time included both the cubist-derived compositional sculpture of Anthony Caro or David Smith, and Minimal Art, the thoroughly austere, geometrical work of Donald Judd, Robert Morris, and Carl Andre. These tendencies differed greatly, as chapter 2 will show in detail. However, they were both concerned with the production and display of objects, and the journal clearly saw critical value

in both of them. The Los Angeles show represented both kinds. The problem for Leider and his journal was that the museum environment one way or another seemed to negate the critical content of the sculpture, and turn it into a form of decoration.

This can be seen in three ways. First, the scale and opulence of the Los Angeles exhibition contrasted with the circumstances in which most American sculpture was produced, which were more often highly informal, light-industrial premises in run-down parts of New York. It was also shown in small galleries, whose plain, informal interiors were coming to resemble the places where sculpture was made, as the *Artforum* reader would have been aware. The display of sculpture in such places gave it special cultural meaning. There it could look more easily like a marginal practice, but a critical, and therefore worthwhile, one. Looking at sculpture in such places was hard work, and encouraged serious thoughts. Looking at sculpture at the Los Angeles museum was not like this. The sculptures seemed to embellish the already decorative surroundings, which resembled, as the reviews made clear, the commercial building for which its architects were well known. At any museum, but especially this one, it was hard for sculpture to look like a critical practice.

Secondly, the show in many respects represented a form of technological triumphalism, a sentiment at odds with *Artforum*'s critical approach. Several works have been described as technological achievements, and some reviews treated the show in the same terms. Worryingly for *Artforum*, there were statements in these reviews, and in the anthology of artists' statements in the catalogue, which showed that Minimal Art could just as easily be identified with technological triumphalism as with the more critical statements of Judd, Morris, or Smithson. 'Artists in the sixties', said the Minimal artist Robert Grosvenor to *Newsweek*, 'are still a great deal behind Cape Kennedy.'[21] Grosvenor's statement was perhaps not made in all seriousness, but it still suggests an attitude to sculpture at odds with the critical practice of sculpture promoted by *Artforum*. Grosvenor implied that sculpture would proceed through technological improvements, and by extension the artist was obliged to make use of new technology as and when it appeared. His understanding of sculpture placed it effectively in competition with other types of manufacture.

Finally, we could speculate about the expense of the show. Although the New York art world was undergoing a period of expansion, few of the artists mentioned were financially secure, and the cost of fabricating Minimal Art was relatively high. In her well-known history of Minimal Art, Frances Colpitt has suggested that the differential between the extravagance of the Los Angeles show and the relative poverty of the artists it exhibited may have been a source of tension. Colpitt reported that 'Judd continually complained of the lack of funds for artists', and 'though private and government support increased for artists in the sixties, most sculptors were caught in a circular situation: no money to produce sculpture, no sculpture to sell to make money to produce sculpture'.[22] A 1966 letter from Morris to Aegis, the Long Island fabricators he used (and recommended to Eva Hesse), provides evidence of the economic precariousness of most sculptors' lives. He

wrote he was 'close to nervous collapse' over their slow rate of production, going into detail about how this was affecting his financial situation.[23]

Artforum's negative response to the Los Angeles show pointed up a long-standing weakness in its own position. While supportive of various kinds of abstract sculpture as long as they appeared serious enough, *American Sculpture of the Sixties* made clear that such forms of sculpture could easily become decorative given the wrong environment. They could simply end up embellishing the kind of commercial development that avant-gardes usually affected to despise. *Artforum* appeared to acknowledge this problem and respond to it in the summer 1967 issue. This special issue on American sculpture led with Leider's review of the Los Angeles show, and included further articles by (in order of appearance) Michael Fried, Robert Morris, Barbara Rose, Robert Smithson, Max Kozloff, Sidney Tillim, James Monte, Wayne Andersen, Fidel A. Danieli, Jane Harrison Cone, Sol LeWitt, Robert Pincus-Witten, and Charles Frazier. Of the essays, four have achieved some fame: Fried's 'Art and Objecthood', Morris's 'Notes on Sculpture Part 3', Smithson's 'Towards the Development of an Air Terminal Site', and 'Paragraphs on Conceptual Art' by Sol LeWitt have been widely reproduced.

The notion of sculpture described by the Summer 1967 *Artforum* differed from Tuchman's in two significant ways. It was, first, very much more inclusive. Here were articles about object-based sculpture – indeed these were probably in the majority – but 'sculpture' defined here also included Smithson's 'earth projects', which meant massive earthworks visible only from the air. It also meant a lot of speculation about crystallography and geology, not all of which would lead to the production of objects.[24] It meant 'conceptual art' according to Sol LeWitt, in which the idea behind an artwork was what was declared to matter, its realisation being a perfunctory business that need not actually take place at all.[25] And in Morris's essay 'Notes on Sculpture Part 3: Notes and Nonsequiteurs', it meant the 'control of energy and the processing of information'. Sculpture, as a result could be anything: 'anything that is used as art must be defined as art', he concluded.[26]

Secondly, the best-known and most widely read essay in the issue, Fried's 'Art and Objecthood', was extraordinarily defensive in tone. Arguing for the defence of sculpture as an object-based practice, it nevertheless sounded as if such a position was no longer intellectually tenable. 'Art and Objecthood' was exceptionally widely discussed. It provoked contemporary replies from the artists Allan Kaprow and Robert Smithson, and the critics Lawrence Schaffer, Peter Plagens, Barbara Reise, Lucy Lippard, and John Chandler, amongst others, with much historical comment in later years.[27]

It was a sustained attack on Minimal Art ('literalist' art was the term Fried preferred) on the grounds that it was fundamentally 'theatrical', 'theatre' being that which lay 'between' the arts. Fried's attack on Minimal Art was therefore premised on a concept of purity resting on the maintenance of well-policed boundaries between painting, sculpture and other traditional categories of art. Minimal Art's

'theatricality' was revealed in a number of areas: that it relied on 'presence' for effect, 'conferred by size or the look of non-art', in other words something like the surprise of the unexpected;[28] that its effect depended on a 'whole situation', that by implication included the beholder; that the apprehension of Minimal Art explicitly took place in time, in other words emphasising the 'duration of the experience'. By contrast, Fried accounted positively for Anthony Caro, whose work, he argued, was simply 'present': it did not depend on the presence of the beholder to complete the experience.

Fried's analysis was heavily reliant on Morris, both Morris's art and his theories of art. But in a footnote he described 'theatre' as characteristic of not just the 'literalists', but 'Kaprow, Cornell, Rauschenberg, Oldenburg, Flavin, Smithson, Kienholz, Segal, Samaras, Christo, Kusama … the list could go on indefinitely'.[29] In other words, a large part of contemporary art making in the United States, perhaps indeed most of it, was infected by 'theatre': this charge certainly adhered to *Artforum* which had reported the activities of those artists in its pages, and included most, if not all of them, in its special issue on sculpture.

American Sculpture of the Sixties and the Summer 1967 *Artforum* together present a curious picture of the condition of sculpture in the United States. A vast celebration of modern sculpture paradoxically appeared to mark its demise: against the surroundings of the Los Angeles County Museum, sculpture could barely hold its own. Critics savaged the building, and its contents, and wished for something more vital (Kurt Von Meier, for example, wrote that drag racing was a far better spectacle, and better fulfilled the ambitions of any sculptural avant-garde).[30] At the same time, an influential art journal published a special issue on sculpture, but what it contained were articles about sculpture which described its dissolution as a recognisable practice. Or, in the case of one of the articles, Michael Fried's, when it did make a defence of modern sculpture, the very idea of doing so seemed out of step with prevailing views. The exhibition and the journal describe a paradoxical moment in the history of modern sculpture. The moment at which it was most fully celebrated was also the moment at which it ceased to be viable, at least for its most critically engaged public.

This book describes many sculptures which might be thought of in dialectical relation to modern sculpture. One of the best-known is *Splashing*, a work in lead by the American artist Richard Serra, first shown in New York in 1968, and at Bern and Amsterdam the following year (Figure 1). In its first installation, at the Leo Castelli Gallery's warehouse in one of the less salubrious parts of New York's Upper West Side, it comprised a quantity of molten lead splashed for 3 feet or so along the join between the wall and the floor. The process was messy, spreading lead droplets some way up the wall, and across the floor so that the viewer might inadvertently stand on them. There are several ways in which *Splashing* might be understood as a critique of modern sculpture. It was, unlike the majority of the work shown at the Los Angeles show, quite hard to see. It was low on the floor and

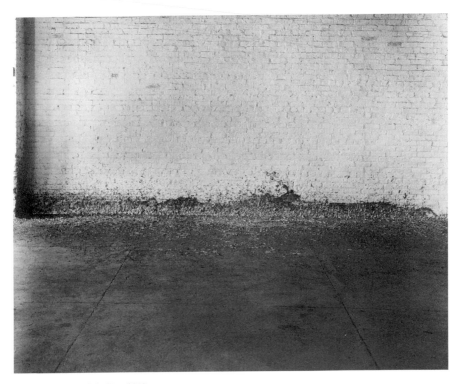

1 Richard Serra, *Splashing*, 1968.

had no structural integrity of its own so that it did not stand out from its surround-ings. It was virtually colourless, closely related to the dirt of the warehouse floor. It was temporary, this being an object installed once and then destroyed. It could not be moved from one location, transacted, or possessed in the normal way. It was decidedly crude in terms of materials, lead being an ancient technology, malleable with the simplest tools (neither was it a material conventionally associated with art. Welded steel had by contrast quite a pedigree as a sculptural material, celebrated by Pablo Picasso, David Smith, and Anthony Caro). Its installation was equally crude. The process of splashing a liquid has closer associations with the disposal of waste material, than with any form of construction, let alone art. And the mark making itself, a big, damaging gesture, was in effect a graffito, an act of vandalism against the building in which it was displayed. And the building itself, although nominally an art gallery, was only a public space in the most limited sense. As I describe else-where in the book, the space was unheated, barely altered from its former condition as a place of storage, and was in a dubious geographical location. It positively dis-couraged visiting, at least by Castelli's usual clientele.

What Serra seemed to be doing at the warehouse was to make something that strategically avoided attention. By contrast, the event at the Los Angeles County Museum was spectacular. The building and the works clamoured for attention,

through light, colour, scale, technical ambition, composition. We can see these two events in dialectical relation to each other, the one a straightforward negation of the other. This is precisely how Douglas Crimp once described Serra's work, writing of the 'shock' he registered at seeing the warehouse show, and its strategic negation of all conventional notions of what comprised a work of sculpture and the way it should be displayed.[31] To understand Serra's work in this way is useful as a first step, but it only gives a partial sense of the variety of possible debates about sculpture. There are, I would say, about four quite distinct ways of accounting for Serra's piece, using contemporaneous concepts; there are another four or five concepts which could provide an account but were not used directly in relation to Serra. It is the job of this book to describe these concepts.

Serra's work came to widespread public attention in 1968, through various media including Robert Morris's essay 'Anti Form'.[32] 'Anti Form' was a critique of preconceived form in sculpture, on the grounds that form was of itself conservative and led to a lack of appropriate consideration of the properties of materials themselves; Morris proposed a sculpture of flexible materials like felt that would acknowledge their surroundings, and he illustrated a contemporary work of Serra's to make the point that such an investigation into materials was already in fact in progress. Morris's very direct, dialectical response to formalism in sculpture is the subject of chapter 2. In chapter 4, I consider Serra's work in relation to Anton Ehrenzweig's popular theories of artistic creativity.[33] Morris cited Ehrenzweig in a 1969 essay, suggesting that the increasingly scattered and dispersed work of American sculptors, including Serra and Morris himself, was informed by Ehrenzweig's concept of 'undifferentiation'. This was the deliberate, trained refusal to see objects against a ground, in favour of seeing only an undifferentiated ground. Chapter 5 describes a rather different way in which Serra's work was accounted for. 'Dematerialization', a term used by the art critics Lucy Lippard and John Chandler, was the title of their 1968 essay which argued that contemporary art, whatever form it took, was losing its attachment to objects.[34] What mattered increasingly were ideas: the artist's studio, they wrote, was becoming a study, rather than a place of manufacture. The longest demonstration of the 'dematerialization' thesis was Lippard's 1973 book, *Six Years*, already mentioned, which included many examples of Serra's work along with conceptual art, performance and body art, and other diverse tendencies of the 1960s and early 1970s. My final chapter treats Serra in yet another way, this time against the concept of Arte Povera, the name given to a group of Italian sculptors by the critic and curator Germano Celant, later expanded (rather like 'dematerialization') to account for, seemingly, all contemporary art.[35] Celant asserted in 1967 that the use of simple materials was a political act, an act of resistance against the consumer society. The production of 'poor art' was, in his words, a form of guerrilla warfare. He was initially thinking of artists such as Giovanni Anselmo and Gilberto Zorio, both Turin-based, but by 1969 Celant showed great interest in Serra and other American artists, and interpreted their work in a similar way.

These are four ways in which *Splashing* might be regarded, using contemporary concepts of sculpture: as a dialectical response to formalism, as an illustration of a new perceptual mode, as evidence of the 'dematerialization' of art, and as a means of resisting capital. These are the concepts which one way or another make explicit use of Serra's work. We could equally refer to the material in chapter 6, which treats the new forms of sculpture as evidence of a new consciousness about the context of sculpture, a chapter in which there is extensive reference to the warehouse exhibition at which *Splashing* was first shown. We could equally look at the concept of 'eccentric abstraction' described in chapter 3.[36] An earlier attempt to account for contemporary sculpture, eccentric abstraction proposed, like the later 'Anti Form', a sculpture of indeterminacy. But unlike other concepts, it suggested that the motivation behind the new forms was subjectivity, of both the artist and the viewer, that the dissolution of preconceived form had to do with the representation of (for example) erotic desire. Chapter 7, finally, discusses the discourse that emerged in 1968–69 around earth, specifically the idea that the use of earth in sculpture, or the making of sculpture in the earth as opposed to the gallery or the museum, might be a means of advancing sculptural debate. *Splashing* was made of lead, but its form, and the means of its realisation, were extremely similar to the methods used by the so-called earth artists: Serra in fact assisted Robert Smithson on the well-known earth project *Spiral Jetty*, and would go on to make work of his own in the 1970s that addressed similar issues.

Splashing is used here simply as an example and the points I have made about it could apply to any number of other works of the 1960s. To reiterate my main point, it is a work that is normally described in dialectical terms, a negation in other words of existing practice in order to further sculpture as a whole. This is true in so far as there is a critical discourse that makes this point. It is also an oversimplification. There are many competing, overlapping discourses of the dissolution of sculpture, all of which did, or could have, accounted for Serra's work. It is the project of this book to provide a history of them.

Like any history, this one is prejudiced. It excludes concepts or events that others would have included; it includes other things that might have been left out. The principal objection a reader might have to this particular history is likely to be that, despite the claim of my subtitle to deal with European art, this is really an American history. My claim to discuss European art rests on the final chapter, and that concerns itself for the most part with Arte Povera. I do not say anything much about artists in Germany, the United Kingdom, or anywhere else in Europe. And if this history is biased towards the United States, it is – even more chauvinistically, perhaps – oriented to New York City and its artists, critics, galleries, and institutions. The artists I write most about – Morris, Smithson, Serra, Hesse, Nauman, Sonnier, Le Va, Kaprow – all had studios in New York during the years 1965–70, albeit temporarily in the case of Nauman and Le Va. They were all represented at some point by New York dealers, Castelli, Dwan, and Fischbach in particular, and

their works were consumed by a New York public, either in the form of sales, or through reviews and commentaries in such New York-based publications as *Artforum*, *Art in America*, *Art News*, *Arts*, the *New York Times*, and the *Village Voice*. I also refer to *Art International*, Lugano-based but a magazine that reported extensively on events in New York, and made use of artists and critics based in the city, Smithson and Lippard to name two.

In making this emphasis, I may appear to some readers to advance a triumphalist narrative ('The Triumph of American Sculpture' perhaps, to paraphrase Irving Sandler), and this might seem to marginalise other quite compelling narratives of origin. There is, for example, an important literature on the role of German dealers in supporting American sculpture through the 1960s. Their patronage, far greater in the first instance than that of the Americans, provided studio space, solo exhibitions, equipment, technical expertise, and many sales. Of the artists I have mentioned in this chapter, most – Hesse, Morris, Nauman, Smithson, Sonnier, Le Va, Kaprow – were resident, if sometimes only for short periods, in Germany at various points in the 1960s. Sonnier remarked in interview with me that German galleries such as Ricke in Cologne were much more supportive of his work for a long time than American ones, providing studio space, exhibitions, and materials with a generosity that was inconceivable in the United States.[37] Walter de Maria made his first 'earth room' installation – a gallery filled to a depth of several feet with earth – at Heiner Friedrich in Munich, nine years before anything comparable was realised in New York. The critic Phyllis Tuchman remarked in a piece for *Artforum* that German patronage of art had been so thorough through the 1960s that it was as easy to see contemporary American art in Germany as it was in New York.[38] European museums, even relatively conservative ones, also seem to have been much more adventurous in taste than their American counterparts. Morris received his first museum retrospective at Eindhoven in 1968, while *Op Losse Schroeven* and *When Attitudes Become Form*, at Amsterdam and Bern respectively in the early part of 1969, provided ambitious survey exhibitions of the new tendencies in sculpture several months before anything comparable in the United States.

My prejudice in favour of American art also marginalises Joseph Beuys, an artist about whom there is a vast literature. Beuys's work of the later 1960s formally resembled that of his American peers. Like them he used commonly found, cheap, temporary materials, including felt and animal fat. There were works which closely resembled, for example, works by Morris. There is a stiff triangle of felt for the corner of a room, made in the mid-1960s, a form which seems to reappear almost exactly in a Morris work of the same period. Morris in fact met Beuys at his studio in 1965 while working on a show for the Gallery Schmela, Dusseldorf, and recalled later that he enjoyed the meeting. Beuys had an old Cadillac, and a good sense of humour, characteristics of which Morris greatly approved. Morris went on to invite Beuys to participate in *Nine at Leo Castelli*, the warehouse show which he curated in 1968. Beuys was also present at *Op Losse Schroeven* (Amsterdam, 1969)

and *When Attitudes Become Form* (Bern, 1969), two widely reported international exhibitions which showcased contemporary developments in sculpture.

However, Beuys's relationships with American art, and America in general, were tense. He refused Morris's invitation to participate in the warehouse show, and remarked disdainfully in an interview with Willoughby Sharp that it had perhaps been a good thing, as he had been told the show hadn't been very good.[39] In the same interview, he expressed 'surprise' at Morris's use of felt in sculpture, suggesting that Morris had stolen the idea from him. And interrogated about Minimal Art, which his work in some ways resembled, he repeatedly denied there was any connection. We could take these rejections of American art as indicative of an engagement, of a dialectical kind, with sculptural debate. But Beuys's consistent intention was to shift the ground of debate on to matters quite distinct from sculpture. In Sharp's interview with him, his denial of Minimal Art was accompanied by the assertion of the centrality of symbolism in his own work, specifically a symbolism connected with the representation of events in his life. The felt and fat were, notoriously, the materials used by nomadic Tartars to protect and heal the injured Beuys after his Stuka crashed in the Ukraine during the Second World War.

Rosalind Krauss and Yve-Alain Bois similarly regarded Beuys as a problem. In their notes accompanying their exhibition *L'Informe: Mode d'Emploi*, a survey of modern art that placed 1960s American sculpture at its centre, they declared against Beuys.[40] His work, whatever its formal resemblance to contemporary sculpture elsewhere, was fundamentally different: it was symbolic, as already stated; it was transcendent, declaring low substances (the felt, fat, and so on) to be sacred, 'everyone' to be an artist, and every uttered word a part of a great collective sculpture; it was centrally concerned with the promotion of a cult of personality around the artist, who appeared variously as a 'shaman, a martyr, a wandering Jew'. These concerns were, they felt, inimical to theirs. At *Informe* they wanted to present a history of modern art in which the primary motivation was anti-transcendent, an urge to render things formless, and meaningless as the title *Informe* suggested. Morris, who was well represented at *Informe*, has been equally suspicious of Beuys's approach, after his early enthusiasm. In a 1997 interview with me, he stated that Beuys, like Warhol, 'thrived in the glare of the media. Artist as public entertainer. Are these two to be blamed for the considerable amount of art today that seems imbricated with the regressive, grinningly lobotomised infantilism of entertainment?'[41]

I concur with these opinions to the extent that Beuys's project seems to me to be concerned more with foreclosing debate than opening it up. His declarations that everyone was an artist, and everything sculpture, do not invite a response: they are theological pronouncements more than anything. My project here is to describe a number of interlinked debates about the condition of sculpture, and the nature of Beuys's statements, in this sense, isolates him. More prosaically, the critical debate about Beuys is most concentrated in the 1970s. His most interesting activities simply lie outside the frame of this project.

If, finally, one of my prejudices is to marginalise Beuys, another is to push Morris to the centre. In many ways Morris is emblematic of the project as a whole. As Beuys's remarks about him show, he is also a problematical artist. Beuys's suggestion in 1970 that Morris had taken ideas from him has been reiterated, in various forms, by many different artists and critics since the 1960s. The Californian artist Stephen Kaltenbach described trying to influence Morris, telepathically, from his West Coast studio as a way of accounting, humorously, for the fact that Morris seemed to use his ideas and call them his own.[42] Richard Serra, less charitably, described Morris as the kind of child who always 'wanted to play in his sandpit'.[43] The recent critical reception of Morris has been similarly unfriendly, with repeated accusations of artistic kleptomania, most notably from Roberta Smith, the critic of the New York Times.[44] The same reviewers criticised Morris's lack of consistency, and his refusal to adopt a signature style.

Yet even if we take these criticisms at face value, for this project it is precisely Morris's lack of consistency, his supposed kleptomania, that makes him a worthwhile artist. The critical debate about sculpture in the 1960s is represented nowhere better than in Morris's work, whether his sculpture, his critical writings, or his curatorial activity. The work is highly contradictory as a result, but it follows every twist in that debate. Morris was making formless sculpture from 1967, representing them first as straightforward dialectical responses to Modernist formalism; they then come to represent a new mode of perception; then even, to an extent, symbolism; then, drawing, seemingly on Arte Povera, they are increasingly presented in political terms. This activity, this commentary on contemporary debate is worth focusing on, much more so than a futile debate about origins. In focusing on Morris and American art I cover some familiar ground. But as I hope becomes clear, this book deals with late 1960s sculpture in more depth than has been attempted before. It is also, unlike other accounts, written at some geographical and social distance from the material it describes. This is, I hope, a strength, and that as a result the reader finds in the following chapters a genuinely critical perspective on the material.

Notes

1 Sam Wagstaff, 'Talking with Tony Smith', *Artforum*, 5:4 (December 1966), 14–19.
2 Rosalind Krauss, 'Sculpture in the Expanded Field', *October*, 8 (Spring 1979), 31–44.
3 Lucy R. Lippard, *Six Years: The Dematerialization of the Art Object from 1966 to 1972* (New York, Praeger, 1973).
4 Rosalind Krauss, *Passages in Modern Sculpture* (Cambridge, Mass., and London, MIT Press, 1977).
5 Jon Thompson, 'New Times, New Thoughts, New Sculpture', in Hayward Gallery, *Gravity and Grace: The Changing Condition of Sculpture 1965–1975* (London, Hayward Gallery, 1993).

6 Hal Foster, 'The Crux of Minimalism', *Individuals: A Selected History of Contemporary Art 1945–1986* (Los Angeles, Museum of Contemporary Art, 1986), pp. 162–83. Very broadly, Foster identifes Minimal Art as marking a discursive break with earlier forms of art, emphaising in particular the new concepts of spectatorship that surround it. This is one of the most useful historical treatments of Minimal Art, but in describing it as the major discursive break of the 1960s, it obscures some of the (many) other artistic phenomena of that time which could be seen in the same terms.

7 Gregory Battcock (ed.), *Minimal Art: A Critical Anthology* (New York, E. P. Dutton, 1968).

8 Maurice Tuchman, 'Introduction', in Los Angeles, County Museum of Art, *American Sculpture of the Sixties* (Los Angeles, Los Angeles County Museum of Art, 1967), p. 10.

9 'When Tuchman envisioned this show two years ago he had in mind an exhibition of about seven or eight major sculptors. This number grew until he realised that nothing short of a major show would be reasonable in terms of giving an accurate representation of American sculpture of the sixties and in meeting the needs of the Los Angeles and California community, both audience and artists.' See F. Tuten, 'American Sculpture of the Sixties: A Los Angeles Super Show', *Arts Magazine*, 41:7 (May 1967), 42.

10 The artists represented were as follows: Arlo Acton, Peter Agostini, Jeremy Anderson, Carl Andre, Stephen Antonakos, Larry Bell, Fletcher Benton, Tony Berlant, Ronald Bladen, Alexander Calder, Anthony Caro, John Chamberlain, Chryssa, Bruce Conner, Joseph Cornell, Tony DeLap, Walter de Maria, Jose de Rivera, Mark di Suvero, Tom Doyle, Dan Flavin, Peter Forakis, William R. Geiss III, Judy Gerowitz, David Gray, Robert Grosvenor, Lloyd Hamrol, Paul Harris, Duayne Hatchett, Robert A. Howard, Robert Hudson, Donald Judd, Ellsworth Kelly, Ed Kienholz, Frederick J. Kiesler, Lyman Kipp, Gabriel Kohn, Gary Kuehn, Sol LeWitt, Alexander Liberman, Alvin Light, Len Lye, John McCracken, Marisol, John Mason, Charles Mattox, Robert Morris, Robert Murray, Forrest Myers, Reuben Nakian, Bruce Nauman, Louise Nevelson, Isamu Noguchi, Claes Oldenburg, Harold Paris, Kenneth Price, Richard Randell, Robert Rauschenberg, George Rickey, Lucas Samaras, George Segal, David Smith, Tony Smith, Robert Smithson, Kenneth Snelson, Robert Stevenson, George Sugarman, Michael Todd, Ernest Trova, Anne Truitt, De Wain Valentine, Vasa, Stephan Von Huene, David von Schlegell, Peter Voulkos, David Weinrib, H. C. Westermann, William T. Wiley, Norman Zammitt, Wilfrid Zogbaum. In numerical terms, the best-represented artists were Claes Oldenburg, Joseph Cornell, and David Smith.

11 Tuten, 'American Sculpture', 40.

12 Tuten, 'American Sculpture', 40.

13 Philip Leider, 'American Sculpture at the Los Angeles County Museum of Art', *Artforum*, 5:10 (June 1967), 6.

14 Leider, 'American Sculpture', p. 6.

15 'In one way or another, almost every worth-while artist … in *American Sculpture of the Sixties* had been seen in Los Angeles before the show. The job of the museum thus becomes not to pour this tide of information back on the public in the same disordered state in which it came, but to impose on it some order of quality, to sift from within it that which is worthy.' Leider, 'American Sculpture', 9.

16 Leider, 'American Sculpture', 11.

17 Leider, 'American Sculpture', 11.

18 Hilton Kramer, 'Nostalgia for the Future', *New York Times* (7 May 1967), D25.

19 Kurt Von Meier, 'Los Angeles: American Sculpture of the Sixties', *Art International*, 11:6 (Summer 1967), 64.

20 This is admittedly speculation.

21 'Art', *Newsweek* (8 May 1967), 92.

22 Frances Colpitt, *Minimal Art: The Critical Perspective* (Seattle, University of Washington Press, 1990), p. 20. This is unfortunately not an argument she goes on to develop.

23 Robert Morris. Letter to Aegis (30 October 1966), Robert Morris Archive, Solomon R. Guggenheim Museum, New York.

24 Robert Smithson, 'Towards the Development of an Air Terminal Site', *Artforum*, 5:10 (June 1967), 36–40.

25 Sol LeWitt, 'Paragraphs on Conceptual Art', *Artforum*, 5:10 (June 1967), 79–83.

26 Robert Morris, 'Notes on Sculpture Part 3: Notes and Nonsequiteurs', *Artforum*, 5:10 (June 1967), 24–9.

27 Colpitt, *Minimal Art*, p. 91.

28 Michael Fried, 'Art and Objecthood' (1967), in Battcock, *Minimal Art*, p. 123.

29 Battcock, *Minimal Art*, p. 130.

30 Von Meier, 'Los Angeles'.

31 Douglas Crimp, 'Richard Serra: Sculpture Exceeded', *October*, 18 (Fall 1981), 67–78.

32 Robert Morris, 'Anti Form', *Artforum*, 6:8 (April 1968), 33–5.

33 Anton Ehrenzweig, *The Hidden Order of Art: A Study in the Psychology of Artistic Imagination* (London, Weidenfeld and Nicholson, 1967).

34 Lucy R. Lippard, and John Chandler, 'The Dematerialization of Art', *Art International*, 12:2 (20 February 1968), 31.

35 Germano Celant, 'Appunti per una Guerriglia', *Flash Art*, 5 (November–December 1967), 3.

36 Lucy R. Lippard, 'Eccentric Abstraction', *Art International*, 10: 9 (November 1966), 28, 34–40.

37 Keith Sonnier, unpublished interview with the author, New York City (27 April 1995).

38 Phyllis Tuchman, 'American Art in Germany: The History of a Phenomenon', *Artforum*, 9:3 (November 1970), 58–69.

39 Willoughby Sharp, 'Interview with Joseph Beuys', *Artforum*, 8:3 (November 1969), 40–7.

40 Rosalind Krauss and Yve-Alain Bois, *L'Informe: Mode D'Emploi* (Paris, Centre Georges Pompidou, 1996).

41 Richard J. Williams, 'Cut Felt: Robert Morris interviewed by Richard J. Williams', *Art Monthly*, 208 (July–August 1997), 10.

42 Cindy Nemser, 'Interview with Steve Kaltenbach', *Artforum*, 9:3 (November 1970), 47–53.

43 Richard Serra, *Writings, Interviews* (Chicago, University of Chicago Press, 1994), p. 153.

44 Roberta Smith, 'A Hypersensitive Nose for the Next New Thing', *New York Times* (20 January 1991), II, 33.

2

Form and Anti Form

In this chapter I deal with modern sculpture, and Robert Morris's straightforward dialectical response to it, 'Anti Form'. The most direct way to introduce this debate is through sculpture itself, so let us begin by considering images of two sculptures made in 1967, *Prairie*, by the British sculptor Anthony Caro, and an untitled piece in industrial felt by the American Robert Morris (Figures 2 and 3). Both the artists and their works would have been familiar to readers of such journals as *Artforum* and *Art International*: both works were exhibited in New York in 1968, Caro's at the Kasmin Gallery in January, and Morris's at Leo Castelli in March. Caro's piece *Prairie* was a predominantly horizontal assemblage of steel components, painted a uniform yellow. The parts themselves resembled the metal forms that might be found in a light-engineering works – rectangular steel plates, girders, rolled metal tubes – but they were balanced in a way that was not legibly functional. Four tubes rested precariously on the other parts, fixed so lightly to them that they appear to float in mid-air. The Morris was formally quite different, an arrangement of 254

2 Anthony Caro, *Prairie*, 1967.

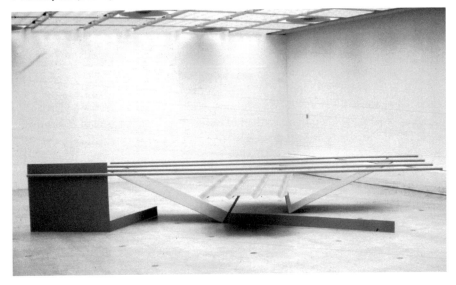

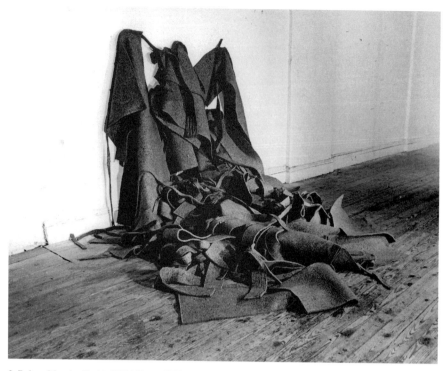

3 Robert Morris, *Untitled* (*254 Pieces of Felt*), 1967.

strips of thick industrial felt, cut to varying lengths, and heaped, piled, and stacked against the gallery wall. A horizontal row of nails at a height of 5 feet allowed some of the larger strips to hang down, giving the composition a vertical emphasis. But overall the work appeared indeterminate and random. The works were materially distinctive, the one made from a soft, virtually colourless, textile, the other from hard, brightly painted metal. They were formally distinct too. The Morris appeared highly indeterminate, as if its final form was dictated by the nature of the material as much as by the artist. The Caro meanwhile was a composition, with one element juxtaposed against another for aesthetic effect. The works nevertheless had their large scale in common – the longest axis (if we can speak of it having an axis at all) of the Morris measured over 10 feet, of the Caro over 20. These were big pieces, made for the public space of the art museum, not any domestic setting. They were also works that make a feature of their modernity. Their materials were not those traditionally associated with sculpture, but industry. The steel fragments of the Caro look as if they have some engineering use, and we might say the same for Morris's felt, a good insulator.

I begin with these images for three reasons, and these reasons form the structure of the present chapter. First, for critics of contemporary art everywhere in 1967, Caro and Morris in many ways represented modern sculpture. Their work

was regularly discussed in print, and they were the subject of frequent exhibitions. This is not to say that there were not other sculptors around, but that in 1967 for an American journal such as *Artforum*, Caro and Morris were perhaps the major foci of critical attention. Secondly, if they were critically important, they represented divergent critical positions as to what modern sculpture should be. Expressed most clearly by Michael Fried in the essay 'Art and Objecthood', this split identified work that was supposedly illusionistic (Caro) versus work that was not (Morris); work that emphasised the character of the finished object (Caro) against work that emphasised the processes – including pre-executive ideas – involved in its manufacture (Morris).[1] But thirdly, Caro and Morris, whatever these differing critical presentations, were nevertheless fundamentally concerned with form. In a 1968 essay, Morris argued for new means of making sculpture that would avoid the highly formal compositions of an artist such as Caro (his solution, as we shall see, was something like non-composition using soft materials). But despite Morris's opposition to traditional formal composition at this stage, the essay's argument, and its provocative title – 'Anti Form' – made clear that form was still the major term of reference. 'Anti Form' therefore performs a dual role in this chapter, identifying on the one hand a discursive break with what I call the 'modern', but on the other making clear that the break is by no means a total one.

The first part of the chapter considers the critical position represented by Caro, and by extension other Modernist sculptors such as David Smith, Julio González, and Pablo Picasso; the major critical texts here are writings by Michael Fried and Clement Greenberg. The second part considers the critical position represented by Morris, and artists such as Donald Judd, Carl Andre, and Sol LeWitt (let us call them Minimalists); the key writings in this case include Morris's own essays on sculpture, as well as a further essay by Fried, 'Art and Objecthood'. The final part of the chapter, however, argues that whatever the differences between these critical positions, they were nevertheless positions in relation to a discourse about form. This discourse has different characteristics from other discourses I identify elsewhere in the book. It is for example a discourse that in all aspects pretends to be objective. There is not much room here for the subjective feelings of the artist or critic, nor for psychology, psychoanalysis, politics, humour, or any of the other things that are important elsewhere in the book. And it is a discourse that is essentially American. It occurs in American criticism, in American journals, in and around American museums and galleries. Non-American artists and critics (such as Anthony Caro) make an appearance, but they are very much part of an American debate. As we shall see, these characteristics are very different from those of other, later, forms of sculpture.

This is Michael Fried writing about Caro's *Prairie* in early 1968:

> Once we have walked partly around *Prairie* there is nothing we do not know about how it supports itself, and yet that knowledge is somehow eclipsed by our actual experience of the piece as sculpture. It is as though in *Prairie* as so often in Caro's

work, illusion is not achieved at the expense of physicality so much as it exists simultaneously with it in such a way that, in the grip of the piece, we do not see past the first to the second. This is mostly due to the nature of the relationships amongst the various elements that compose *Prairie*, relationships that make a different kind of sense to the mind and to the eye. For example that three of the long metal poles are held up at only one end is *understood* to mean that the full weight of each pole is borne by a single support far from its center; but the poles are *seen* as being in a state of balance as they are, as if they weighed nothing and could be placed anywhere without support.[2]

Fried went on to declare that the work was a 'masterpiece' and 'one of the great works of modern art'. The passage is, I think, very useful in exemplifying the critical position associated with Caro and artists like him. In the review, it came after a long passage in which Fried quite successfully managed to describe the various parts of the sculpture and their relationships with each other, and the above passage is the point where he tried to arrive at some form of judgement. Let me make four remarks about it, which I think represent well his position. It was first an understanding of sculpture based on the creation of illusions. Fried wrote at length about how the sculpture is made and the various ways in which individual parts related to each other, but at this point in the text what he describes is the subversion of that logical understanding of form. The work, he wrote, managed to convince the viewer of something that was patently impossible, namely that steel bars may float unsupported, in space. Secondly, the passage made clear that the nature of the illusion was optical: our apprehension of the work was entirely visual. What was presented was an 'image', of in this case weightlessness. (It will become clear later how different this is to other contemporary ideas of sculpture, in which the experience is envisaged in much more physical terms.) Thirdly, the passage – in fact the whole article – made it understood that the sculpture, and more importantly the viewer's apprehension of it, was abstract. An illusion was created, but an illusion of a 'modality', a word used by both Greenberg (in 'The New Sculpture') to mean an abstract way of being, for example weightlessness, hardness, or sharpness.[3] It was in no sense an illusion of some concrete thing. And considering the earlier part of the essay, it is remarkable how successfully Fried avoided any kind of allusion in writing about *Prairie*. It was, on these terms, simply not supposed to be like anything other than the abstract concept of weightlessness. Fourthly, and finally, the passage showed that this understanding of sculpture was predicated on there being an objective way of looking. Fried wrote for example of the 'mind' as if it were universal, engendering the same form of apprehension. More specifically he wrote of the apprehension of the illusion in the first person plural ('we do not see past the first to the second'), as if his understanding of the sculpture's illusionistic qualities was actually universal to all viewers. In all of this the dominant term is certainly form, this characteristic being seen as the most central to sculpture. All other things – history, allusion, material, politics – could be declared extraneous, and therefore not worthy of comment.

The position Fried expressed in his review was the result of personal conviction, as he freely admitted, but by this stage conviction was supported by a carefully worked-out argument. His starting point was the art criticism of Clement Greenberg, whom he had read as a student, and whom he got to know in 1958.[4] Greenberg's writings on sculpture are few – he regarded painting as inherently more advanced – but he wrote sympathetically about David Smith, whom he regarded as enhancing a tradition of constructed sculpture begun with Picasso and Braque and continued through Jacques Lipchitz, Julio González, Alberto Giacometti, and the Constructivists. Greenberg's position on sculpture was set out most clearly in 'The New Sculpture', an essay published in 1948, revised and republished as 'Sculpture in Our Time' in 1958, the form in which it appeared in the influential collection of essays *Art and Culture*. Greenberg began with a statement of principle about Modernist art. Reminiscent to later readers of Greenberg of 'Modernist Painting', it read

> a modernist work must try, in principle, to avoid dependence on any order of experience not given in the most essentially construed nature of its medium. This means amongst other things, renouncing illusion and explicitness. The arts are to achieve concreteness, 'purity', by acting solely in terms of their separate and irreducible selves.[5]

Painting, he continued, had managed to achieve purity through abstraction, or as he put it 'renouncing the illusion of the third dimension'. Sculpture by contrast had been handicapped by the closeness of its relationship with the representation of figures, particularly the human figure. The materials it traditionally used (clay, plaster, and so on) were ones which could approximate the body, where paint would always retain a distinctness from it. Sculpture seemed as a result, wrote Greenberg, 'too literal, too immediate'. But the new sculpture, the subject of the essay was able to find a way forward, by appropriating ideas from Modernist painting, in particular an emphasis on materials, and a new concern for the visual image in place of the physical illusion of bodily presence. Materials changed from those which could best resemble bodily form, to ones which had their own distinctive properties; they typically came from industry and Greenberg wrote of 'iron, steel, alloys, glass, plastics, celluloid'. And if sculpture's purpose, through the use of these materials, was to be separated from the representation of the human body, its apprehension was no longer to be physical, but optical. 'The human body', wrote Greenberg, 'is no longer postulated as the agent of space in either pictorial or sculptural art; now it is eyesight alone.'[6] He amplified this concern in his concluding remarks, in a much quoted formulation: 'Instead of the illusion of things, we are now offered the illusion of modalities; namely that matter is incorporeal, weightless and exists optically like a mirage.'[7]

In making these remarks, Greenberg's reference point would have been something like *Home of the Welder*, a welded steel sculpture made by David Smith in 1945 (Figure 4). Both the artist and critics referred to works like these as 'line drawings' or 'line sculptures', for they comprised linear steel sections composed

4 David Smith, *Home of the Welder*, 1945.

in a highly pictorial arrangement.[8] The works stood upright on plinths, but their main axis was horizontal (like a landscape painting), and they were only really legible as three-dimensional pictures, albeit abstract ones. What Greenberg termed 'eyesight' was clearly important here: there was not much to be gained in walking around the sculpture, as all its incident was concentrated on one plane, very much like a picture.

For Michael Fried, Greenberg's essay was crucial. His own understanding of sculpture, and all his critical writing about it, emphasise abstraction and opticality, the two fundamental concepts of 'The New Sculpture'. But when Fried began to

write about sculpture in the early 1960s, he extended Greenberg's analysis to include references to structuralism (Ferdinand de Saussure) and phenomenology (Maurice Merleau-Ponty). These new interests, as well as his debt to Greenberg, are clearly legible in his catalogue essay for Anthony Caro's retrospective exhibition at the Whitechapel Art Gallery in September and October 1963, a prestigious commission for a student writer still in his early twenties.[9]

Its purpose is not to describe the works in the exhibition, but, as he puts it, 'to put forward a way of looking' at them which is aimed at those visitors encountering them for the first time.[10] The 'way of looking' was founded on two premises: first, that Caro's work should be thought of in terms of the linguistic metaphor of 'syntax' (that it is in other words 'about' the use of a sculptural language); secondly, that it had an overall effect which could be described phenomenologically. The first premise referred to Saussure's work on linguistics, the second to Merleau-Ponty, and both marked substantial revisions of the concepts that underpinned Greenberg's understanding of sculpture, namely abstraction and opticality. To elucidate the idea of Caro's work being essentially linguistic, Fried asked the viewer to imagine his predicament on being faced with it for the first time as being 'analogous to that of a small child on the verge of speech, in the company of adults conversing amongst themselves'. Not knowing anything of the meaning of particular words, the child would therefore respond to language as something both 'abstract and gestural'. Translated to the apprehension of sculpture, individual forms (the coloured girders or geometrical panels in Caro's latest sculpture) therefore have no direct correspondence with things or ideas in the world: they did not represent, like words. All the meaning in these sculptures therefore resided, to continue Fried's analogy, in the way these individual forms related to each other. It was these relationships that conveyed meaning. As Fried put it later on in the essay: 'in Caro's sculptures one's attention is made to bear only upon gesture itself. Everything in Caro's art that is worth looking at – except the color – is in its syntax.'[11] In 1965 Clement Greenberg, agreeing with Fried's analysis, added that the emphasis on syntax (or the 'relations between discrete parts' as he put it) led to a 'radical unlikeness to nature'.[12] Caro's sculptures were not like things in the world: they did not evoke plant forms as Alexander Calder's mobiles tended to do. They were simply about the quasi-linguistic relations between parts.

About the second premise, that the overall effect of Caro's sculpture could be understood phenomenologically, Fried wrote:

> Whereas in painting the 'modernist reduction' has thrown emphasis on the flatness and shape of the picture surface, it has left sculpture as three-dimensional as it was before. This additional dimension of physical existence is vitally important – not because it allows sculpture to continue to suggest recognisable images, or gives it a larger range of formal possibilities – but because the three-dimensionality of sculpture corresponds to the phenomenological framework in which we exist, move, perceive, experience, and communicate with others. The corporeality of sculpture, even at its most abstract, and our own corporeality are the same.[13]

This understanding of the term 'phenomenology' does not correspond to the one popularised by Gaston Bachelard's book *The Poetics of Space* which was available in an English translation in the United States in the early 1960s (published, incidentally, by Beacon Press of Boston, the same Unitarian Universalist publisher responsible for Greenberg's *Art and Culture*).[14] Bachelard wrote of the feelings produced by different kinds of interior space: attics, cellars, corners, nests. It was this concept of phenomenology that certain critics of Minimalism adopted in the mid-1960s: they wrote, for example, of crowding or claustrophobia, produced by the occupation of small gallery spaces by very large geometrical objects (Fried himself would also pick up on this idea in 'Art and Objecthood'). No – what Fried meant by phenomenology here was the evocation of 'bodily feeling or movement' through the language of sculpture. In other words, bodily feeling was present in all experience of sculpture, but in Caro's sculpture (and implicitly in all good sculpture) the feelings produced were empathetic. One did not empathise with a box, but one did with the thrusting beams and panels of Caro's work, because in some way they corresponded with bodily parts. He wrote later: 'When I first saw *Midday* and *Sculpture Seven* in Caro's garden I felt I was about to levitate or burst into blossom … Merleau-Ponty provided philosophical sanction for taking those feelings seriously and trying to discover where they led'[15] (Figures 5 and 6).

5 Anthony Caro, *Midday*, 1961.

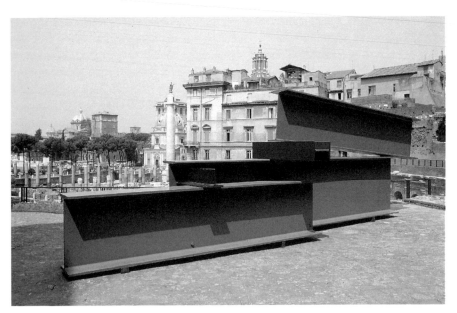

6 Anthony Caro, *Sculpture Seven*, 1961.

Fried's sculptural criticism therefore made substantial revisions to Greenberg. In place of Greenberg's straightforward prejudice in favour of abstraction, we have Fried's insistence on linguistic metaphor to explain the work. If sculpture no longer represented bodies, it came to be about a set of linguistic relationships. And instead of Greenbergian 'opticality' (about which Fried was not very interested, he said later) we have an argument about phenomenology. As viewers of sculpture, we were no longer supposed to apprehend it simply in terms of visual imagery: we were supposed, because of its three-dimensionality, to respond to such imagery empathetically, feeling in it some vestigial, abstract bodiliness. But if Fried made Greenberg's theories of sculpture a good deal more sophisticated, he was certainly sympathetic to them, and we can understand both critics as contributing to the same Modernist critical position. Our understanding therefore is still that sculpture should be fundamentally abstract, that it should concern the relationships between parts, that it should eliminate all things that do not contribute to this fundamental essence of sculpture, that it could be understood universally, that it provoked a primarily visual rather than physical experience, and that it should generate experience centred on the perception of sculptural objects, rather than any of the surroundings in which they were set. These were, incontrovertibly, the values of Modernist sculpture.

In the Summer 1967 issue of *Artforum*, Fried published what became his best-known critical essay, 'Art and Objecthood'.[16] Writing in support of Caro and other Modernist sculptors, Fried reiterated the position described above. However, he

embellished it with a statement to the effect that the best sculpture was capable of provoking transcendent experience, a moment of instantaneous revelation in the viewer that would lift him or her out of the everyday world. This characteristic Fried termed 'presentness', and he contrasted it with 'literalness' or 'literal presence', in other words the character of ordinary objects. The essay concluded, famously: 'we are literalists all, or most, of our lives. Presentness is grace.' Fried's target here was Minimal Art (or Minimalism, ABC Art, Primary Structures, or one of the other terms in use at the time) (Figure 7). Associated with New York-based artists including Carl Andre, Donald Judd, Sol LeWitt, and Robert Morris, it was increasingly prominent in fashionable New York galleries, and a coherent, seemingly anti-Modernist critical position had developed around it. I describe this position here.

Minimal Art had been visible in New York for some years. Morris showed Minimal works at the Green Gallery as early as 1964, while Donald Judd, Carl Andre, and Sol LeWitt followed shortly afterwards. There had also been significant publications including Judd's theorisation of his work, 'Specific Objects', published in 1965, and Morris's 'Notes on Sculpture' published from early 1966. In that year, the Jewish Museum in New York put on a large, albeit rather eclectic, survey of the tendency, which attracted international critical attention. *Primary Structures*, curated by Kynaston McShine with the unacknowledged help of Lucy

7 Carl Andre, *Equivalent VIII*, 1966.

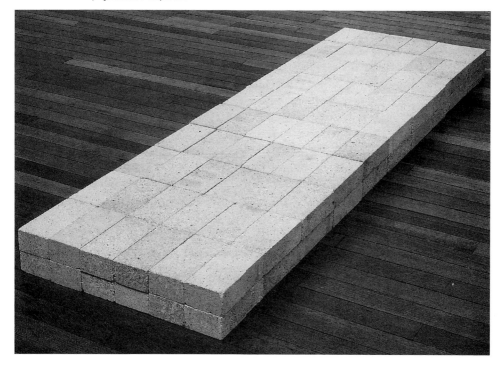

Lippard, showed work by Morris and Judd as well as pieces by Andre, Dan Flavin, Ad Reinhardt, Robert Smithson, Frank Stella, and – confusingly, in retrospect – Anthony Caro. The journal *Arts* carried a review by the artist and critic Mel Bochner entitled 'A Declaration of a New Attitude as Revealed by an Important Current Exhibition'. The title of this alone indicates the kind of claims that were made for the show, and the interest of the long-established (and somewhat conservative) *Arts* in it, and their willingness to use such a little-known critic as Bochner is indicative of a change of attitude.

But a much more consistent presentation of Minimal Art, albeit a smaller one, was *10*: I will use it here to stand as a practical realisation of the Minimalist position. Held in October 1966 at the Dwan Gallery on New York's West 57 St., it presented one work each by Andre, Jo Baer, Flavin, Judd, Agnes Martin, Morris, LeWitt, Reinhardt, Smithson, and Michael Steiner.[17] A visitor would have been struck by the formal severity of the show: there were no curves to be seen, and the coloration of all works was subdued if there was colour at all. Not only did all works – whether paintings or sculptures – consist in straight lines, flat planes and right angles, but they were all aligned exactly with the walls or the floors. Surfaces were either reflective or plain. As regards the painting, the only depicted forms were grids. Traces of artistic handling (brushmarks, impressions of fingers or hands, modelling, carving) were all but eliminated. And where a work consisted in more than one element, the interval between one part and another was made absolutely regular. Indexical of this extremely reduced formal vocabulary were the works by Morris, Judd, and LeWitt, respectively a grey-painted plywood box standing about waist-height to the viewer, six cubic steel boxes arranged in a horizontal series on one wall, and a white-painted open cuboid, like a mathematical drawing in space.

10 is indicative of the increased critical interest in Minimal Art after the Jewish Museum show. There were reports of it in four American journals and one French one between October 1966 and January 1967, one of the American reviews going on to be republished as part of an anthology in 1968. All in all it was an unusual amount of attention for such a small show at a newly established gallery. Also unusual was what the critics, or at least some of them, actually said. There was a marked tendency to ignore the objects themselves in favour of remarks on how they interacted with their environment. The critic Michael Benedikt, for example, wrote in *Art International* that the gallery space was just as important as the works themselves. Writing of the works by Morris and Judd, or rather the space surrounding them, he wrote 'one felt in both cases that one was strolling around an important aspect of the work'.[18] He went on to complain about the carpet ('truly: after placing bets on all things reductive and minimal and mainly black and white it seems to me that no gray-brown textured rug should have been left around at the Dwan'). About the work itself, Benedikt actually said very little: he only described the Morris and the Judd, or rather their effects on their environment, ignoring the sculptures by Andre, LeWitt, and Smithson, and all of the painting, which is to say that in conventional terms he ignored most of the show.

Benedikt's somewhat decentred approach to the show was shared by other critics, who tended to write about it as an environmental experience rather than a collection of art objects. All of them seemed to exemplify what another critic, Brian O'Doherty, had already – very astutely – called 'critical paralysis' in the face of Minimal Art. O'Doherty wrote in 1966:

> The latest objects which pretend to be inert or non-emotional (this is simply a brilliant convention of camouflage within which art is functioning now) has clearly patented a way of avoiding all the expectation about how 'new' art should behave when it appears ... The most intellectually rigorous New York art now ... cancels clichés of avant-gardism and sidesteps the expected dialectic. It is through these exact cancellations that the objects are brought into their state of marvellous paralysis that has reduced some criticism to phenomenology.[19]

What O'Doherty meant by phenomenology was not clearly stated, but the implication seems to me clear enough: phenomenology is not here a sense of empathy with sculpture, the sense in which Fried used the term earlier. These objects are not seen as encouraging the viewer to 'levitate' or have any other kind of transcendent experience. Instead, the sense of the term here is more Bachelardian, to do with the perception of situations or spaces, or rooms. Both O'Doherty and Benedikt (and very likely, all the other critics who wrote about *10*) would have known Robert Morris's 'Notes on Sculpture Part 1', published in the February 1966 *Artforum*, an essay which would have begun to provide a theoretical basis for these observations. That essay, part of a series of four which appeared between 1966 and 1969, proposed that physical, not optical, considerations were the true province of sculpture. Therefore sculpture should emphasise the properties of 'scale, proportion, shape, mass', all terms which the astute reader would have noted were in some way relative, dependent for their effects on the existence of some environmental factor exterior to the sculptural object. Morris was more explicit about this in the second essay, 'Notes on Sculpture Part 2', whose publication coincided with the Dwan show, and which Michael Benedikt almost certainly had read. Morris wrote at length about scale in this essay, opening with remarks about the different effects objects had relative to the size of the human body. 'A larger object', he wrote 'includes more of the space around itself than does a smaller one. It is necessary literally to keep one's distance from large objects in order to take the whole of any one view into one's field of vision.'[20]

In other words, what mattered in the apprehension of sculpture was not so much the visual image of the work, but the physical act of moving, in this case backing away, to obtain that image. (The viewer would equally have to move closer in to peer at a smaller object.) Morris continued with a statement to the effect that the sculptural object was henceforth to be understood as a vehicle for the generation of responses to environmental conditions: 'The better new work takes relationships out of the work and makes them a function of light, space and the viewer's field of vision. The object is but one of the terms in the newer aesthetic.'[21] In which case as

a critic one was now supposed to consider what Morris termed the 'whole situation' and not just the sculptures. Following Morris's lead, critics of Minimal Art began to treat sculpture as simply one of the elements in a wider perceptual field. Hence Benedikt's remarks about the Dwan Gallery's carpet. And while some critics continued to write about Minimal Art in Modernist terms, the critical discourse around it very rapidly centred on phenomenology as the key concept, a fact underlined by Fried's attack on Minimal Art, 'Art and Objecthood'. Fried did not use the word phenomenology, but it is – in the sense used above – undoubtedly implied in his term 'theatre', the charge he makes against Minimal Art. That art's 'theatrical' characteristics were those things that showed that it made its surroundings an integral part of the art experience. Minimal Art was theatrical because it manipulated scale, inducing the viewer to shift his or her position, or experience sensations of crowding. It was theatrical because it was concerned with the 'duration of the experience' as Fried put it: the viewer was encouraged to spend time with the objects, to walk around them, to play with them, to observe changes of illumination at different times of the day. And it was theatrical, because in all of this, it made the viewer or beholder a central term in the art experience. The work could not exist, wrote Fried, without the presence of the beholder. Theatre is, I am arguing, phenomenology: the fact that Fried chooses this term as the basis of his lengthy and sustained critique is indicative of the centrality of phenomenology to the Minimalist position.

This chapter began with a commentary on a highly formal discourse of sculpture, in which form was privileged as the essential term. It continued by looking at a discourse, around Minimal Art, in which the terms were quite different – indeed fundamentally opposed in Michael Fried's view. In place of form, both critics and artists seemed to be concerned with space and light, or other environmental concerns. This final part of the chapter discusses how such non-formal ideas of sculpture were extended by Morris in a famous essay, 'Anti Form', but how – perversely – form retained a central place in this discourse of sculpture.

About 'Anti Form': it was a short essay, occupying just three pages, including illustrations, of the April 1968 *Artforum*, the journal which had already published Morris's three 'Notes on Sculpture', Fried's 'Art and Objecthood' and numerous other articles and reviews concerning Minimal Art. Despite the revolutionary promise of the title, it was legibly a continuation of the author's existing critical project, namely the 'Notes on Sculpture', essays which as we have seen worked towards a definition of Minimal Art. In each one, Morris focused on a particular issue – shape, size, relationships between forms – critical attention to which would allow him to make a further move in the reduction of sculpture to essentials. By 1968 Morris thought that Minimal Art had reached an impasse. In its drive towards essentials, it had neglected the fact that the geometrical objects it favoured, and the geometrical arrangements in which they were placed, presented an 'order of facts' beyond the literally existing things.[22] In other words the work could be conceived of

before it was made, whereupon its making became perfunctory. The solution Morris proposed was to focus on the making of the work of art rather than its object character, and using the example of Jackson Pollock, he proposed an investigation into ways of making art in which conception and execution were seamless. Pollock was instructive, wrote Morris, thinking of the painter's legendary working methods, as 'the stick that drips paint was in far greater sympathy with matter because it acknowledged the inherent tendencies and properties of that matter'.[23] In other words Pollock's famous drip paintings revealed the natural tendency of paint to act as liquid, a fact concealed by the conventional tools of the painter. For sculpture, 'Anti Form' demanded the adoption of working methods in which process was prioritised over product. Morris wrote of making sculpture without tools, of emphasising gravity, of arrangements that were 'casual, imprecise and unemphasised'. He concluded: 'Random piling, loose stacking, hanging give passing form to the material. Chance is accepted and indeterminacy is implied as replacing will result in another combination.'[24]

An investigation of such things was already, he declared, in process: the essay illustrated works by Claes Oldenburg, Richard Serra, David Paul (an artist who mysteriously never appeared anywhere else), and Alan Saret, all represented by works that employed soft or flexible materials.[25] However, the investigation was best represented by Morris's own new work in the form of two untitled works in thick, industrial felt, a dense, greyish material used for insulation and available, it seems, in vast quantities. One, whose photograph occupied most of the essay's first page, comprised 254 felt strips of varying thickness, the largest pieces heaped randomly on the floor, the smaller ones hung from hooks on the adjacent wall (Figure 3). The resultant composition occupied the space of a large wardrobe, although its physical presence was somewhat different. Morris's other piece was more straightforward, comprising three large pieces of felt rolled up together like a carpet. The works by the other artists illustrated involved the use of similarly soft or flexible materials including the cast rubber (Serra), chickenwire (Saret), fibreglass (Serra), and PVC (Oldenburg). The reader of 'Anti Form' might well have seen these or similar works, for its publication coincided with Morris's latest exhibition at Leo Castelli Gallery, which included a variety of felt sculptures (Figure 8).

'Anti Form', in its title, and in its rhetoric of process, clearly set out to break with formalist ideas of sculpture, and this tends to be how it has appeared in subsequent accounts. In the context of this book however, there are ways in which 'Anti Form', interesting though it is, makes an imperfect break with formalism, and in fact maintains form as an essential term. Let us consider, to begin with, the essay's argument. Its rhetoric of process, or 'making' in Morris's phraseology, could not be more clearly stated. Instead of considering works in terms of their final forms, the essay encouraged the artist/reader to experiment with materials for the sake of 'making' itself. Process in other words should be emphasised over product, the making over form. The 'random piling, loose stacking, hanging' with which Morris concluded were clearly processes. That said, process in Morris's

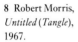

8 Robert Morris,
Untitled (*Tangle*),
1967.

sense was circumscribed by the need to use materials which left a clear trace of the
processes used to manipulate them. Pollock's drip paintings were therefore good
because they were seen to be indexical of the way they were made.[26] Sculptures
made of industrial felt were good because they also revealed how they were made,
first cut (the material retained a clear right-angled edge) and then arranged,
responding to gravity and the immediate environment. There was therefore a
concern for the finished product implicit in the whole concept, this being under-
lined by the nature of the essay's illustrations, all of which represent finished
sculptures. We might make a further observation about process: that it remained a
private thing, done to materials by the artist in his (not very likely her) studio, and
to this end, photographs of the materials in the act of being worked are rare. And
where they do exist, in the case of Morris and Serra, they tended to confirm
existing paradigms of the artist at work.[27]

The rhetoric of process certainly enabled Morris to develop new kinds of sculp-
ture, but it does not address any of the conditions of spectatorship. And at Morris's
Castelli show in 1968, most of these conditions seem to have remained in place: the
works were photographed extensively, but not ever with people around them. The
gallery as usual encouraged visitors to keep their distance, and the experience of
apprehending these works remained in many sense an optical one. The process of
making the objects also seems worth commenting on at this point: the rhetoric of

process contained the idea that the works incorporated chance and indeterminacy, and environmental factors such as gravity, and in the works Morris showed in 1968 this was to an extent demonstrated: they hung from nails, or slumped in corners, or manifested themselves as impossible heaps of stuff that could only have been contrived by chance. Morris wrote installation instructions for these works which also appeared to leave much to chance. An undated set of instructions for the work comprising 254 pieces of felt read:

> (1) mix up the pieces thoroughly and heap on the floor with no special arrangement of the pieces (2) the wall may be used within special limits ... the pieces of felt can be heaped on the floor and some on the nails.[28]

But the earlier stages in the making of the work involved a predetermined sequence of some complexity. Seven layers of felt, each measuring 6 ft by 9 ft, were laid out and cut into a series of progressively smaller strips ranging in width from 72 in. down to 1⅛ in. We could say that the decisions involved in determining this process, and in fact the decisions about how the strips were to be arranged, were aesthetic decisions of the same order as those made by an artist like Caro or David Smith: to what extent were their steel compositions predetermined, and to what extent were

9 Richard Serra, *Belts*, 1967.

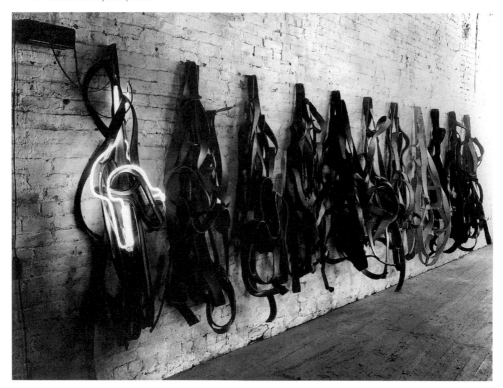

they based on chance events in the studio? And the temporality that Morris wanted to introduce into the work ('replacing results in another configuration') seems to have been subverted by gallery and museum curators – and probably the artist himself – who have reconstructed these works of the 1960s based on minute observation of the original installation photographs. Rather than emphasise process, the impulse recently when they have been shown has been to get the works 'right'.

Finally, let us consider the curious title of the essay. It was, as has already been stated, part of a continuing project to define sculpture, and can be considered as a further move in the series 'Notes on Sculpture': indeed Morris saw no reason why the essay should not have been called 'Notes on Sculpture Part 4'.[29] The title 'Anti Form', he claimed both privately and publicly, was an invention of Philip Leider, the then editor of *Artforum* who 'coined the term and then pasted it on an article I wrote'.[30] Leider disagreed, writing that he would have preferred the essay to be published as part of the earlier series ('I would suspect it was Bob's title because I would probably have preferred "Notes on Sculpture" – Perhaps Bob realised that sculpture was not as useful a term as it once was').[31] Whatever the truth of the matter, what is clear is that the concept, the presentation of the idea of process, was set up – by whoever – in opposition to form. But in doing this, the author of the term privileged form as the major term of reference: which summarises the main points I want to make about 'Anti Form'.

The character of 'Anti Form' – its questioning of Modernist criticism while maintaining form as the essential term – recalls an art historical text which was well known at the time. *The Shape of Time: Remarks on the History of Things* was published by the Yale professor of art history George Kubler in 1962.[32] Kubler's research concerned pre-Columbian art, and the book's argument seems to derive from his frustration with conventional art-historical methods in dealing with non-Western art. Both Morris and his friend and fellow artist Robert Smithson regularly cited Kubler in their writings: the most important reference is certainly Morris's Master's thesis written under E. H. Goossen at Rutgers University. Titled *Form-Classes in the Work of Constantin Brancusi*, it applied one of Kubler's better-known concepts ('form-classes') to the study of modern sculpture. Morris went on to cite Kubler in two of the 'Notes on Sculpture', as did Smithson in, for example, his ironic account of a day's sightseeing in New Jersey, 'The Monuments of Passaic', published as an article for *Artforum* in 1967. What appealed to Morris and Smithson about Kubler was undoubtedly his critical approach to art history, in particular his rejection of many of the usual terms by which value judgements were made: style, for example, or biography. Kubler provided a theoretical model which seemed to be able to account for art without making ultimately subjective judgements of value. (It may also have had a romantic appeal for Smithson: Kubler's work provided a way of accounting for contemporary art in the same terms as the art of the remote geographical and historical past, an interest of his since childhood.) At the same time Kubler's work maintained form as the central term in the

history of art, like Fried and other Modernists, and like Morris and other of their supposed opponents. In concluding this chapter with Kubler, I am therefore interpreting the material in terms of a discourse around form, rather than specific battles about form within that discourse.

Let me say a little more about *The Shape of Time*. It had some of the character of a polemic. It was short (130 pages) and was written quickly in a short sabbatical from Yale. It was not a historical work, unlike Kubler's other publications; its principal theme instead was art history, or to be more precise the inadequacy of modern art-historical methods to deal with a very wide range of material culture (though 'material culture' was a term he also found inadequate for what he wanted to describe). His specific targets included the emphasis on biography in the history of art, Kubler's objection here being that it was inevitably a form of narration, and the narrative historian 'never is required to defend his cut (or where he begins and ends his story) because history cuts anywhere with equal ease and a good story can begin anywhere the teller chooses'.[33] For similar reasons Kubler attacked the notion of 'style' in art history, writing that it simply produced a mass of information that could never be properly interrogated. It was simply 'stock-taking', culminating in 'irreproachable and irrefutable lists and tables'. Likewise, Kubler attacked the familiar biological metaphor present in traditional art history, the notion of birth, flowering, and death. At least, he remarked, this metaphor offered a provisional explanation of the recurrence of events rather than treating each one in isolation, but it failed, for example, to account for 'the transmission of some kind of energy; with impulses; with generating centres, and relay points; with increments and losses in transit; with resistances and transformers in the circuit'. 'In short', he concluded, 'the language of electrodynamics might have suited us better than the language of botany.'[34]

One senses that at the heart of Kubler's attack on traditional art history was a distaste for traditional forms of classification, and their attendant hierarchies: painting above sculpture, both above any form of artefact, and so on. It is an understandable objection given the absence of normal Western art forms from the subject of Kubler's research. In place of traditional art history, he proposed a 'History of Things', signalled by the book's title. Such a history would abolish the normal concern for biography, and the forms of classification that tend to flow from it, and in its place put a non-hierarchical method which (while recognising difference in use or intention) would account for all kinds of made thing. Kubler wrote:

> the 'history of things' is intended to reunite ideas and objects under the rubric of visual forms: the term includes both artefacts and works of art, both replicas and unique examples, both tools and expressions – in short all materials worked by human hands under the guidance of connected ideas developed in temporal sequence. From all these things a shape in time emerges. A visible portrait of the collective identity, whether tribe, class, or nation comes into being.[35]

The attractiveness of Kubler's work for Morris and Smithson has on the one hand to do with its offering an alternative critical model to Modernist criticism: this has

already been stated. But Kubler's definition of the 'history of things' shows how it might have two other kinds of appeal, more closely related to the sculpture they were making in the later 1960s. First, there is the manifest desire to collapse normal categorical boundaries, so that 'art' and 'artefact' are give equal value, and all forms of made things are held to be expressions of ideas, solutions to historically arising problems as he puts it elsewhere in the introduction to the book. There are strong echoes of this collapse, or conflation, in 'Anti Form'. In that essay, Morris began by critiquing the persistence of form regardless of materials – an idea which is itself seemingly derivative of Kubler – before going on to propose a new way of making sculpture in which the making and the final form become one. As we saw earlier, the method involved the use of soft materials, the manipulation of which would see the distinction between tool and material deliberately blurred. 'Sometimes', Morris wrote, 'material is manipulated without the use of a tool at all.'[36] It is no accident that Morris should pick on this particular opposition, between tool and material, for it is a re-reading of Kubler.

Secondly, let us consider the notion of originality. One of Kubler's more striking proposals was to abolish the distinction between an original object and a copy of it, in doing so detracting from one of the special characteristics of art. Shortly after the publication of *The Shape of Time*, Morris exhibited an array of Minimalist works at the Green Gallery, New York, works which were made from the simplest materials (mainly plywood and grey paint), which required no special skills to make, and which could be – and were – easily fabricated in series. And Morris went on to show works throughout the 1960s which were deliberately made in multiple editions so there could even be simultaneous exhibitions of the same work (there are numerous instances of this). Several of Smithson's works similarly confused the distinction between original and copy: the 1970 earth work, *Spiral Jetty*, was so large and remote that it could only be consumed in the form of photographs, a magazine article, and a film, all of which were needless to say produced in multiple editions. The same is in fact true of any number of artists working during the period covered by this book: Kubler's text provided a theoretical model for such questioning.

And yet in spite of these challenges to traditional art history, and the way in which these questions apparently legitimise new forms of sculpture, Kubler's central term (and by extension at this point, Morris's) was form. 'Ideas and objects', wrote Kubler, 'are united under the rubric of visual form.' And form was said to express precise historical and social conditions, 'nation, class or tribe'.[37] Kubler's method (and Morris's) was not therefore a kind of formalism, the discussion of form to the exclusion of all other factors, but a method which privileged its study because it was believed to express all other factors. It will come as no surprise therefore to read that this position was entirely consistent with Clement Greenberg's understanding of form, and Michael Fried's, both of whom believed that the study of form held the key to the understanding of all other factors. Common to all these positions were beliefs about the nature of sculpture and its apprehension. Whatever the precise form of sculpture, it was still at this point something that was

to be shown and apprehended in the special circumstances of the modern art gallery. It was something that assumed a universal spectator – there is no room for any kind of subjectivity here. It was something essentially divorced from its social and cultural surroundings, whatever the play Minimal Art made of its immediate environment. And it was still a visual art, dependent on long-established conventions of looking. There is more consistency than first appears between ostensibly opposite positions. In later chapters we will see that consistency break down, as theories of sculpture address the subjectivity of its viewers, its conventions of display, and its social and political contexts.

Notes

1 Michael Fried, 'Art and Objecthood', *Artforum*, 5:10 (June 1967), 12–23.
2 Michael Fried, 'Two Sculptures by Anthony Caro', *Artforum*, 6:6 (February 1968), 24–5.
3 The concept of abstract 'modalities' also appears in Fried's criticism of painting: he writes of a Kenneth Noland of 1969 expressing 'lateralness and extension', ideas deriving straightforwardly from the composition. More sophisticated (though less convincing to me) is his account of a Morris Louis, in which paint is poured directly on to unprimed canvas. The 'modality' expressed here is of the 'firstness of marking'. See Michael Fried, *Art and Objecthood: Essays and Reviews* (Chicago, University of Chicago Press, 1998), pp. 186 and 119.
4 Fried, *Art*.
5 Clement Greenberg, 'The New Sculpture', *Art and Culture* (Boston, Beacon Press, 1961), p. 139.
6 Greenberg, *Art and Culture*, p. 143.
7 Greenberg, *Art and Culture*, p. 144.
8 Cleve Gray, (ed.), *David Smith by David Smith: Sculpture and Writings* (London and New York, Thames and Hudson, 1968), p. 68.
9 The essay, simply called 'Anthony Caro', is reprinted in Fried, *Art*, pp. 269–76. It was first published simultaneously with the exhibition in *Art International*, 7 (September 1963), 68–72. Fried later criticised the essay, pointing out that it didn't refer to any specific works of Caro's, and describing its use of Merleau-Ponty and other writers as 'obtrusive'. This may be so, but the essay is nevertheless important historically: Fried quotes extensively from 'The New Sculpture', and explains how it can be expanded upon. It also provides a useful index of his theoretical interests at this point.
10 Fried, *Art*, p. 269.
11 Fried, *Art*, p. 273.
12 Clement Greenberg, 'Contemporary Sculpture: Anthony Caro' (first published 1965), in John O'Brian (ed.), *Clement Greenberg: The Collected Essays and Criticism 4: Modernism with a Vengeance* (Chicago, University of Chicago Press, 1993), pp. 205–6.
13 Fried, *Art*, p. 274.
14 Gaston Bachelard, *The Poetics of Space* (Boston, Beacon Press, 1969).
15 Fried, *Art*, p. 28.
16 Fried, 'Art and Objecthood'.

17 Dwan Gallery, New York, *10* (4–29 October 1966).

18 This and the following quotation: Michael Benedikt, 'New York Letter', *Art International*, 10:10 (December 1966), 65.

19 Brian O'Doherty, 'Minus Plato', in Gregory Battcock, *Minimal Art: A Critical Anthology* (New York, E. P. Dutton, 1968), pp. 251–5. The essay, first published in early 1966, deals specifically with the coming 1966–7 art season.

20 Robert Morris, 'Notes on Sculpture Part 2', *Artforum*, 5:2 (October 1966), 20–3.

21 Robert Morris, 'Notes on Sculpture Part 2'.

22 Robert Morris, 'Anti Form', *Artforum*, 6:8 (April 1968), 34.

23 Morris, 'Anti Form', 34.

24 Morris, 'Anti Form', 35.

25 'David Paul' was very likely one of Morris's inventions, of the same kind as the three fictional 'extra-visual artists' who Morris discussed in his 1971 essay 'The Art of Existence'. For more on Morris's fictionalisation of his activities as an artist, see chapter 5 below on so-called 'dematerialization'. If by any chance David Paul exists, and is reading this, perhaps he would be kind enough to contact the author.

26 Rosalind Krauss makes precisely this argument in 'Reading Jackson Pollock, Abstractly', in the collection *The Originality of the Avant-Garde and Other Modernist Myths* (Cambridge, Mass., and London, MIT Press, 1983).

27 There are pictures of Morris making 'Anti Form' sculptures in the catalogue to the artist's retrospective exhibition at Eindhoven in 1968 (Stedelijk Van Abbemuseum, Eindhoven, 16 February–31 March 1968), and also in Jack Burnham's article, 'Robert Morris: Retrospective in Detroit', *Artforum*, 8:7 (March 1970), 65–75. None of these images was available for use at the time of publication, unfortunately.

28 Undated instructions for *Untitled (254 Pieces of Felt)* (1967), Robert Morris Archive, Guggenheim Museum, New York.

29 Robert Morris, unpublished letter to the author (1995).

30 Morris, unpublished letter. He makes exactly the same point in interview with E. C. Goossen in 1970. See 'The Artist Speaks: Robert Morris's, *Art in America*, 58:3 (May–June 1970), 104–11.

31 Philip Leider, unpublished letter to the author (22 March 1995).

32 George Kubler, *The Shape of Time: Remarks on the History of Things* (New Haven and London, Yale University Press, 1962).

33 Kubler, *Shape*, p. 2.

34 Kubler, *Shape*, p. 9.

35 Kubler, *Shape*, p. 9.

36 Morris, 'Anti Form', 35.

37 Kubler, *Shape*, p. 9.

A new subjectivity

In chapter 2 I considered one response, 'Anti Form', to dominant forms of sculpture in the mid-1960s. Its self-declared task, as we saw, was to subject any preconceived form to the same questioning that Minimal Art had put to traditional notions of composition. The results were, as we also saw, a type of sculpture using flexible materials, whose form could not be absolutely predetermined in advance: at least it strongly gave that impression. Such sculpture was highly allusive – later, Robert Morris, the author of 'Anti Form', wrote of 'guts and offal' in connection with the felt works, the 'skin-like' quality of the felt, and his own feelings of nausea when manipulating the materials, precisely because of their resemblance to organic matter.[1] Yet at the time of their production, 1967–68, there was no critical vocabulary to express such feelings, whether on the part of the artist, or on the part of the viewer. 'Anti Form', whatever the strange character of the works it advocated, was in spirit a continuation of the work of Morris's essays on Minimal Art, pretending objectivity and distance, and attending solely to matters of form. The allusive qualities of the work, and their potential effects, psychological or other, on the spectator, did not form part of the discourse. The artist as subject was not really imagined here: things were produced which had (supposedly) only one quality, things which did not in other words represent the character of a person. Neither was the viewer as subject really imagined, other than as a universal, esentialised, pair of eyes. To put it another way, subjectivity, whether the artist's or the viewer's, was not at issue in 'Anti Form'.

As we saw in the last chapter, one place where subjectivity very clearly was at issue was in Michael Fried's art criticism. His contemporary reviews of sculpture by Caro were entirely concerned with the legitimisation of highly subjective feelings. He wrote of wanting to 'levitate' or 'burst into blossom' when faced with two of Caro's pieces for the first time.[2] Making these feelings available for art criticism, making them objects of serious attention, was very much the task of his criticism, and he set out to achieve it with reference to Merleau-Ponty and other phenomenologists. In mid-1960s New York, sculptural debate was in some senses polarised between subjectivity and objectivity, or to put it another way, between critics like Fried who appeared to take their subjective feelings seriously, and others, particularly Morris and the Minimalists, who did not. Such a polarisation is also clearly bound up with questions of representation, whether sculpture could, or should,

describe anything in the world – even something as vague as an 'abstract modality' – or whether it should simply be there.[3]

I think this polarisation is clearly legible in, for example, *Artforum*, which represented both positions. However, in this chapter, I want to show how subjectivity became an issue for artists and critics who were otherwise close to the Minimalists, how their interest in subjective feeling, on the part of both artist and viewer, provided a new way for accounting for sculpture. I will say also that this was a parallel investigation to Morris's, that the work I discuss here was quite close to his in some ways, and that it was likewise conceived of as a critique, or revision of modern sculpture.[4] Some of the artists (Hesse and Nauman, for example) were included in his show at the Castelli warehouse in 1968, while some of the critics (Lippard, for example) wrote approvingly of his work. But whatever closeness there was, and whatever the similarity of the work under discussion, there is a different discourse in operation, a discourse that ultimately has some relevance for (for example) the highly subjective, almost autobiographical, sculpture of artists working in the 1980s and 1990s: Helen Chadwick, Rachel Whiteread, and Tom Friedman are all, in different ways, good examples.

The work I discuss in this chapter is again predominantly American, but the artists I discuss were younger than Morris, not necessarily New York-based, and they belonged to rather different social groups. I also say a great deal about the work of an art critic, Lucy Lippard. I begin with her, and discuss at some length her curatorial projects of the 1966–67 art season, namely an exhibition called *Eccentric Abstraction*, and a critical essay of the same title. I go on to discuss the critical discourse around two young artists who appeared in Lippard's show, the German-American Eva Hesse and the Californian Bruce Nauman. Both were younger than Morris, and in different ways let it be known that their work was to be understood in partial relation to it and that of artists of his generation. Their interviews, and diaries (Hesse's), and the reviews of their work constantly cited Morris and Minimal Art as a reference point. In all of this discussion, my sources are agreed upon the fact that subjectivity had been repressed, to use a Freudian metaphor, from Minimal Art. What was at stake in these new tendencies was the recovery of that subjectivity.

Let us begin with *Eccentric Abstraction* (Figure 10). The show bearing this title opened on 20 September 1966 at Fischbach, a small commercial gallery of contemporary art at 29 West 57 St., New York. Curated by Lippard, by then a respected and widely published art critic, it showed new sculptures by Alice Adams, Louise Bourgeois, Eva Hesse, Gary Kuehn, Bruce Nauman, Don Potts, Keith Sonnier, and Frank Lincoln Viner, none of whom (with the exception of Bourgeois) was especially well known at the time.[5] Most of the work was rather large – most works had an axis of at least 6 ft, which is to say that they were about the same size as the Minimal Art then prominent in New York galleries. Like Minimal sculptures, the works at *Eccentric Abstraction* tended to sit on the floor, or hang from the walls, and

10 Fischbach Gallery, *Eccentric Abstraction*, September 1966.

most exhibited a marked horizontal axis. A few works sat conventionally on plinths; most did not. The materials the work used were, in common with those used by Minimal artists, not those traditionally associated with sculpture. Here they were somewhat reflective and fetishistic–looking such as leather, rubber, fibreglass, vinyl, polythene.

The installation was dominated by several very large pieces: Eva Hesse's *Metronomic Irregularity*, a wall–mounted work comprising three horizontally spaced square black plywood panels, drilled with regularly spaced holes, connected with an unfathomable mass of cotton–covered wires (Figure 11); Frank Lincoln Viner's assemblage of hanging vinyl objects, resembling a row of plastic bags; Don Potts's leather–covered plywood objects, with 'the scale of playground equipment, but the feel of high–class luggage' according to the critic David Antin;[6] Keith Sonnier's inflatable geometrical forms made of clear plastic and plywood (Figure 12). Against these works those by Nauman, Bourgeois, and Kuehn looked small and dejected, and are hard to make out in the photographs.

The exhibition, which occupied the gallery until 8 October, was only one mani-festation of a more ambitious critical project. In the summer of 1966, Lippard had given a lecture entitled 'Eccentric Abstraction' at the University of California, Berkeley, and then at the Los Angeles County Museum of Art.[7] A short statement with the title 'Eccentric Abstraction' accompanied the September exhibition, and a much longer article with the same title appeared in the November 1966 *Art*

11 Eva Hesse, *Metronomic Irregularity*, 1966.

12 Keith Sonnier, *Untitled*, 1966.

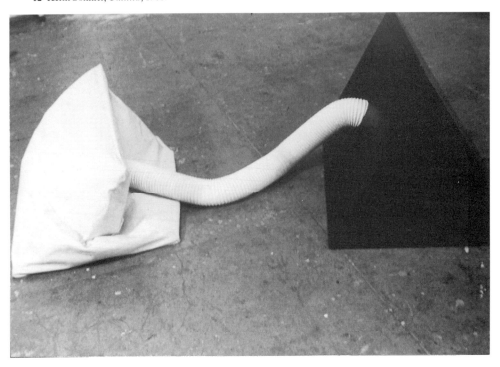

International (although it is highly unlikely that any additions were made after the exhibition was mounted, correspondence between Lippard and the journal's editor, James Fitzsimmons, indicates that a final version of the essay was ready by the end of the summer).[8] A similar article, albeit with the title 'Eros Presumptive', appeared in the *Hudson Review* in 1967.[9] Revised versions of both 'Eccentric Abstraction' and 'Eros Presumptive' would go on to be published in a number of anthologies, including Gregory Battcock's *Minimal Art: A Critical Anthology* in 1968, and Lippard's own collected essays, *Changing: Essays in Art Criticism*, published in 1971.[10]

Lippard's success in publicising such a small exhibition deserves note: there were reviews in three internationally known publications, the *New York Times*, *Arts Magazine*, and *Artforum*.[11] The exhibition also has a substantial existence in subsequent histories of 1960s art, appearing in work by Lippard herself in 1971 and 1976, and more recent critical writing by Rosalind Krauss and Briony Fer. However, nobody much seems to have liked it, including Lippard who wrote in 1971 that it had received an 'unjustified' amount of attention, 'because several of the artists in it are now so well known'.[12] She went on to criticise the essay of the same title, writing that Robert Morris's 'Anti Form'[13] was 'a much clearer discussion of the way the nature of materials and physical phenomena determine the shape of much new sculpture'.

If it was something of a critical failure, 'Eccentric Abstraction' was nevertheless a project to which sustained critical attention was directed, and it might be said that Lippard's criticism of it above appeared on its republication in her collected essays in 1971 in a form that was significantly changed from the original. For all its problems, she clearly still thought it was an idea worth restating. Whatever faults it may have, the text nevertheless has two clear purposes, to define the concept of eccentric abstraction, and to identify it with a group of American artists. Let us consider first Lippard's opening remarks. 'The rigors of structural art', she began,

> would seem to preclude entirely any aberrations to the exotic. Yet in the last three years an extensive group of artists on both East and West coasts largely unknown to each other, have evolved a nonsculptural style that has a good deal in common with the primary structure as well as, surprisingly, aspects of Surrealism. The makers of what I am calling for semantic convenience, eccentric abstraction, refuse to eschew imagination and the extension of sensual experience while they also refuse to sacrifice the solid formal basis demanded of the best in current nonobjective art. Eccentric abstraction has little in common with the sculpture of the fifties, since it rarely activates space, or with assemblage, which incorporated recognisable objects and was generally small in scale, additive, and conglomerate in technique. In fact the eccentric idiom is more closely related to abstract painting than to any sculptural forms.[14]

Lippard's language here requires a little clarification. What she referred to as 'structural art' or 'primary structure' or 'the best in current nonobjective art' was Minimal Art, in other words the highly reductive, geometrical sculpture then

prominent in New York galleries. At the time that 'Eccentric Abstraction' was published, Judd's essay 'Specific Objects' was well known, as were the first two of Morris's 'Notes on Sculpture', all of which, even if they were somewhat contradictory, were understood as theorisations of the same thing.[15] Meanwhile, the installation of the exhibition *Eccentric Abstraction* shortly followed the Jewish Museum's survey of Minimal Art called *Primary Structures*, which Lippard in fact helped to curate. It also coincided with *10*, the small but much reported survey of Minimal Art held at the Dwan Gallery.[16] Not only did these exhibitions coincide temporally, but they took place in the same building, as the Dwan Gallery and the Fischbach shared the same West 57 St. premises at the time.

One of the contexts for 'Eccentric Abstraction' is therefore the theory and practice of Minimal Art, and Lippard's opening remarks posited a clear relationship with it. The work had, she noted ' a good deal in common' with it; it subscribed to its 'solid formal basis'; and it had a closer relation to abstract painting than sculpture, one of the claims made by Judd for his work in the essay 'Specific Objects'. ('The new work', he wrote, 'obviously resembles sculpture more than painting, but it is nearer to painting.')[17] The closeness of the relationship between the two concepts was to a large extent confirmed by the reviews of the September exhibition. One included the point that many of the works at Fischbach could equally have been shown at the Minimal Art exhibition *Primary Structures*, and indeed one artist, Gary Kuehn, was represented at both.[18] Hilton Kramer, in his review for the *New York Times*, also characterised the new work as 'literalist', meaning that it was concerned with 'real' relations in 'real' space rather than the creation of illusions, a concept that was already very present in the discourse around Minimal Art.[19]

If eccentric abstraction was therefore *of* Minimal Art, it was also a departure from it. The first sentence makes this clear, suggesting that Minimal Art (or 'structural art' as she called it at this point) had prevented investigation (or 'aberration' in her words) towards the 'exotic', again her word. None of these terms is precise, especially 'exotic', but Lippard nevertheless clearly represented Minimal Art as a repressive force. A little later in Lippard's preamble, she indicated what form this repression might take, writing that her eccentric abstractionists 'refuse to eschew imagination and the extension of sensuous experience', implying that Minimal Art repressed precisely these things.

This is a fair point. The discourse around Minimal Art had no room for the imagination, and where it accorded a place to the spectator, that person was universalised, free of individual character or gender, barely, in fact, a person at all. Let us return, briefly, to the Minimal Art texts mentioned above. Judd's 'Specific Objects', which appeared first in the 1965 edition of the *Arts Yearbook*, was an early attempt to theorise the new work, and although lengthy, it restricted its analysis to formal matters. The new work – Judd rejected the term Minimal Art – was, he asserted, neither painting nor sculpture, fundamentally abstract, and radically opposed to any kind of illusion. Judd did not refer to the experience of apprehending the work other that to note, somewhat cryptically, that a work need only be

'interesting', and that 'most works have finally one quality'. In a comparable way, Robert Morris's account of Minimal Art restricted itself to the most fundamental matters of form, and the critical justification for such forms. The first part of Morris's 'Notes on Sculpture' discussed the appropriate shape sculpture should take, arguing – from an understanding of gestalt psychology – that cubes, cones, and cylinders were best as they were instantly understood as sculptural, as opposed to painterly. 'Notes on Sculpture Part 2' extended the argument by considering the appropriate size sculpture should take, the not very remarkable answer being 'between ornament and monument'.[20] Unlike Judd, Morris took account of the spectator in his version of Minimal Art, and his justification of the shape and size of the work had to do with the perception and relative position of the spectator (leading to Michael Fried's famous charges of 'theatricality' in 1967).[21] However, the kind of spectatorship Morris had in mind was extremely restricted, limited to the perception of one, or perhaps two qualities. Minimal Art as theorised here was no place for the imagination, or sensuous experience.

To return to those qualities allegedly repressed by Minimal Art, by 'imagination', Lippard appeared to admit the possibility of allusions, illusions, or both, things which Judd and Morris expressly forbade. Early on she described eccentric abstractionist work as the creation of 'a new kind of funeral monument – funereal not in the derogatory sense, but because their self-sufficient unitary or repeated forms are intentionally inactive'.[22] In other words a row of equally spaced Minimalist boxes could be read as coffins, or something like them.

Lippard's later remarks added to the sense of imagination that she felt was now permissable. Of Louise Bourgeois's work she wrote of forms that were 'labially slit', and other 'mounds, eruptions, concave-convex reliefs and knotlike accretions ... with a suggestion of voyeurism'.[23] She clearly tried to engage the viewer's imagination here, with references to female genitalia, or evocations of disease. I wonder if there is something polemical in the inclusion of Bourgeois in both the essay and the exhibition. Bourgeois, born in France in 1911, was much older than any of the other artists Lippard referred to, and had been active as an artist in New York since the 1940s. Her work, including the work she submitted to *Eccentric Abstraction*, was not so much allusive as representational. Deploying a vocabulary of phalluses and vulvas, kitchen implements, insects, and other clearly recognisable forms, its primary concern was the representation of the human figure in a highly personal way. Bourgeois's presence here encourages formal comparison between her work, and say, Hesse's, and I am sure this was intended. More than this, I am sure Bourgeois was included as a keynote: the explicitness of bodily representation in her work was supposed to make such things more legible in the works by other artists.

What then of 'sensual experience', that other aspect of the perception of sculpture supposedly repressed from Minimal Art? Continuing her account of the sculpture of Louise Bourgeois, Lippard wrote that her 1964 objects provoked 'that part of the brain which, activated by the eye, experiences the strongest physical sensations'. 'Such mindless, near-visceral identification with form', she continued,

for which the psychological term 'body ego' or Bachelard's 'muscular conscious-
ness' seems perfectly adaptable is characteristic of eccentric abstraction. It is dif-
ficult to explain why certain forms and treatments of form should elicit more
sensuous response than others. Sometimes it is determined by the artist's own
approach to his materials and forms; at others by the viewer's indirect sensations
of identification reflecting both his personal and vicarious knowledge of sensorial
experience in general. Body ego can be experienced in two ways: the desire to be
caught up in the feel and the rhythms of the work; second, through repulsion,
the immediate reaction against certain forms and surfaces which takes longer to
comprehend.[24]

Here Lippard developed her argument about imagination. If the sculpture she
described was in effect a vehicle for the imagination on the part of the viewer, as she
suggested, then such imaginings must also be capable of physical effects. Lippard's
sources for the sensual aspects of eccentric abstraction, Freud and Bachelard, both
insisted that the imagination was inextricably linked to bodily experience. 'Body
ego' (though the correct term is 'bodily ego') was discussed by Freud in *The Ego
and the Id*. 'The ego is first and foremost a bodily ego', he wrote, it is not merely a
surface entity, but is itself the projection of a surface.[25]

Freud's account of bodily ego posited a clear relationship between the body and
the imagination, between internal and external lives, but he was more interested in
the traffic from the body to the imagination, rather than in the other direction.
Lippard's concept of eccentric abstraction in some ways described traffic flowing
the other way, in other words the production of physical sensations from imagina-
tive experience. It is perhaps the fact that the Freudian term 'bodily ego' does not
quite fit here that she turned to Bachelard in the second edition of the essay. She
referred to his term 'muscular consciousness', suggesting by association its equiva-
lence to 'body ego'. What is certainly expressed here is the idea that the imaginative
experience of place (which Lippard translated to the experience of sculpture) could
be also physical, and that it was a direct relationship, 'visceral' in Lippard's words.
Our bodies 'think', wrote Bachelard, implying that they simply respond to things
or situations without conscious intervention. Besides Freud and Bachelard, there is
possibly a third source for Lippard's thoughts on the sensual experience of sculp-
ture, an essay by a Yale psychologist, Gilbert J. Rose, 'The Springs of Art: A
Psychoanalyst's Approach', published in January 1966. Anne Wagner has referred
to this in an essay on Eva Hesse, reporting that Lippard's account of body ego in
terms of a 'symbolic linking' in which 'every symbol refers simultaneously to the
body and the outside' could be traced directly to Rose.[26]

Let us pause to reconsider eccentric abstraction as it has been described. It was a
project conceived with Minimal Art very much in mind. As an exhibition it pre-
sented work that closely resembled Minimal Art, and as a phenomenon of the New
York art scene, it was literally surrounded by it. As an artistic concept, it also
resembled Minimal Art, in proposing a fundamentally abstract art, unitary in
form, and three-dimensional, but (rhetorically) closer to painting than sculpture. It

was of Minimal Art, but a departure from it. The form of that departure, as we have seen, consisted first in the admittance of the imagination: Lippard encouraged the allusive qualities of the sculptures, their capacity to be suggestive. It consisted, sec-ondly, in the admittance of sensual experience, or the creation of a physical response to the object. Both of these departures centred on the reception of the object by the viewer or beholder, rather than the production of the object by the artist, and both, I think, make a useful critique of Minimal Art, pointing up the repressiveness of its approach.

I have used the word 'repression' deliberately. It seems to me that one of Lippard's concerns, however clumsily expressed, was to articulate her critique of Minimal Art in terms of the Freudian concept of the return of the repressed. The accounts of Minimal Art that appear in the writing of all the authors mentioned here have been psychoanalytically based, and 'Eccentric Abstraction' can be read, usefully, as an early example of this approach. In 'Jensen's *Gradiva*', the psychoanalytical treat-ment of a novel by Wilhelm Jensen, Freud described how the repression of memory could lead to return of that memory at a later stage, with devastating results.[27] Most importantly for our present purposes, he noted that 'when what has been repressed returns, it emerges from the repressing force itself'.[28] *Gradiva* was treated as the story of precisely such a return, concerning an archaeologist whose repressed sexual feelings for a girl in childhood re-emerge in an obsession with a Roman sculpture of a girl with a similar physical character. Freud gave other examples of the same phe-nomenon, including Rousseau's attempt to use mathematics as a distraction from sex, before finding in mathematical questions precisely the carnality he was trying to avoid: 'Two bodies come together, one with the speed of … etc.' and 'on a cylinder, the diameter of whose surface is m, describe a cone … etc.'[29]

Rousseau's problem brings us rather neatly to Minimal Art. The cylinders and other geometrical forms are not supposed to make us think of things outside their literal presence as objects in space. In the repressive discourse of Minimal Art, our relations with them are proscribed by their authors: we may walk around, amongst, or over them, but all the time considering no more than their size, or shape, or another equally limited concern. Lippard's achievement in eccentric abstraction was therefore not simply the presentation of new work, as it was not, after all, very much different from the work shown at *Primary Structures*. Instead, by shifting the emphasis to the reception of the object from its production, she facilitated what can be described as the return of what Minimal Art had repressed, the individual imag-ination and sensual experience. In the scenario I have outlined here, the value of eccentric abstraction therefore lies in its offering a way beyond the impasse that was Minimal Art. It is a useful project because it asks different questions to those asked by Morris, or Michael Fried, or any of those other writers who appear to dominate the discourse around Minimal Art.

One of the artists Lippard included in her project was Bruce Nauman, a recent graduate of the University of California, Davis, and an artist whose work had not

up to that point been seen in New York. Nauman was well-read and articulate, and aware of current trends in New York galleries and elsewhere. He did not, as far as we can tell from contemporary interviews and other published sources, present his work in Freudian terms as Lippard did, although many of the works of the period seemed to invite psychoanalytical readings. But he did make subjectivity a major part of his activity at this point, in particular the subject of the artist. The sources for this are the critical discourse around Nauman's show at the Leo Castelli Gallery in early 1968, a show which presented a large number of objects, and represented considerable critical commercial success for a very young artist.[30] There were also two articles, Fideli Danieli's 1967 piece for *Artforum*, and Willoughby Sharp's 1970 interview with the artist for *Arts Magazine*: both of which have been republished in anthologies and catalogues, and are basic source material for our ideas about Nauman at this time.[31]

Let us consider first some images. Nauman's show at Castelli showed forty-four works, all of them made in the period 1965–68; the show was accompanied by a catalogue which reproduced an image of each one; there was a short introductory text by David Whitney, an art critic and also the owner of several works. It is hard to generalise about the exhibition given the large number of pieces exhibited, and their eclecticism. What we can say with certainty, however, is that there were a number of works that resembled contemporary developments in New York sculpture, but were unmistakeably a subjective response to them. About half the exhibition comprised roughly geometrical objects, which in their size, geometry, materials, and placement (directly on the floor, or mounted on the wall) recalled Minimal Art. A good example would be *Platform Made Up of the Space Between Two Rectilinear Boxes on the Floor* (1966), an object in fibreglass resembling two roughly made interlocking triangles. Measuring about 6 feet by 3, it sat directly on the floor of the gallery, a low, horizontal, artfully artless object. Like Minimal Art in most respects, this object nevertheless differed in the self-conscious way it displayed its origins. Many Minimalist sculptures contrived a somewhat otherworldly quality, the result of precise manufacturing processes in which their authors did not – indeed could not – take part. And their forms, cubes, boxes, and cylinders, seemed often to aspire to the character of universal forms, the imaginary products of entire cultures rather than the mind of an individual artist. By contrast, Nauman's work seemed to present its origins for scrutiny. Its elaborate title explained all, and suggested, as did the titles of many other of the works in the show, that it was the result of a chance configuration of objects in particular circumstances. Works expressing a similar idea include *Shelf Sinking into the Wall with Copper Painted Plaster Casts of the Spaces Underneath*, also of 1966 and now owned by the Tate Gallery. The work was supremely casual in both its concept and its execution. Made roughly out of painted wood and plaster, it used the cheapest, most readily available materials, and its form, a 6-foot shelf with attenuated supports so that it gave the appearance of disappearing into the wall, was totally explained by the title. Like Minimal Art, it was all surface: there was no mystery about it,

nothing to express. But unlike Minimal Art, it was a work grounded in a specific reality.

In interview with Willoughby Sharp in 1970, Nauman explained that much of his sculpture was the result of precisely such circumstances. Initially motivated by lack of financial resources, Nauman began to make use of whatever immediately came to hand – or at least this is the narrative presented to Sharp. Speaking about his life on leaving graduate school at Davis, Nauman remarked:

> I was working very little, teaching one class a week. I didn't know what to do with all that time. I think that's when I did the first casts of my body and the name parts and things like that. There was nothing in the studio because I didn't have much money for materials. So I was forced to examine what I was doing there. I was drinking a lot of coffee, that's what I was doing.[32]

This narrative, repeated in various forms throughout this and other interviews of the time, provides a basic rationale for the work. The sculptures may have looked roughly like Minimal Art – and Nauman acknowledged an interest in Morris more than once – but their sources were pragmatic, determined by the peculiar, individual circumstances of their manufacture. They were legible as an index of the workings of a particular subject. They lack any aspiration to the universal. To this end, the works were surrounded by narratives grounded in Nauman's experience of the world and providing the rationale for the final form of the work. So the *Platform* and *Shelf* were works which make use of materials and forms found casually in the artist's own studio. *Window or Wall Sign*, a sculpture in neon bearing the words 'The True Artist Helps the World By Revealing Mystic Truths', was therefore a response, albeit a rather ironic one, to a neon sign advertising beer that Nauman could see from his window; *Mold for a Modernized Slant Step*, a variation on a peculiar, ambiguous, object ('The Slant Step') found by Nauman's friend W. T. Wiley in a Californian junk shop, and made the subject of an exhibition project.

Subjectivity was at issue in these works through the narration of the peculiar circumstances of their creation. In other, slightly later works, subjectivity was present in the representation of the artist's body. In *Cast of the Space Underneath My Chair* (1967), a Minimal-looking but ultimately much more subjective object, Nauman's body was present, perhaps only tangentially, in the representation of a particular object (a chair) used by that body (Figure 13). It was much more strongly present in works which made a feature of the literal trace of the body: *From Hand to Mouth* (1967) was a cast of the artist's right arm, shoulder, and the lower part of his face, to make a literal representation of a common figure of speech. Or *Collection of Various Flexible Materials Separated by Layers of Grease with Holes the Size of My Waist and Wrists*, precisely that: a strange rectangular amalgam of foil, felt, and grease, punctured by holes, indexical of the bodily process by which it was made. At the same time Nauman worked on a number of projects on film and in photographs, which documented in even more literal form the artist's body. Caught on film in the moment of spitting water out towards the camera, he declared himself a

13 Bruce Nauman,
*Cast of the Space
Underneath My Chair*,
1967.

'fountain'; a film shows him naked from the waist up covering himself in black theatrical makeup; another film, *Black Balls*, was a bizarre variation on the same theme, focused on the artist's testicles while they were subject to the same decorative treatment.

Nauman's starting point, as he made clear in contemporary interviews, was sculpture, and he intended his work (if we can speak of intention here) to be read as a commentary on it. His revision of contemporary ideas about sculpture consisted in making them specific to his own personal circumstances, to making the Minimalist boxes and simple forms speak of the artist as subject, a theme which was developed in the works on film. Philip Leider, reviewing Nauman's contribution to *Nine at Leo Castelli*, the show Robert Morris organised at the Castelli warehouse, accused him of narcissism, indicating that subjectivity was at issue in Nauman at this early stage. In the same review, Leider criticised Eva Hesse's work, an artist about whom very similar remarks could be made. Hesse's revision of Minimal Art, like Nauman's, seemed to bear on making it personal, on having it represent the artist as subject once again.[33]

Before discussing the extent to which subjectivity is at issue in Hesse's work at the time of its production, let me describe the way Hesse has been treated in historical writing, for it is the question of subjectivity which has been central to all historical accounts of her work since the artist's death at the age of thirty-four in 1970. Simply put, the issue has been the extent to which Hesse's work should be seen as autobiographical, representing in other words, something personal to the artist herself. The evidence for such a view has been very largely the copious diaries that Hesse wrote throughout her life, and which were made available to Lucy Lippard and Robert Pincus-Witten after her death. Other sources include contemporary interviews, including one made by Cindy Nemser just before the artist's death, in which she appeared to make specific connections between her art and her life, the latter apparently supposed to represent the former.

Pincus-Witten emphasised and perhaps exaggerated these kinds of connections, writing in 1971 of a direct link between the form of Hesse's work as a student at Yale, and the gynaecological problems she suffered there and wrote about in her journal.[34] A similar expression of the connectedness of Hesse's work and life is Anna Chave's essay for a retrospective exhibition of Hesse held at the Yale University Art Gallery in 1992.[35] Titled 'A Girl Being a Sculpture', Chave's essay set up Hesse's problem, or the question she posed for herself in her art, of how she might 'inscribe her femininity' in her art, and more practically how she might achieve status in an art world that was overwhelmingly dominated by men. This

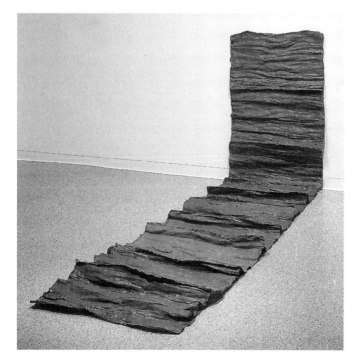

14 Eva Hesse, *Area*, 1968.

statement suggests that Hesse herself saw her work in explicitly feminist terms. The artist and by implication the viewer are recast here as gendered subjects: Chave therefore implied that Hesse's imagined subject is quite different from, say, the universal, ungendered subject imagined in the work of Robert Morris.

Chave supported her view with evidence from Hesse's notebooks in which the artist described the conflict between her career, and the domestic roles she was also expected to perform in support of her sculptor husband, Tom Doyle. Chave therefore set up Hesse as a model artist for future feminist art practice, but she went further than this to suggest that certain works were not only informed by a feminine sensibility, but are specifically autobiographical, representative of specific episodes in the artist's life. So *Contingent*, a series of hangings made of resin-coated cheesecloth, was in her words 'giant, soiled bandages', referring to the artist's many, well-documented spells in hospital. [36] Or worse, it was 'like so many flayed human skins (distantly evocative of the Nazis' use of human flesh to make lampshades)', referring to Hesse's flight from Germany in the 1930s after Nazi persecution.[37] Or *Tori*, another work of 1969, was an analogue of the artist's unhappy sexual life, having the effect of 'dismembered, squashed and discarded female genitalia'.[38]

In Chave's account, both Hesse's understanding of contemporary art, and her relationships with her artistic peers, especially Robert Smithson, Carl Andre, and Sol LeWitt, were circumscribed by her gender, and her personal circumstances. She used evidence from the notebooks to suggest that Hesse's relationships with Smithson and his peers were characterised by alienation, given her nervousness in their presence and their liking for raucous, alcohol-fuelled, debate. According to Chave's evidence, neither did Hesse share these artists' linguistic precision, and she quoted a journal entry in which Hesse wonders if men were not inherently more intelligent than women. In this account Hesse is first and foremost therefore a female artist, one who effects a revision of contemporary sculpture by recasting it in feminine terms. The work was gendered. Further to this, it is work that is specific to a particular woman: that in some way it seeks to represent the artist's very distinctive life experiences: her alienation from the place of her birth, her insecurity, her destructive and damaging relationships with men, her endless illnesses and spells in hospital.

Chave's account – and by extension all such accounts of her work – were strongly challenged by Anne Wagner in a 1994 essay for the journal *October*, which took issue with these writers' use of sources.[39] Wagner argued that Hesse's close identification with her work expressed in the journals was as much a cultural construct as any other, and as such needed to be treated with caution. The attractiveness of the idea of Hesse as martyr tragically dead at the height of her powers led, Wagner argued, to such readings, which were inherently mythical. Her alternative treatment of Hesse pressed into service other kinds of evidence from the diaries to show that the artist could be seen as involved in a critical debate about sculpture as much as her contemporaries: she described, for example, a page from one of the notebooks showing a series of sketches of so-called 'prop' pieces by Richard Serra,

evidence of Hesse's interest in and engagement with contemporary debate, rather than her alienation from it as a woman artist. Hesse was in this account an artist who happened to be a woman rather than a woman artist, and the artistic subject that is performed here is consequently a different one.

This historical debate shows that subjectivity has long been at issue in Hesse's work. It is also an issue that was present at the time of its making, although in a less exaggerated form. The artist's death, rather inevitably, seems to have increased interest in the artist as an individual. The source material for the idea of Hesse as an artist who somehow performed her subjectivity includes an interview with Cindy Nemser, published posthumously in the May 1970 *Artforum*. Chave makes a great deal out of this source, as it contains a number of remarks which link the artist's work with her life. In response to Nemser's question 'do you identify with any particular school of painting?' Hesse listed artists she admires such as de Kooning, Gorky, Kline, Pollock, and Oldenburg, then remarking, notoriously, about Carl Andre, 'I feel emotionally connected to his work. It does something to my insides. His metal plates were the concentration camp for me.'[40] Nemser wondered, reasonably, about Andre's likely reaction. 'I don't know!' exclaimed Hesse.

> Maybe it would be repellent to him that I would say such a thing about his art. He says you can't confuse life and art. But I think art is a total thing. A total person giving a contribution. It is an essence, a soul, that's what it's about … in my inner soul art and life are inseparable.[41]

There were other statements in the interview to the same, autobiographical, effect. Whether we take them literally as art historians such as Chave have done, or whether we treat them more sceptically, like Wagner, what is certain is that a distinct, subjective concept of sculpture is advanced here. There were clear precedents in the art of Pollock, de Kooning, and Gorky (three of the artists Hesse mentions as influences) for the idea of art as a form of autobiography, but what is significant is the extent to which this view of the role of art was out of favour with Hesse's peers. The exchange about Andre is therefore important, outlining as it does two distinct ways of interpreting the work. For Hesse, it resonated with personal meaning, providing, to put it another way, a means of realising in visual form a memory from Hesse's own past. For Andre it did nothing of the sort, or at least this was the declared position.

It should be said however that the Nemser interview is unusual in the extent to which it outlined for Hesse an autobiographical scenario for her work. Until her death in 1970 there were few accounts which made so direct a connection between the life and the work, and with the exception of Pincus-Witten, the first historical accounts (such as Lucy Lippard's in 1976) were careful to avoid making too direct a connection. That said, Hesse seems to have encouraged narrative, in a rather similar way to Nauman.

Let us look at this in connection with a work, *Metronomic Irregularity*, first made in 1966 for Lippard's show *Eccentric Abstraction*. It was a big work, overshadowing

Hesse's other works in the same show. It was also big in the sense that it attracted a lot of critical attention, Hilton Kramer, for example, giving it extensive, if not entirely sympathetic treatment in the *New York Times*. It also attracted some commercial interest: Lippard reported in her monograph that a Texan collector showed interest in the work but backed out at a late stage, although other works by Hesse did indeed sell.[42] These comprise in effect one narrative supporting the work, the breakthrough piece, the piece that established Hesse's critical reputation, or the piece that raised her status among her peer group.

There are other narratives supporting the work, all of which seem to have been deliberately encouraged, by Hesse's peers, by critics, and by the artist herself, such that the work, unlike that of peers such as Andre or Morris, is inseparable from the stories around it. One story, recounted by Lippard in 1976, and repeated in other accounts, concerns the moment of the installation. Lippard expressed 'surprise' on seeing the work for the first time: it was, she wrote, too 'precise', too close at first glance to the Minimalism that she was trying to put in question through the show *Eccentric Abstraction*. She was, she wrote, 'put in the frustrating position of the critic whose generalisations have proved untenable'.[43] *Metronomic Irregularity* was in some senses precise. Its main compositional elements, the three plywood panels, were regularly spaced, and are fixed to the wall in a horizontal series that at a distance resembles the contemporary work of Donald Judd, an artist whom Hesse greatly admired. In fact, at the same time as *Eccentric Abstraction*, and in a gallery in the same West 57 St. building as Fischbach, one could have seen precisely such a work, and it is very likely that a visitor to one gallery would have seen the other, and made the formal comparison.

Lippard used the story in a self-deprecating way, and it reinforced other negative perceptions of the show (concerning the value in the coining of yet another style label, and so on).[44] But beyond the narrative of misplaced expectations which Lippard's 'surprise' is about, this is a narrative about a specific moment, and a distinct, subjective response to an object. It is significant that this is what gets restated in later accounts, rather than a generalised response to the object.

A second, more dramatic narrative supports the work. Lippard was not immune to the desire we have seen in other writers to have Hesse's work narrate her life. So in her account, the psychological background to *Metronomic Irregularity* is all-important: the recent death of Hesse's father, and the consequent (in Lippard's view) re-living of 'the terrors of parental abandonment'. She continued: 'The fall of 1966 was very tense, a combination of her anxieties about her show, her father's death, her usually suppressed envy of her rapidly succeeding male artist friends, her personal longing for a satisfying relationship with a man, and her lingering emotions for, and anger at Doyle.'[45]

The result of this emotional tension was a literally tense work, the wires linking the three wooden panels themselves being put under physical strain. As the piece was wired up in the gallery, the stress on the panels increased to the point where it suddenly 'burst off the wall'. Some hysteria ensued: Hesse was taken for a drink,

while her artist friends Mel Bochner and Sol LeWitt rehung the work and restored the damage.[46] The story reappeared in most subsequent accounts. Here was a moment of trauma – Lippard used the word to describe Hesse's mental state – a moment also that was intimately connected with personal processes. If we discount these things, we are nevertheless left with a narrative that is highly specific: it is of a particular time (just before the opening of the exhibition), a particular place (the Fischbach Gallery), the failure of particular materials and processes, the effect on the artist, the resolution of the problem.

There is nothing to compare with this in the literature around Minimalism. There are in some of Morris's writings anecdotes about making, for example, fibre-glass boxes, but they have the flavour of bar-room stories, somewhat embellished: tales of physical pain and the consumption of vast quantities of alcohol.[47] They may or may not have a bearing on reality. Other Minimalists we know little more about. But in Hesse's case there seems to have been a performance. There may not have been a great deal of published material on her during her lifetime, but she seems to have been eager to tell interviewers and friends much more about the process of making works. Whether or not we take literally the connections the artist wanted to make between art and life, there is no question that subjectivity is at issue around the work, in a way that questions existing contemporary notions of the artistic sub-ject, and the viewer as subject.

There are several notions of subjectivity that I have outlined in this chapter, all of which revise, or at least put in question contemporary, dominant ideas about sculp-ture. I began with Lippard's concept of 'Eccentric Abstraction', an idea that what-ever weaknesses it may have in its reading of Freud nevertheless put into play the subject of the viewer in contemporary sculpture. Minimal Art, as we saw in an ear-lier part of the book, acknowledged the existence of the viewer, and concerned itself with the making of environments through which the viewer would pass; the viewer was nevertheless somewhat essentialised, certainly in Morris's writing. In the opposite camp to Morris, Michael Fried provided a phenomenological vocabulary to describe sculpture, but it was one that famously could not accept Minimal Art as sculpture. What Lippard did was in some way acknowledge both of these positions, and accept that Minimal Art, and art like it, could produce highly subjective feel-ings in the spectator. In 'Eccentric Abstraction' she often accounted for sculpture in erotic terms, thinking that sexuality in Freudian terms was polymorphous, expe-rienced through an infinite variety of objects, and was hence the most personal, most subjective of experiences. Lippard went on to develop her argument about the erotics of sculpture more clearly in a 1967 essay for the *Hudson Review*, 'Eros Presumptive'. In this essay, Lippard situated 'Eccentric Abstraction' in terms of a much wider interest in eroticism in New York.

The work Lippard chose for the exhibition was supposed, we must infer, to act as a vehicle for the production of erotic (or other, similar) feeling in the viewer, and we can imagine that being the case in Bourgeois, Hesse, Nauman, or Sonnier, all of

whose works were vaguely sexual in appearance but were abstract enough to allow for the projection of personal imagination. But the subjectivity at issue in Hesse and Nauman (and, of course Bourgeois) was more complex, involving the projection of the artistic subject too. In Hesse's case, and Bourgeois's, this projection verged on the desire for autobiography, that the work be seen to represent the life. The extent to which this idea was represented in the contemporary literature around Hesse was limited, a function perhaps of the artist's status before her death. But she clearly let it be known that she wanted the work to be regarded as an expression of her personal history, and this idea was enthusiastically taken up in historical accounts of her work, by writers as diverse as Lippard, Pincus-Witten, and Chave.

The subjectivity in Nauman is different again. Like Hesse, Nauman, in interviews and other contemporary sources, accounted for the work in autobiographical terms, but his sense of autobiography was more limited. Nauman's personal history was not presented as of significance: what mattered, or what was supposed to matter was the history of the works in terms of their being an expression of the condition of the artist at a particular moment. They appeared therefore as expressions on the subject of Nauman as artist at a precise point in time: they represented, literally, chance configurations of objects in his studio; things he noticed from the studio window; the literal body of the artist. Hesse, it seems, wanted to present her entire history for scrutiny; as subject she is constituted in both artistic and personal terms. Nauman by contrast presented us only with an artist.

The subject of the viewer, the subject of the artist: these are quite different matters, and are treated in different ways by different figures. An interest in such things is nevertheless underpinned, I think, by an understanding of Freud, however unsophisticated that may be. This was explicit in 'Eccentric Abstraction' and the later essay, and we know from Hesse's diaries that she was conversant with Freudian theory, and was herself in analysis for much of the 1960s. Freud was present in two ways, and both help provide a new vocabulary for sculptural criticism. The first was the interest in what is repressed from Minimal Art. At the exhibition *Eccentric Abstraction*, this was nicely illustrated in Keith Sonnier's works made from PVC, plastic tubing, and electric fans: they were severely geometrical until they deflated, which they did rhythmically. It was a process with obvious sexual connotations, and which revealed something new, hidden in the hard forms of Minimal Art, a very literal enactment of the return of the repressed. The second way Freud is present is in the contention (implicit and explicit) that what was repressed was the individual, and his or her specific desires, responses, motivations. What followed was a revival of interest in subjectivity, on the part of both artist and viewer.

In the following chapter I continue the psychoanalytical theme, but consider how psychoanalytical ideas impacted on sculpture in terms of the representation of society instead of the individual. My concern moves, following the pattern of Freud's own thought, from the treatment of the individual subject, to the treatment of civilisation.

Notes

1 Rosalind Krauss, 'Robert Morris: Autour du Problème Corps/Esprit', *Art Press*, 193 (June 1994), 24–32. In this interview, see especially p. 29: 'the meat hook on the wall hangs out the hides of felt. The tangle of the 1963 *Knots* grows like a virus into the twisted strands of felt and threadwaste. Entropic collapse invited inside. Sickness of the times. Falling bodies. Cambodia. Kent State, assassinations right and left, or from the right onto the left. Horizontality as a row of body bags.'

2 Michael Fried, 'An Introduction to my Art Criticism', *Art and Objecthood: Essays and Reviews* (Chicago, University of Chicago Press, 1998), p. 28.

3 See Fried, *Art*, pp. 119 and 186 for what I mean by 'modalities'. There is further discussion of this in chapter 1 above.

4 As stated in chapter 1, my use of the term 'modern' here includes both Modernist sculpture and Minimal Art.

5 It was highly unusual for an art critic to take on a curatorial role in 1966.

6 David Antin, 'Another Category: Eccentric Abstraction', *Artforum* 5:3 (November 1966), 56–7.

7 Lucy R. Lippard, 'Eccentric Abstraction', in *Changing: Essays in Art Criticism* (New York, E. P. Dutton, 1971), p. 98.

8 Lucy R. Lippard, 'Eccentric Abstraction', *Art International*, 10:9 (November 1966), 28, 34–40.

9 Lucy R. Lippard, 'Eros Presumptive', *Hudson Review*, 20:1 (Spring 1967), 91–9.

10 Gregory Battcock (ed.), *Minimal Art: A Critical Anthology* (New York, E. P. Dutton, 1968).

11 Hilton Kramer, '*Eccentric Abstraction*: It's Art but Does It Matter?', *New York Times* (25 September 1966), D27, D29; Mel Bochner, 'Eccentric Abstraction', *Arts Magazine*, 41:1 (November 1966), pp. 57–8; Antin, 'Another Category'.

12 Lippard, *Changing*, p. 98.

13 Robert Morris, 'Anti Form', *Artforum*, 6:8 (April 1968), 33–5.

14 Lippard, *Changing*, pp. 98–9.

15 Donald Judd, 'Specific Objects', *Arts Yearbook*, 8 (1965), 74–82; Robert Morris, 'Notes on Sculpture Part 1', *Artforum*, 4:6 (February 1966), 42–4, and 'Notes on Sculpture Part 2', *Artforum*, 5:2 (October 1966), 20–3.

16 Jewish Museum, New York, *Primary Structures* (27 April–12 June 1966); Dwan Gallery, New York, *10* (4–29 October 1966).

17 Lippard, *Changing*, p. 99; Judd, 'Specific Objects', 43.

18 Antin, 'Another Category', 56.

19 Kramer, '*Eccentric Abstraction*', D29.

20 Morris, 'Notes Part 2'.

21 Michael Fried, 'Art and Objecthood', *Artforum*, 5:10 (June 1967), 12–23.

22 Lippard, *Changing*, p. 100.

23 Lippard, *Changing*, p. 101.

24 Lippard, *Changing*, p. 102.

25 Sigmund Freud, 'The Ego and the Id', in A. Richards (ed.), *Penguin Freud Library*, 11 (1984), pp. 364–5.

26 Anne M. Wagner, 'Another Hesse', *October*, 69 (Summer 1994), 64.

27 Sigmund Freud, 'Delusions and Dreams in Jensen's *Gradiva*', in Albert Dickson (ed.), *Penguin Freud Library*, 14 (1985), pp. 33–117.

28 Freud, 'Jensen's *Gradiva*', p. 60.

29 Freud, 'Jensen's *Gradiva*', p. 61.

30 New York, Leo Castelli Gallery, *Bruce Nauman* (27 January–17 February 1968).

31 Fideli A. Danieli, 'The Art of Bruce Nauman', *Artforum*, 6:4 (December 1967), 15–19. Willoughby Sharp, 'Nauman Interview', *Arts Magazine*, 44:5 (March 1970), 22–7.

32 Sharp, 'Nauman Interview', 24.

33 Philip Leider, 'The Properties of Materials: In the Shadow of Robert Morris', *New York Times* (22 December 1968), II, 31.

34 Robert Pincus-Witten, 'Eva Hesse: Post-Minimalism into Sublime', *Artforum*, 10:3 (November 1971), 32–4.

35 Anna Chave, 'A Girl Being a Sculpture', *Eva Hesse: A Retrospective* (New Haven and London, Yale University Art Gallery, 1992).

36 Chave, 'A Girl'

37 Chave, 'A Girl'.

38 Chave, 'A Girl'.

39 Wagner, 'Another Hesse'.

40 Cindy Nemser, 'An Interview with Eva Hesse', *Artforum*, 8:9 (May 1970), 59. By 'metal plates' Hesse means one of a series of works Andre made in the late 1960s comprising arrangements of square metal pieces, usually in a twelve by twelve configuration. The metals used included steel, aluminium, and magnesium, and were made to be walked upon.

41 Nemser, 'An Interview', 59.

42 Lucy R. Lippard, *Eva Hesse* (New York, New York University Press, 1976).

43 Lippard, *Eva Hesse*, p. 131. This disjunction, between the apparent precison of Hesse's work, and her aims for the show, is the starting point for Briony Fer's very interesting essay 'Bordering on Blank: Eva Hesse and Minimalism', *Art History*, 17:3 (September 1994), 424–49. This essay informs my analysis of Lippard's project, particularly in the sense of failure that clouds it.

44 See for example the title of Hilton Kramer's review: 'And now Eccentric Abstraction: It's Art, but Does It Matter?', *New York Times* (25 September 1966), D27, D29.

45 Lippard, *Eva Hesse*, p. 78.

46 Lippard, *Eva Hesse*.

47 Pepe Karmel, 'Robert Morris: Formal Disclosures', *Art in America*, 83:6 (June 1995), 88–95, 117, 119. See especially p. 94. Karmel's humanistic intention in this interview is to provoke the normally reticent Morris into saying something about his life as a means of explaining the work. Morris's response is an interview that is all anecdote, mostly pre-posterous. His strategy here compares with his 1971 essay 'Three Extra-Visual Artists', discussed in chapter 5 below.

4

'The vacant, all-embracing stare'

In the previous chapter, I introduced the idea that for some critics and artists of the 1960s, Freudian psychology provided a new way of accounting for sculpture, and indeed making it. In a concept such as 'eccentric abstraction', Freudian ideas may have been applied rather unsystematically, but they nevertheless legitimised some new ideas about sculpture. Minimalist forms in art from that point on could be read in non-essentialist terms: it became possible to see them subjectively, representing feelings of the artist or indeed the viewer. According to Lucy Lippard, such content had been repressed from Minimal Art. The legitimisation of subjectivity is crucial, I argued, to the presentation and reception of an artist such as Eva Hesse. It is also, I suggested, crucial to the understanding of more contemporary work by – for example – the British artist Rachel Whiteread, whose work uses the formal vocabulary of Minimalism, but invests it with memory and nostalgia.[1]

This chapter continues the psychoanalytical theme, but in place of subjectivity, it discusses psychoanalysis in the service of society, or more accurately, representations of society. My argument, as in the previous chapter, is that through the reading of certain psychoanalytical texts by artists and critics, a form of representation once again becomes possible in sculpture. In this case, what is represented is something like destruction, so that a highly indeterminate work like Robert Morris's *Threadwaste* becomes – in the eyes of some critics and artists – an image of the violent disturbances that intermittently paralysed American cites in the later 1960s, or even an image of the nuclear annihilation that threatened the existence of civilisation. Max Kozloff expressed these sentiments very clearly in 1969 after visiting a show of 'earth art' at Cornell University. Society, he wrote, was in crisis, ungovernable at national, international, and municipal levels. It was no accident therefore that sculptors provided 'a species of material chaff, seemingly fallen, scattered, or dug out of the ground, muzzy stewings or fragmented chips left to bemuse a society entangled in the debris of its own incoherence'.[2]

Kozloff was writing for the left-wing journal *The Nation*, but his views about the condition of urban life in the United States were certainly not uncommon, and for the most part the sculptors whose work I describe here can be aligned, more or less certainly, with the American Left – Morris and Andre were, for example, members of the Art Workers Coalition, an attempt to establish a power base of radical values in the art world; Lippard was active in the AWC and on many different fronts

throughout the 1960s. What Kozloff says therefore matters because it is represen-
tative of a wider set of views about art. Specifically, this view represents the idea
that the new sculpture represents the world in which it appears, and that the legit-
imisation of such a concept of sculpture comes from the understanding of certain
psychoanalytical texts.

The artworks I deal with in this chapter are all American, made by artists working
in and around New York. I say a lot, again, about Morris, and the various accumula-
tions, arrays, and scatterings that constituted his sculpture in 1968 and 1969. I say a
good deal about Morris's friend Robert Smithson too, and his works from the same
period. I also give an account of the public conversation they appeared to be having
during these years about certain ideas deriving from psychoanalysis. I also say some-
thing about the work of Richard Serra and Barry Le Va, two artists who came to
prominence at this time, and who were used by Morris to illustrate his current
thinking about sculpture. The texts I refer to are, first, two essays by Morris and
Smithson, 'Notes on Sculpture Part 4: Beyond Objects' and 'A Sedimentation of the
Mind' respectively.[3] The psychoanalytical works I write about include *The Hidden
Order of Art: A Study in the Pychology of Artistic Imagination* by Anton Ehrenzweig
and *Eros and Civilisation* by Herbert Marcuse.

Neither Ehrenzweig nor Marcuse were psychoanalysts as such (they were an
educationalist and a Marxist philosopher respectively), but they found in Freud's
writing useful ways of accounting for art (Ehrenzweig) and culture (Marcuse).
They were contemporaries, but they did not, I think, know each other and their
projects are quite different. But each of them found in Freud something that
helped them to revise the field in which they were working. Ehrenzweig therefore
used Freud to write a new account of artistic creativity, while Marcuse found in
Freud a model for future society. Art was a concern for both writers, although nei-
ther said much about sculpture, and there is no sense in which their work can be
said to propose, say, Anti Form. That said, both Ehrenzweig and Marcuse provided
theories that argue for a revaluing of, or a refocusing on, areas of human existence
normally repressed from civilised life, and in doing so they legitimised the use of
waste materials in sculpture. Morris and Smithson's use of debris or discarded
material in their sculptures, and their adoption of procedures resembling the act of
disposal of waste (throwing, scattering, pouring) was, as we shall see, a conscious
response to their ideas. They also found in Ehrenzweig and Marcuse an image.
Both writers presented an apocalyptic vision of the world, the perceived relevance
of which to contemporary society, especially American society, is indicated by the
popular success of their works. The image of destruction in these works was not
just there for its own sake, or there to represent some universal psychological prin-
ciple: it was there to represent an apocalyptic view of a whole civilisation, a view
which necessarily touched the work of the artists I describe.

Let me begin with Ehrenzweig, and his 1967 book *The Hidden Order of Art: A
Study in the Psychology of Artistic Imagination*.[4] The connections I want to make

here, between Ehrenzweig's book, and the American artists Morris and Smithson might not initially seem very strong. A Viennese émigré of the same generation as Ernst Gombrich and Aby Warburg, Ehrenzweig spent most of his working life at Goldsmiths' College, London, as a lecturer in Art Education, a position which he held until his death in 1966. Although actively involved with contemporary artists during his lifetime, Ehrenzweig's contacts were those of the British art world, as *The Hidden Order of Art* made clear.[5] And while the book met with evident success in Britain (first published in July 1967, it reached a second printing in March 1968), its fate was less certain in the United States, where it appears it was remaindered as early as 1968. There is anecdotal evidence to suggest that its first appearance in the context discussed here was in a bookshop specialising in remaindered books, whereupon it was found by Smithson, who read anything and everything.[6]

In common with his contemporary, Gombrich, Ehrenzweig accepted a given canon of great art, and like Gombrich, his primary concern was to show that the canon was a measure of artistic quality. Ehrenzweig was not prolific, and excluding internal publications for Goldsmiths' on art education, his bibliography indicates that the majority of his academic research had been completed by the late 1940s. His two major academic articles, for the *British Journal of Medical Psychology*, appeared in 1948 and 1949.[7] The first of these reappeared, with little alteration, in a book, *The Psycho-Analysis of Artistic Vision and Hearing: An Introduction to a Theory of Unconscious Perception*, which first appeared in London in 1953.[8] *The Hidden Order of Art*, Ehrenzweig's second and last book, appeared posthumously in 1967. Although deriving from academic papers, and in the latter case research supported by the Bollingen Foundation, both books were intended for a general audience. They were lightly footnoted, and declared sympathy with the non-specialist.[9] He also contributed to *The Listener* (the BBC's political and cultural journal) and *Art International*.[10] His main concerns were consistent, to the point of being repetitive: an explicitly Freudian concept of the mind, the importance of the unconscious to artistic creation, and hostility to the work of the Gestalt psychologists. All of Ehrenzweig's psychoanalytical writing was polemical in tone, insisting that conventional, which is to say Gestalt-oriented, ideas about art, perception, and artistic creation must change.

It is clear from the glossary to *The Hidden Order of Art* that the source for Ehrenzweig's view of the mind was almost exclusively Freud.[11] Of the terms that it defined, it was the opposition between the Ego and the Id that underpinned virtually all of Ehrenzweig's theories of art. His writing was suffused with such binary oppositions. He wrote therefore of primary process and secondary process, referring to the processes of the unconscious and conscious minds respectively; of syncretistic and analytic vision, referring to comparable processes of perception; of 'depth' and 'surface' vision, meaning much the same; of 'undifferentiated' and 'differentiated' visual perception. It was the first part of each opposition that is valued, which is to say the part that referred to the unconscious. This emphasis was clearly signalled by the titles Ehrenzweig gave to his publications of which *The Hidden Order of Art* is a good example.

Ehrenzweig's work challenged then dominant Gestalt theories of perception, associated with the work done in the 1930s of the psychologists Köhler and Petermann. They had argued that perception was a matter of the brain's projection of order on to the perceived field, a process that was 'secondary' or conscious.[12] The shapes, or orders, that the brain projected were termed 'gestalts', a word normally left untranslated. In terms of art, the Gestalt Principle would emphasise the figure over the ground, at any rate making a very clear separation between the two. This was, Ehrenzweig wrote, contradicted by art education with its emphasis on for example the perception of negative shapes: 'What the pupil is taught amounts to a technique of perception *against* the Gestalt Principle, particularly as he has to look out for patterns which are superimposed over the outlines of real objects.'[13]

The Hidden Order of Art was not simply a negation of the Gestalt Principle, but an argument for a new kind of perception altogether. The first chapter of the book, 'The Child's View of the World', described the perception of children below the age of eight as 'undifferentiated'. They did not, in other words, distinguish between different parts of their perceptual field, for example figure and ground. Their vision, which Ehrenzweig also termed 'syncretistic' or 'global', seemed according to then recent research to depend on the response to cues that were associated with real objects rather than abstract shapes. Young children and animals (the author did not differentiate between them) might therefore recognise a person or a thing by a colour, not an abstract shape such as the triangular appearance of a person's nose if seen in profile. Such recognition of objects by 'cues', he wrote, marked the beginning of 'syncretistic' or 'undifferentiated' vision, and it was manifest in the young child's drawings, which to Ehrenzweig were bold experiments with colour and form, and unquestionably superior to what came later. By the age of eight, the child had begun to compare his own work with that of adult artists or photographers, and ceased to experiment as a result.[14]

The ensuing chapters developed and expanded this view, arguing that the best art showed evidence of 'creative conflict' between 'surface and depth' sensibilities, or to put it another way, the conflict between the syncretistic vision of the early child and the analytic vision that later developed. The modern artist was therefore engaged in a constant battle between surface and depth sensibilities: he

> attacks his own rational sensibilities in order to make room for spontaneous growth … The attacked surface faculties fight back in self-defence and overnight the spontaneous breakthrough from below is turned into another deliberate, manneristic device. This in turn stifles spontaneity, and has to be overthrown with another burst from the depth.[15]

What Ehrenzweig described here could provide a theoretical model for an avant-garde, although he did not investigate this or use the term. But it is also a useful image in that it can be used to summarise the two main concerns of *The Hidden Order of Art*. It was first a view of art predicated on the Freudian battle between surface and depth, between conscious and unconscious minds. But secondly, and

more importantly, it was a view of art that insisted that progress must be made through perceptual change. Ehrenzweig described the modern artist as someone who did not take the perceptual structures within which he operated for granted, but in fact proceeded by questioning them. Ehrenzweig referred to this kind of perceptual change, this intentional attack on conventional, implicitly Gestalt-based modes of perception, as '*de*differentiation'. Therefore, if the early child's perception was 'undifferentiated', the attempt to recover this state by the sophisticated adult artist would be made through the process of dedifferentiation. The task was aptly summed up in the chapter on 'The Fragmentation of Modern Art': 'Our attempt at focusing', he wrote, 'must give way to the vacant, all-embracing stare.'[16]

Robert Morris made this precise demand central to his 1969 essay 'Notes on Sculpture Part 4: Beyond Objects'.[17] I take its appearance there as representative of the conversation Morris and Smithson (and other artists such as Richard Serra) were having about Ehrenzweig: let me sketch this out briefly. 'Notes on Sculpture Part 4' theorised the artist's own new work in terms of dedifferentiation, arguing that purposefully undifferentiated perception would result in purposefully unfocused, centreless art. The point was underlined with a photograph of the 1968 sculpture *Threadwaste* (Figure 15). Comprising between six and seven hundred

15 Robert Morris, *Untitled (Threadwaste)*, 1968.

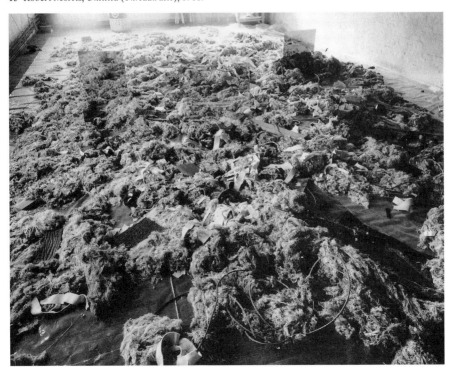

pounds of cotton waste (a by product of textile manufacture), copper tubes, asphalt lumps, and mirrors, the piece was an array of heterogeneous matter without any clear centre of attention. Not only that, as photographed in Morris's studio it was virtually indistinguishable from the debris that surrounded it.

Morris asserted the importance of Ehrenzweig for a wider group of American artists, suggesting that dedifferentiation motivated works by Carl Andre, Bill Bollinger, Barry Le Va, Richard Serra, and Robert Smithson, all of whom had recent sculptures illustrated in the article (Figures 16–19).[18] As far as could be seen from the photographs, these sculptures were effectively inseparable from their surroundings, and none had a clear point of focus. Serra's illustrated work, titled *Scatter Piece*, was one of two he had made for the group show at the Castelli warehouse, consisting of torn strips of cast rubber spread over a large area. Above this, scarcely visible in the original photograph, was a wire, stretched between two points above the rubber. In reviews of the original show, some critics noted the presence of the wire, as if it were a compositional counterpoint to the rubber: but here, in reproduction, the wire was more or less invisible. What mattered was the lateral spread of the piece and its lack of clear focus. These points were underlined by the warehouse interior, clearly visible in the picture, and the fact that it was hard to separate the rubber fragments from the grubby warehouse floor. These points could also be made about Le Va's work, an untitled array of rubber fragments, spread painstakingly over a gallery floor: the work's formal characteristics were lateral spread, lack of central focus, and continuity with its surroundings. Whatever the phenomenological character of these works, in Morris's photographs, they could be used to illustrate the same points as *Threadwaste*. Finally, we might note that in describing these works Morris seemed to find in Ehrenzweig a new language for describing sculpture,

16 Barry Le Va, *Continuous and Related Activities Discontinued by the Art of Dropping*, 1967.

17 Barry Le Va, *Untitled*, 1966.

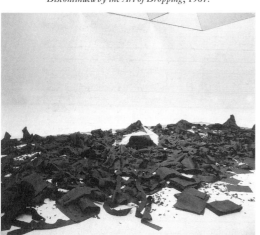

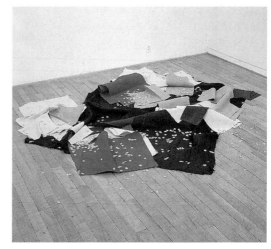

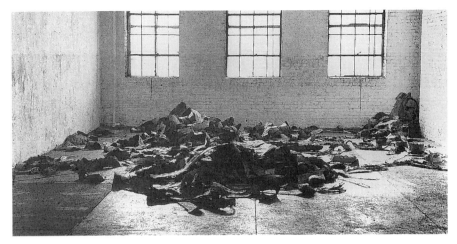

18 Richard Serra, *Scatter Piece*, 1968.

one which broke decisively from the spirit of philosophical inquiry that had characterised his writing to date.

However, it seems that it was Robert Smithson who first came upon *The Hidden Order of Art*, and then passed it on to Morris, and Serra.[19] It made its first appearance in Smithson's writing in the essay 'A Sedimentation of the Mind: Earth Projects', published in the September 1968 *Artforum*, and he went on to refer to Ehrenzweig in several other sources, such as an interview given in early 1969 with William C. Lipke

19 Robert Smithson, *Mirror Trail*, 1968.

of Cornell University, in which he described Ehrenzweig's theory of 'containment' and 'scattering' as integral to his work.[20] 'A Sedimentation of the Mind' is not easy to summarise: it is part manifesto, part satire, part prose-poem. It is also evidence of a conversation between Smithson and Morris, for it referenced the latter's 'Anti Form' more than any other text, and was in some respects a reply to it.[21]

The main purpose of 'A Sedimentation of the Mind' was to justify Smithson's latest work.[22] This increasingly took the form of 'non-sites' (Smithson's term): two-part sculptures comprising a photograph, a map, or other documentation of a site of geological interest, accompanied by a large, geometrical bin containing rocks or earth from the site identified in the document. At this point Smithson was certainly in the stages of planning much larger landscape works, which could only be visited with extreme difficulty, such as the *Spiral Jetty*, and he had already written about his involvement as an 'artist-consultant' for the Dallas–Fort Worth airport project, in which he had imagined a series of giant earthworks.

All of this work was entropic, to employ the term that suffuses Smithson's writing. The concept, deriving from the Second Law of Thermodynamics, describes the irreversible depletion of the universe's energy and its evolution towards a condition of equilibrium in which no further exchanges of energy can take place. This ultimate death is known as entropy (sometimes 'heat death' in science fiction). Smithson's understanding of the term may or may not have involved his reading of the Second Law, but it was a concept very present in science fiction of the 1950s and 1960s, of which he was a keen reader. In science fiction, entropy manifested itself in scenarios of cosmic destruction or decay, such as Brian Aldiss's novel *Earthworks* which described a catastrophic global soil shortage. Smithson's own writing often resembled this kind of science fiction: he described Aldiss's book at the beginning of 'The Monuments of Passaic', a 1967 essay which took the reader on a highly ironic tour of the artist's New Jersey birthplace (Figure 20). The 'Monuments' of the title were mostly the workings associated with the construction of a great highway along the banks of the Passaic river – the pumping derricks, sewage pipes, and drainage channels – which Smithson wrote about as if they were ruins and the city of Passaic were sinking into decay rather than the reverse.[23] An essay published the previous year made a comparable fiction out of real situation. 'Entropy and the New Monuments', superficially a review of recent Minimalist sculpture, discussed the work of Donald Judd, Sol LeWitt, Robert Morris, and others as illustrative of the condition of entropy.[24] (I might add that the appearance of the mysterious monolith in Stanley Kubrick's 1969 film *2001: A Space Odyssey* indicates that the possible connections between Minimal Art and science fiction were quite generally understood.)

'A Sedimentation of the Mind' described a similarly entropic world view. The way Smithson accounted for his and others' 'Earth projects' had less to do with the fabrication of a kind of sculpture, and more to do with destruction. Conventional boundaries, such as those between a work and its surroundings were strategically blurred. Smithson even refused to differentiate the tools with which such works

20 Robert Smithson, *Fountain Monument* from *The Monuments of Passaic*, 1967.

were made from the material they purported to manipulate: they were after all made from the same elements. And the caterpillar tractors, drills, explosives, and digging machines made construction take on the look of destruction. 'They seem to turn the terrain into a site or organised wreckage', he wrote. 'A sense of chaotic planning engulfs site after site. Subdivisions are made – but to what purpose?'[25] The titles of the essay's various subdivisions underline the sense of entropic collapse present in the text: 'From Steel to Rust', 'The Dislocation of Craft – And the Fall of the Studio', 'The Dying Language', 'The Wreck of Former Boundaries', 'Cracking Perspectives and Grit in the Vanishing Point'.

Smithson made clear that his concept of entropy was aligned with Ehrenzweig: the images of entropic collapse he presented at the beginning of the essay were also images of 'undifferentiation'. The artist, he wrote, now experienced 'undifferentiated methods or procedure'; artistic tools were 'undifferentiated' from the material on which they were used. He went on: Tony Smith's night-time drive on the incomplete New Jersey Turnpike (recently reported in *Artforum*, in which the sculptor described the collapse of the road, the lights in the distance, the speed of the journey into one famously entropic experience) Smithson described as a process of 'dedifferentiation'.[26] In other words, dedifferentiation and entropy were the same thing. Writing of a visit to a Pennsylvanian slate quarry, Smithson wrote how 'all boundaries and distinctions lost their meaning in this ocean of slate and collapsed all notions of gestalt unity', while 'the present fell forward and backward into a tumult of de-differentiation'.[27]

This is not quite right. Ehrenzweig in fact used both 'dedifferentiation' and 'entropy' and meant different things by them. By the former, as I have explained, he meant a purposeful detachment from an object-centred perception, in order to perceive a limitless field. It was a process of perceptual change, made, implicitly, by a sophisticated viewer. By the latter, he meant the burnt-out future of the universe, implied by the Second Law of Thermodynamics. But Smithson's conflation of these two concepts is important, giving to *The Hidden Order of Art* a cultural agenda specific to the United States in the late 1960s. Smithson's (mis-) reading of dedifferentiation turned it from a perceptual game played by sophisticated viewers into a world view, in which destruction was privileged over creation, and annihilation, total and utter, was the world's ultimate fate. To be more specific, I suspect that the fate of the world that is imagined here is *nuclear* annihilation, although this is only present metaphorically in Smithson. In other words, as read by American artists, Ehrenzweig's book is transformed from an argument about artistic perception, to an argument about how one begins to represent nuclear destruction – at a moment when such fears were especially real, but when the artistic avant-garde had no explicit means of representing them.

The image of nuclear destruction was similarly present in Morris, specifically *Threadwaste*, and the text that underpinned it, 'Notes on Sculpture Part 4'. The text was a further part of Morris's critical project to define sculpture, as it had appeared in the pages of *Artforum* during the previous three years. Each part had concentrated on a fundamental problem of contemporary sculpture. The 'Notes' had taken in turn the issues of shape, size, and placement as their emphases, while the focus of 'Anti Form,' the fourth essay in the series, was materials. The spirit in which the essays were written was that of a philosophical inquiry, and Morris's language repressed any metaphorical characteristics, and – especially – any explicitly subjective readings of sculpture.

The focus of 'Notes on Sculpture Part 4' was perception. Morris argued that sculpture had until this point been concerned with a single focus of attention, which was to say that it had been concerned with the making of objects. To progress sculpture further would require that this premise be addressed, hence the essay's subtitle 'Beyond Objects'. Morris proposed 'a shift from a figure–ground perceptual set to that of the visual field' which, physically, would amount to 'a shift from discrete, homogeneous objects to accumulations of stuff, often very heterogeneous'.[28] But although 'Notes on Sculpture Part 4' superficially resembled the earlier work, its language differed fundamentally. It is something of a surprise, for example, to read Morris's description of the new materials involved in sculpture. Instead of referring, in a rather essentialising manner, to 'materials' – as he did in 'Anti Form' – Morris now described 'stuff, substances in many states – from chunks, to particles, to slime, to whatever'.[29] Materials acquired specificity here, and connotations of waste or decay. This is language that

is not only highly allusive, but also subjective, indicating the writer's feelings about the material and the cultural associations that they have for him.

I want to continue by suggesting three further ways in which the essay marks a discursive shift. First, illustrations: at first sight, they followed the pattern set by the earlier writings, photographs of new work by Morris set in the context of work by other new artists, giving the impression (thought misleading by some) of his leadership in the New York art world.[30] In this case, Morris showed a photograph of *Threadwaste*, along with pictures of new work by artists including Smithson, Barry Le Va, Richard Serra, and Carl Andre. But alongside these photographs of new sculptures, Morris presented two images that were startlingly different from the rest: the August 1948 'Varga Girl', a pin-up used to advertise car batteries, and the Model A Ford, a vehicle produced by the Detroit company in the 1920s ('Notes 4', Figures 3 and 4). Both were explicitly commercial images, with no pretensions whatever to high culture. The Varga image was especially commercial, showing a barely clad girl on her stomach, accompanied by a verse which invited the drooling (male) reader to imagine the view should she turn over: 'I'm soaking up the sunshine/And I'm being glori-fried/If you think I'm well-done here/You should see the other side.'

These images of cars and girls were, Morris wrote solemnly, productive of the strongest Gestalts, remarking that 'Once seen (they) can never be forgotten.'[31] Like the Minimalist objects he had once made, but temporarily rejected, these images were symmetrical, legible as figures on grounds, and for him at least, memorable. Morris's reduction of his interests to cars and girls is probably a joke – a rather good one – as well as a clear example of what he meant by Gestalt perception. However, what interests me here is the fact that such images should appear at all, given their worldliness. All Morris's previous illustrations had shown artworks in depopulated art galleries, clearly insulated from the world.[32]

The inclusion of the Varga girl and the Model A Ford marks the reappearance of the world in concepts of sculpture, and this fact, once recognised, infects the reader's understanding of the other images in the essay. The works they depicted were all, in some real way, integral to their surroundings, such that it is hard to tell where the works began and ended. And further to that, the settings for the works were in each case rather worldly – a disused warehouse, a forest, an artist's studio – and by their clear presence, these surroundings were meant to be seen. Nowhere is this clearer than in the photograph of *Threadwaste* that illustrated the essay ('Notes 4', Figure 1). At the artist's Castelli exhibition in 1969, the audience was kept at some distance from the piece: according to John Perrault, the then art critic of the *Village Voice*, one was not allowed to smoke in its presence, or even enter the room in which it was displayed.[33] The photograph of the piece for the essay did not, by contrast, show it in a gallery but in the artist's studio in 1968, mounted on a plastic sheet, but surrounded by studio debris – a paint can, pieces of wood, a prominent skirting board, marks on the studio wall. As viewers, we are supposed to see these things, and understand them as part of the work. The separation between art and

the world was presented here, at least rhetorically, as having broken down. By extension, the world was represented here, after a long period in which any form of representation had been repressed.

'Notes on Sculpture Part 4' not only asserted, through its images, the dissolution of the boundary between the art object and the world, but it made statements about the condition of the world. The most startling of these returns us to the image of nuclear destruction, which I have argued is present in Smithson's work. In Morris's case, the image is present in 'Notes on Sculpture Part 4' in the form of a quotation from *Earth In Upheaval* by Immanuel Velikowsky, which demanded that 'the past of mankind, and of the animal kingdoms too, must now be viewed in the light of the experience of Hiroshima, and no longer from the portholes of the *Beagle*'.[34]

Velikowsky's pseudo-scientific work was popular during the 1960s. Each of his books reworked the thesis that cosmic catastrophes were both more common and more recent that had previously been assumed, and that the end of the world was an ever present threat. His method was the relentless accumulation of ancient stories or anecdotes, supposedly describing the same event: both his evidence and his methods have now been generally discredited.[35] There is no question that this work, like so much science fiction of the same period, played on popular fears of nuclear war. The juxtaposition of the text with Ehrenzweig's, and the images of Morris's new work, indicated that *Threadwaste* was to be seen as much as an image of (nuclear) destruction as an exercise in dedifferentiated perception. The point was perhaps reinforced by the formal comparison Morris made between *Threadwaste* and a work of Smithson's. Illustrated side by side with *Threadwaste* was an excerpt of a *Mirror Displacement* he made in early 1969 for the show *Earth Art* at Cornell University.[36] Consisting of a single square mirror, placed in a rocky landscape and photographed, Smithson's work, like *Threadwaste*, presented a mirror in the midst of undifferentiated material, and strategically blurred the boundary between the art object and its surroundings. But Smithson's work, as presented at Cornell, was intensely bound up with the concept of entropy, and the work was one of a number of 'displacements', linking the museum site at Cornell with a local salt mine. Accompanied by numerous maps and other documents, the work – put very crudely – explored the man-made entropy of the mine site. Morris's formal comparison with this work seems to indicate that he wanted *Threadwaste* to be subject to a similarly entropic reading. Ehrenzweig's role in these discursive shifts is to me quite clear. Morris juxtaposed his texts with those of Velikowsky, making explicit the idea that perceptual change was to be accompanied by cultural change. It is also clear that this was not only Morris's work. Smithson had been describing his own work and that of his contemporaries in terms of entropy since 1966, but his essay 'A Sedimentation of the Mind' reconfigured this idea explicitly in terms of Ehrenzweig. Dedifferentiation was, Smithson wrote, Ehrenzweig's word for entropy.

At the beginning of this chapter I wrote that I would discuss sculpture in terms of Herbert Marcuse's critique of civilisation. This is less easy than doing the same for

Ehrenzweig, as the connections are less explicit. Neither Morris nor Smithson cited Marcuse in their writings of the 1960s. It is only the art historical work of Maurice Berger that makes anything of a connection between Morris and Marcuse, asserting that the artist had read Marcuse as a psychology student at Reed College, Portland, and that this influenced his later work.[37]

That said, there is no doubt about the importance of Marcuse for such widely read critics as Ursula Meyer and Gregory Battcock, both of whom were concerned with the possibility of a Marcusian 'anti-art', and both of whom connected Marcusian 'desublimation' with Morrisian Anti Form. In 1973, for example, Battcock published the third in a series of anthologies on contemporary art trends, *Idea Art*, in which there was much treatment of Marcuse in terms of conceptual art. Battcock's own contribution to the anthology described Marcuse's aesthetic argument in *Counterrevolution and Revolt* as (in the first place) a critique of form: in a passage that recalls Morris's 'Anti Form', Battcock reported Marcuse's main objection to form as being that it stabilised repression (indeed Battcock used the terms Anti Art and Anti Form more or less interchangeably).[38] In the same anthology there was an essay by Meyer, a critic who had consistently made the same kinds of connections. Her principal interest, arrived at via Marcuse, was anti art or the possibility thereof. In this category she certainly included such sculptural concepts as Anti Form. In 1970, for example, she encouraged Morris to allow his essay to be published as part of her anthology on anti art.[39] Morris refused as it turned out, rejecting her premise that Anti Form was in any sense anti art, but Meyer's inquiry, and her writing elsewhere indicates that whatever the intention of individual artists, Marcusian views on art, and contemporary theories of sculpture were widely seen as part of the same discourse. What is certainly also true is that Marcuse was widely read by those on the Left in the United States, among whom we can include most of the artists and critics mentioned in this book.

Marcuse was a Frankfurt School philosopher, a contemporary of Theodor Adorno and Walter Benjamin. Born and educated in Berlin, he left Germany in 1934 for the United States, where he pursued an academic career first at Columbia University, then at Harvard, Brandeis, and the University of California at San Diego. His best-known published works include *Eros and Civilisation: A Philosophical Inquiry into Freud* (1956), *One-Dimensional Man* (1964), and *An Essay on Liberation* (1968), by which point he had become in the words of the historian David Caute, 'the official ideologue' of the campus revolutions that occurred at many American and European universities.[40] This was plausible, given that Marcuse's writing provided a post-Marxist vocabulary for personal and social liberation, but it was not a role he initially wished to perform. Marcuse thought the 'beatniks and hippies had become the pathetic refuge of a deformed humanity. Existentialism and Zen were harmless revolts, easily assimilated' (Caute again). By 1968, however, Marcuse had revised his ideas to the extent that he accepted some of the burgeoning counter-cultural movements as indeed illustrating his proposals for a liberated society. 'The End of Utopia', for example, a lecture delivered at the Free

University of Berlin in June 1967, agreed that there were certain tendencies in contemporary society, albeit 'unorganised, spontaneous' ones, that 'heralded a total break with the dominant needs of repressive society'.[41]

Marcuse's writing, in common with that of his Frankfurt School peers, was fundamentally a social critique of Western civilisation from a Marxist perspective. Western freedoms were seen as illusory, dependent, to give one example, on the understanding that leisure time in which free play can take place is limited by the restrictions of work. Marcuse's Marxism was, however, informed by Freud, which gives his language a different character, allowing the concept of the individual to play as important a role as that of society. *Eros and Civilisation* was for the most part a commentary on a late essay by Freud, 'Civilization and its Discontents' (1930), in which Freud expanded his theory of individual psychological development to include that of society as a whole.[42] Freud had argued that civilisation was impossible without the repression of basic instincts, most importantly sexual desire. Any powerful social organisation was, Freud wrote, the result of the redirection of Eros. Mechanisms by which this redirection took place included the formation of character in the development of the individual, and more importantly in the sublimation of desire such that it became a repressed, but socially acceptable form of that desire: love being the prime example, the sublimation (and by implication, control) of Eros. Such restriction placed on basic instincts lead to the redirection of desire toward the social group.

Freud's thinking was premised on scarcity. Hunger, he wrote was a primary motivation in the organisation of society.[43] Marcuse broke with Freud at this point, arguing in *Eros and Civilisation* that scarcity was in no sense a natural, universal characteristic of human existence as Freud implied, but something imposed by social organisations. Scarcity resulted from, for example, the domination of one class by another. He noted elsewhere, in a statement that now seems somewhat idealistic, that developed societies had at their disposal technical and other knowledge to eliminate scarcity.[44] The problem was not scarcity per se, but distribution. Freud's principles were challenged here by Marx; *Eros and Civilisation* proposed a new model of society in which questions of scarcity had been resolved, and in which as a result social relations were radically altered. New concepts of work and leisure would evolve in such a 'liberated' society, and new concepts of good and evil.

Of the Freudian concepts that featured in Marcuse's commentary, perhaps the most important was sublimation, the purification of instinct that Freud speculated was a development of man's evolution from a horizontal to a vertical position, 'a consequence of man's raising himself from the ground, of his assumption of an upright gait; this made his genitals, which were previously concealed, visible and in need of protection, and so provoked feelings of shame in him.'[45] The sublimation of instinct was, according to Freud, related to man's literal sublimation of his body, raising it from the horizontal to the vertical plane. As a means of effecting change, Marcuse therefore proposed 'desumblimation', or the literal reversal of processes of sublimation: the recovery of instinct without guilt, specifically the development

of a polymorphous sexuality.[46] In Marcuse's erotic utopia, one's sexuality would be free, able to attach itself guiltlessly to any person, object, or substance. The concept of sexual perversion would become a thing of the past.

Desublimation is also the aspect of Marcuse's theory that seems to provide a vocabulary to account for the work of Morris and other sculptors of the 1960s. Maurice Berger writes interestingly about this, arguing for example that Morris's performance *Waterman Switch* was an example of the desublimated Eros. In this rather complex piece, Morris performed naked with Yvonne Rainer, the pair locked in a passionless embrace while they inched along a track accompanied by a third performer, Lucinda Childs, dressed in a man's suit and hat. This action took place to the strains of a Verdi aria, the sentimentality of which provided an ironic counterpoint to the highly stylised action on stage. Berger wrote that the absurdity of the performance forbade anything so elevated as love. He continued by identifying desublimatory tendencies in the artist's Anti Form sculptures: close to the ground, they literally recovered the horizontality repressed in normal art; they also appeared to collapse under gravity, or collapse into their individual components, desublimating the elevated category of art. And Anti Form had, as we have seen, been discussed in a Marcusian context at the time.

Of all Morris's activities during the 1960s, the one that is most legible in terms of Marcuse is *Continuous Project Altered Daily*, a work made for the Castelli warehouse in 1969 (Figures 21-6).[47] Part of a show that included an exhibition of sculpture at Castelli's normal premises, *Continuous Project* was less a sculpture, and more an extended performance. It involved the artist visiting the warehouse on each morning of the exhibition (it was open to the public from 1 to 5.00 p.m.), and manipulating a heterogeneous collection of materials including clay, earth, asbestos, grease, cotton, wood, water, felt, plastic, electric lights, and a tape recorder. Morris sometimes went with a plan in mind, but more often did not. At the end of each of twelve of the sessions he took a photograph of the results and stuck it to the wall. On the last day, Morris cleaned up the space, removing all materials, but making a sound recording of the work to add to the photographs.

Castelli published the pictures in the form of a leaflet, and they showed identifiable states of the project, and much change between each state. The first image showed, for example, a huge spread of clay on the floor, with a few tools and barrels lined up against the back wall. Ensuing photographs described the process of making crude tables from the wood he brought into the studio, then covering them with felt, dirt, and more wood. The final picture in the series showed a state at which Morris had removed nearly all of the material: eight photographs remained fixed to the wall, and a tape player attached to a power supply played a recording of the morning's work. *Continuous Project* made use of unlikely materials, but ones that would have been familiar to visitors to the Castelli or Dwan galleries during the previous year: the dirt, grease, felt, and clay had all made an appearance in one form or another. In terms of the present discussion, the fact of such matter, associated with waste, bodily or otherwise, is desublimatory in itself.

21-6 Robert Morris, *Continuous Project Altered Daily*, 1969.

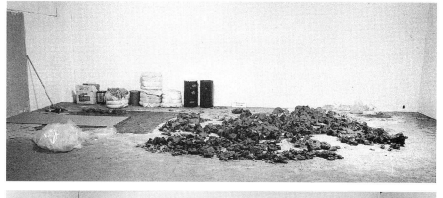

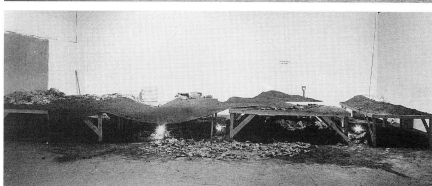

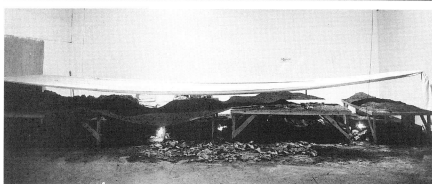

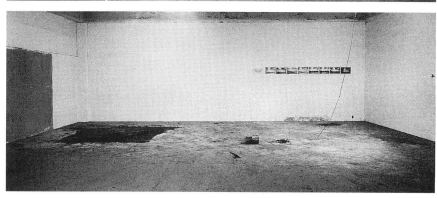

Two aspects of the project were new, however. First, that the project was temporally based, and Ursula Meyer for one thought that temporality, specifically temporariness, was an essential qualification for a Marcusian anti-art.[48] Second, the project seemed to represent for Morris an encounter with Marcusian polymorphous eroticism – although this seems to have been no more than an encounter, in that he seems to have been thoroughly repulsed by the substances he was working with. Writing to the British art critic David Sylvester in 1969 about beginning the piece, he noted with pleasure that in its initial state it 'looked as if seven or eight elephants had shit on the floor'.[49] But in his diary, kept for the duration of the project, such enthusiasm quickly evaporated. The work resembled 'viscera, muscles, primal energies, afterbirth, faeces'; later it was 'a work of the bowels, very moving shit etc.' In another entry he noted feeling nauseous, and wrote that the 'faecal quality' of the work revolted him more than he liked to admit. About the fact that his methods were on public display, he seemed to rue ever having started the project. Overall it made him feel 'extremely uncomfortable' as if he had 'revealed his methods of masturbation'.[50]

The guilt and repulsion in these statements suggest that Marcusian revolution was still some way off. But *Continuous Project* is legible as an encounter with ideas of both desublimation and polymorphous eroticism. Neither was Morris alone in this: we will see later in the book how artists such as Walter de Maria used low materials in a way that seemed designed to provoke extreme reaction; we will see elsewhere how Richard Serra turned his relatively innocuous splashed lead piece into an obscene gesture when transferred from the obscurity of the Castelli warehouse to the facade of the Stedelijk Museum, Amsterdam. And the encounter with Marcusian ideas is, I think, present in a dramatic form in certain works of Robert Smithson, namely *Asphalt Rundown* and *Glue Pour* (Figures 27 and 28).

27 Robert Smithson, *Asphalt Rundown*, 1969. 27 Robert Smithson, *Glue Pour*, 1970.

The first of these Smithson realised in October 1969, as part of his show at L'Attico Gallery, Rome. The piece comprised a truckload of asphalt released down a steep bank in an abandoned gravel quarry on the outskirts of the city. It was possible to visit the site – the gallery provided a map – although the work is better known as a series of photographs and a film. The pictures document different states in the realisation of the piece, from the pouring of the steaming asphalt into the truck, to the moment of its release, to images of the results. Smithson went on to realise the rather similar *Glue Pour* in early 1970 in Vancouver, in which a drum of glue was manhandled to the edge of a slope, again in a quarry, its lid prised off, and the revolting-looking contents left to ooze downwards. There was again extensive photography, this time in colour, and the results have been widely republished. Rosalind Krauss has described these works as a response to Morris's 'Anti Form' in that they illustrated very clearly the operations of gravity and chance.[51] But there is more to them than that: the semi-liquid materials that Smithson chose for these works both behaved and looked in the photographs like bodily products (they had not only liquidity, but strong colour and smell), and their dispersal, their dumping and pouring, had excremental qualities – especially *Asphalt Rundown* and that great dumping from the rear of the truck. I am sure that Smithson was not unaware of such readings – certainly his knowledge of Ehrenzweig would have alerted him to the possible connections between anal eroticism and undifferentiated matter. And further, it seems to me that there was obvious pleasure in the photographs of these works, recording with great care the way the semi-liquid materials oozed, seeped, and congealed. In the case of *Asphalt Rundown*, this reading is, finally, closer to the revolutionary action that Marcuse seemed to intend, in that its libidinal qualities are not hidden. The work was not made in some obscure New York warehouse, but it was a much grander gesture: a great, public, defecation in – perhaps directed at – the Eternal City. Through this project, the encounter with Marcusian ideas in sculpture acquired a more public face. In fact the contexts of sculpture, underwritten by the theories of Marcuse and Ehrenzweig, were increasingly a major preoccupation: context is the subject of chapter 6.

Notes

1 For more on Whiteread and these questions, see Liverpool Tate Gallery, *Shedding Life* (Liverpool, Tate Gallery, 1996).

2 Max Kozloff, 'Art', *The Nation* (17 March 1969), 347–8.

3 Robert Morris, 'Notes on Sculpture Part 4: Beyond Objects', *Artforum*, 7:8 (April 1969), 50–4. Robert Smithson, 'A Sedimentation of the Mind', *Artforum*, 8:1 (September 1968), 44–50.

4 Anton Ehrenzweig, *The Hidden Order of Art: A Study in the Psychology of Artistic Imagination* (London, Weidenfeld and Nicholson, 1967).

5 Ehrenzweig, *Hidden Order*, p. iii.

6 This is pure anecdote – but highly plausible nonetheless.

7 Anton Ehrenzweig, 'Unconscious Form-Creation in Art', *British Journal of Medical Psychology*, 21 (1948), 185–214, and 22 (1949), 88–109.

8 Anton Ehrenzweig, *The Psycho-Analysis of Artistic Vision and Hearing: An Introduction to a Theory of Unconscious Perception* (London, Routledge and Kegan Paul, 1953).

9 Ehrenzweig, *Hidden Order*, p. xi.

10 Anton Ehrenzweig, 'Alienation versus Self-Expression', *The Listener*, 63:1613 (1960); 'Bridget Riley's Pictorial Space', *Art International*, 9:l (1965); 'Towards a Theory of Art Education', *Report on an Experimental Course for Art Teachers* (University of London Goldsmiths' College, 1965).

11 Ehrenzweig, *Hidden Order*, pp. 291–6.

12 W. Köhler, *Gestalt Psychology* (1930) and B. Petermann, *The Gestalt Theory and the Problem of Configuration* (1932) are cited in Ehrenzweig 'Unconscious Form-Creation in Art' 185. He writes: 'The pregnant and simple structure of traditional art bears out the teachings of Gestalt theory according to which all perception or creation of form is subject to a tendency to perceiving as pregnant and simple a structure as possible. The eye as a sense organ only registers an unorganised chaotic mosaic of dots; the brain projects that definite configuration into the chaos which we perceive as the forms and shapes around us. Even if the shapes around us are really chaotic the brain will still project some order into them. From a jumble of dots the eye (or more correctly the brain) will pick out a few which fall into some pattern of which could be interpreted as a human or animal shape. When gazing ino the drifting clouds, or into the embers of a dying fire or at a piece of wrinkled bark, we will easily project such form-phantasies into them. If the form material already posesses some order there the brain will project even better order into it.'

13 Ehrenzweig, 'Unconscious Form-Creation', 188.

14 Ehrenzweig, *Hidden Order*, p. 6.

15 Ehrenzweig, *Hidden Order*, p. 66.

16 Ehrenzweig, *Hidden Order*, p. 67.

17 Up to this point, Morris had theorised his work in terms of Gestalt psychology (for the most explicit example, see 'Notes on Sculpture Part 1'). It is no surprise to see him use Ehrenzweig, a ready-made critique of Gestalt theory, as a means of advancing his work.

18 It should be said that this is no more than an assertion, based on Morris's observation of other, younger, artists' work, sometimes to their displeasure. He had not met Le Va at this stage (who was working in Los Angeles), and his knowledge of Le Va's work stemmed from a recent article in *Artforum*. Le Va seems to have been reasonably happy with Morris's treatment of him (unpublished interview with the author, New York, May 1995), although Serra's attitude has been more negative.

19 Jack Flam, *Robert Smithson: The Collected Writings* (Berkeley and Los Angeles, University of California Press, 1996). Serra, a good friend of Smithson's, wrote relatively little, but cited Ehrenzweig at the beginning of a 1970 essay on sculpture, suggesting that his concept of dedifferentiation was widely used to justify contemporary sculpture. See Richard Serra, 'Play It Again, Sam', *Arts Magazine*, 44:4 (February 1970), 24.

20 William C. Lipke, in Nancy Holt (ed.), *The Writings of Robert Smithson* (New York, New York University Press, 1979), pp. 168–9. Gary Shapiro also refers to this in a useful account of Smithson's understanding of Ehrenzweig in *Earthwards: Robert Smithson and Art after Babel* (Berkeley and Los Angeles, University of California Press, 1995), pp. 88–9.

21 Robert Morris, 'Anti Form', *Artforum*, 6:8 (April 1968), 33–5.

22 Smithson's 'non-sites' appeared in three major exhibitions during the 1968–69 New York season: *Earthworks*, a group show at the Dwan Gallery also featuring Walter de Maria, Michael Heizer, and Robert Morris; *Earth Art*, a much reported group show at Cornell University, Ithaca, featuring many of the same artists plus Richard Long, Gunter Uecke, and Hans Haacke; and Smithson's own solo exhibition at the Dwan Gallery in early 1969. Smithson was also shown in Düsseldorf, Bern, and Amsterdam during the same period.

23 Robert Smithson, 'The Monuments of Passaic', *Artforum*, 7:4 (December 1967), 48–51.

24 Robert Smithson, 'Entropy and the New Monuments', in Holt, *Writings*, p. 9.

25 Robert Smithson, 'A Sedimentation of the Mind: Earth Projects', in Holt, *Writings*, pp. 82–91: 83.

26 Holt, *Writings*, p. 84. Tony Smith's experience on the New Jersey Turnpike is part of an interview with the artist in Sam Wagstaff, 'Talking with Tony Smith', *Artforum*, 4:4 (December 1966). Its appropriation, for varying purposes, by different artists and critics would make a good subject for research. In this case, Smithson reads it as a quintessentially entropic experience, produced by Smith's purposeful detachment from object-based perception. For Michael Fried, the experience represented a debate between what could, and could not, be declared to be art. See Fried, 'Art and Objecthood', *Artforum*, 5:10 (June 1967), 12–23.

27 Holt, *Writings*, p. 89.

28 Morris, 'Notes 4', p. 51.

29 Morris 'Notes 4', p. 54.

30 Morris has been repeatedly accused of plagiarism, by artists such as a Richard Serra, and critics including Roberta Smith of the *New York Times*, and both regard Morris's critical activities in the 1960s as suspect in this regard. A fascinating discussion of this can be found in David Antin, 'Have Mind Will Travel', in *Robert Morris: The Mind/Body Problem* (New York, Guggenheim Museum, 1994), pp. 34–49.

31 Morris, 'Notes 4', p. 51.

32 See Morris's earlier three 'Notes on Sculpture', collected together in *Continuous Project Altered Daily: The Writings of Robert Morris* (Cambridge, Mass., and London, MIT Press, 1993), pp. 1–39. In the second essay, Morris described how the new sculpture made the spectator aware of the 'situation', although the illustrations of highly reductive, Minimalist objects in empty art galleries makes clear that the 'situation' at this stage is contrived for a specific art environment: it does not admit things from the everyday environment.

33 John Perrault, 'Art: Down to Earth', *Village Voice* (13 March 1969), 18,20.

34 Immanuel Velikowsky, *Earth in Upheaval* (London, 1956), p. 227; quoted in Morris, 'Notes 4', p. 53.

35 The best-known attack on Velikowsky appears in Carl Sagan's *Broca's Brain*; of Velikowsky's *Worlds in Collision* (1950), which argued that the widespread use in ancient cultures of a 360-day year was the result of a cosmic disaster which actually shortened the year. Sagan wrote: 'I wonder if we do not see here an echo of the collision between chauvinists of base-60 arithmetic and chauvinists of base-10 arithmetic, rather than a collision of Mars with the earth.' Carl Sagan, *Broca's Brain* (London, Paladin, 1980), p. 111.

36 *Earth Art* was surrounded by all manner of narratives of collapse, social and political, as well as cosmic. See especially Max Kozloff's review in *The Nation* (17 March 1969),

347–8, in which he made a direct comparison between the fragmented, dispersed nature of contemporary American sculpture and the state of contemporary society.

37 Maurice Berger, *Labyrinths: Robert Morris, Minimalism and the 1960s* (New York, Harper and Row, 1989). See also Berger, 'Objects of Liberation', in *Eva Hesse: A Retrospective* (New Haven and London, Yale University Press, 1992), pp. 119–36. In both of these texts, Berger argues that Marcuse, especially *Eros and Civilisation*, is helpful in understanding Morris's work of the 1960s, and also that of Eva Hesse. Berger's work is very useful here, although I think the relationship between Marcuse and the art is less straightforward than he suggests.

38 Gregory Battcock, 'Art in the Service of the Left', *Idea Art* (New York, E. P. Dutton, 1973), pp. 18–29.

39 Robert Morris, Letter to Ursula Meyer (5 June 1970), Morris Archive, New York, Guggenheim Museum. For more of Meyer's writing, see especially 'The De-Objectification of the Object', *Arts Magazine*, 43:8 (Summer 1969), 20–2.

40 David Caute, *1968: The Year of the Barricades* (London, Paladin,1988), p. 25.

41 Herbert Marcuse, *Five Lectures* (London, Allen Lane, The Penguin Press, 1970), p. 69.

42 Sigmund Freud, 'Civilisation and its Discontents', *Penguin Freud Library 12* (London, Penguin Books, 1985).

43 Freud, 'Civilisation', pp. 290, 313, 333.

44 Marcuse, *Eros*, pp. 35–6.

45 Freud, 'Civilisation', pp. 288–9.

46 For example, Marcuse, *Five Lectures*, p. 57.

47 New York, Leo Castelli Gallery, *Robert Morris* (1–22 March 1969).

48 Meyer, 'De-Objectification'.

49 Robert Morris, (1 March 1969), Letter to David Sylvester, Morris Archive, New York, Guggenheim Museum.

50 Guggenheim Museum, *Robert Morris: The Mind/ Body Problem* (New York, Guggenheim Museum, 1994), pp. 234–5.

51 Rosalind Krauss, 'Robert Morris in Series', in Guggenheim, *Robert Morris*, p. 14.

5

Dematerialization

Chapters 3 and 4 discussed the uses to which Robert Morris and Lucy Lippard put their understanding of psychoanalysis. The results of their investigations were, as we saw, quite limited in effect: both Lippard and Morris quickly moved on to other things, although a rather generalised understanding of psychoanalysis remained a presence in sculptural criticism. The subject of this chapter, dematerialization, is a concept of greater durability and critical appeal, although less substantial intellectually. Another of Lippard's terms, it helped provide a new vocabulary to discuss a wide range of contemporary art forms. Although it centred on the development of so-called Conceptual Art, it also accounted for sculpture, including contemporary work by Morris, Robert Smithson, and the Arte Povera group in Italy. Most of the terminology I discuss in this book is as fleeting as the art it purports to describe: dematerialization is different. The subject of a 1968 essay for the Lugano-based journal *Art International*, it was expanded to form the basis of Lippard's 1973 book, *Six Years*, and was all the while a term in use by many critics besides Lippard. In the early 1990s it was revived by one art historian to rationalise his account of two exhibitions of the 1960s.[1] However, if dematerialization was a durable term, and a widely used one, it was never well defined, so that one of its most interesting characteristics, namely the shift in focus from the making of objects to the telling of stories, from sculpture to narrative, is never clearly stated. I deal straightforwardly with such problems in this chapter. I begin with the dematerialization concept, and discuss various applications of it. I go on to discuss its limitations in specific relation to sculpture, precisely Morris's exhibition *Nine at Leo Castelli*, which appeared as an example of dematerialized art in Lippard's 1973 book. I conclude with some speculation about narrative and myth, suggesting that these terms are as present in dematerialization as the straightforward loss of materiality.

In 'The Dematerialization of Art', Lippard and her co-author John Chandler wrote:

> During the 1960s, the anti-intellectual, emotional/intuitive processes of art making characteristic of the last two decades have begun to give way to an ultra-conceptual art that emphasises the thinking process almost exclusively. As more and more work is designed in the studio but executed elsewhere by professional craftsmen, as the object becomes merely the end product, a number of artists are losing interest in the physical evolution of the work of art. The studio is once

again becoming a study. Such a trend is provoking a profound dematerialization
of art, and if it continues to prevail, it may result in the object's becoming wholly
obsolete.[2]

What Lippard and Chandler had in mind here was, to begin with, an understanding
of Minimal Art, that highly geometrical sculpture that was then filling New York
galleries. For some years, the production of this work was increasingly out of the
artist's hands, and light-engineering firms such as Aegis on Long Island (used by
Morris, and recommended by him to Eva Hesse) took more and more responsibility
for the fabrication of objects. There is an amusing account of Morris making fibre-
glass and wood sculptures in the early 1960s, but only because he lacked the commer-
cial success to afford to have them made for him.[3] But the fact that Minimal Art
tended to be made by commercial fabricators rather than artists, although well
known, was not a central part of the critical discourse around Minimalism.

Dematerialization drew on various sources, most clearly the early theorisation of
Conceptual Art by such artists as LeWitt and Joseph Kosuth. LeWitt's 'Paragraphs
on Conceptual Art' appeared in the Summer 1967 *Artforum*, the special issue on
sculpture. In it, LeWitt argued that the emergent tendency proposed an art which
could take any form. What mattered was the idea, not the execution. 'When an artist
uses a conceptual form of art', he wrote, 'it means that all of the planning and the
decisions are made beforehand and the execution is a perfunctory affair. The idea
becomes a machine that makes the art.' Lippard and Chandler's later definition of
dematerialization makes almost exactly the same point as LeWitt. Lippard and
Chandler, however, saw dematerialization as a tendency with a longer history than
Conceptual Art. They also saw it as an idea with wider application than he did,
offering a possible explanation of much contemporary art practice in the United
States. They presented a diverse list of artworks in which, as they saw it, what was
emphasised was idea over execution. Their diverse list of examples included Robert
Rauschenberg's erasure of a drawing by Willem de Kooning, then exhibited as an
'erased de Kooning by Robert Rauschenberg'; Yves Klein's exhibition of an empty
gallery; Claes Oldenberg's invisible monument, a trench dug and then filled in by
public gravediggers behind the Metropolitan Museum; Sol LeWitt's comparable
project for a cube to be buried (and thus hidden from view) at the Dallas/Fort Worth
regional airport; Robert Morris's proposed sculptures in steam.

Dematerialization had a life as a concept beyond the original essay, underpin-
ning very explicitly Lippard's fascinating book *Six Years*, published in 1973.
Subtitled *The Dematerialization of the Art Object from 1966 to 1972*, it was in effect
an annotated bibliography describing in varying amounts of detail about a thou-
sand art exhibitions, events, and texts from all over the world. All of them, 'such
vaguely designated areas as minimal, anti form, systems, earth or process art', were
accounted for in terms of the thesis that the production of art objects was no longer
as important as the ideas behind them. Among the events that Lippard described
was *Nine at Leo Castelli*, including photographs of works by Serra and Sonnier, and
the only published picture of Rafael Ferrer's uninvited contribution to the show, a

pile of autumn leaves dumped at the entrance to the building. As already stated dematerialization was a popular thesis, not only in Lippard's writing, but in other contemporary criticism, and later historical accounts.

In Lippard's 1973 book, and Altshuler's later account, one of the events which is seen to best describe what was meant by dematerialization is an exhibition, *January 1-31 1969*, organised by the independent critic and curator Seth Siegelaub. Taking place in an empty office building on East 52 St., New York, during the period identified by the exhibition title, it showed the work of four artists, Robert Barry, Douglas Huebler, Joseph Kosuth, and Lawrence Weiner. Their interest in the idea of a work of art over its execution was signalled by the exhibition's subtitle which stated that there were '0 Objects, 0 Painters, 0 Sculptors, 4 Artists … 32 Works, 1 Exhibition, 2000 catalogues'. Some works were invisible, such as Barry's two sculptures in radio waves. Two transmitters, one emitting a wave at 88 megacycles, the other at 1,600 kilocycles (built by Barry's father, according to Altshuler), were hidden in a cupboard in the exhibition space, and switched on. The existence of the work was registered in the form of two wall plaques, stating the wave specifications. Barry declared the work to be the waves themselves: the art did not, according to him, reside in either the wave-producing equipment or their identifying labels. He described in a contemporary interview that his interest in invisible works of art had come about through a process of reduction. Beginning as a painter, he moved on to making wire installation after discovering, to his dissatisfaction, that his paintings changed their appearance according to location; he made progressively more refined wire pieces until they were in effect invisible. At this point, he 'discarded the idea that art is necessarily something to look at'.[4] Other works by Barry included a 'radiation piece' – a quantity of barium-133 placed in various locations, and identified with a wall plaque. As with the radio-wave pieces, Barry declared the work to be neither in the documentation, nor the material source of the energy, but in the invisible energy itself.

Dematerialization assumed that a non-material emphasis in art had a relatively long history. Among the older works it cited were several by Morris from the early 1960s. His *Statement of Aesthetic Withdrawal* (1963), for example, comprised a signed, legally notarised statement alongside a relief image of a small sculpture, *Litanies*, which Morris had recently made and sold to the architect and art collector Philip Johnson. Having failed to receive payment for the piece, Morris had the statement typed out to say that he was withdrawing, as he put it, 'all aesthetic content' from it. The statement was signed by Morris and notarised so that it became a legal document. The results were then assembled as a new piece of art, although one where the physical form of the work was dictated by the conventions surrounding the making of legal documentation; the point of the work was the impossibility of the concept of aesthetic withdrawal. In 1969, Morris made a piece which consisted only in terms of documents. Asked to provide a process work for the exhibition *Anti-Illusion*, curated by Marcia Tucker and James Monte at the Whitney Museum, Morris mischievously devised *Money*, which consisted in the depositing of $50,000 in a bank account for the duration of the show, and its accumulation of interest for

29 Richard Serra, *Casting*, 1969.

that duration. The physical form the work took was wholly perfunctory: Morris wrote in his original proposal for the piece that

> the Museum could show any aspect of the project that it chose – e.g. the loan forms, a video of discussion with brokers, a sign changed daily that recorded the amount of profit accruing, the actual money itself that was being earned daily … The work could be sold which would mean that *Money* would continue after the exhibition. The buyer would have to take over the loan. My price would be half the income from the investment for so long as the capital was working. The work, as well as the ownership, would end with the withdrawal of the investment. In the event that the work was not sold, all documentation and records would revert to me.[5]

By process, the curators had in mind the illustration of physical process, and the other works in the show – such as Richard Serra's *Casting* – were legible traces of such material manipulation (Figure 29). The process in Morris's work was wholly conceptual, the material form of the work being of little importance. No only was it declared to be the case, in that the material was said to be only an 'aspect' of the work, its existence being something not necessarily connected with material presence at all – but in various ways Morris ensured that the material form was simply out of his hands. So the museum, he stated, could show anything it liked relating to the project, and offered a range of ideas for the display, some more likely than

others. Furthermore, he permitted the work to be sold as a loan, in which case its material form was left unspecified. Lippard referred to *Money* in a 1971 interview with Morris, in which she questioned him directly about conceptual art. Morris objected to the label, but agreed that much of his work was dematerialized in that it forestalled the creation of lasting forms.[6]

These works of Morris, Barry, and others are easily assimilable within the concepts of both dematerialization and Conceptual Art. They were objects in one sense, but one way or another, they contrived to make their materiality less of an issue than the ideas behind them. What I want to turn to now is an event which Lippard once described as dematerialized, but which through its complexity identifies the limitations of the dematerialization concept. The event was an exhibition held in a warehouse in an unpromising part of New York's Upper West Side in late 1968 (Figures 30-1). Curated by the artist Robert Morris, and titled self-reflexively *Nine at Leo Castelli*, it has often been singled out for special attention – indeed I

30-1 Leo Castelli Gallery, *Nine at Leo Castelli*, December 1968.

am doing the same thing here. Douglas Crimp, for example, began an important essay on Serra and site-specificity with an account of it, writing that 'it defied our every expectation regarding the form of the work of art and the manner of its execution': a grand claim.[7] My interest in it centred initially on the extent to which it represented Morris's idea of 'Anti Form', a process-oriented manner of sculpture that he had theorised earlier in the year. It was on these terms an important case for my project: claims for its significance were made by many critics at the time of its realisation, and afterwards. But the further I took the research, the less certain I became of what kind of existence it had had, or even whether it had taken any material form at all.

I will return to this question presently, but let me say first what sort of an exhibition *Nine at Leo Castelli* was supposed to be. Taking place in a warehouse at 103 West 108 St., in a building until this point rented by the Castelli Gallery for storage, it showed the work of nine young artists from the United States and Italy (Figures 1, 18, 32-4). They were Giovanni Anselmo and Gilberto Zorio, both Turin-based; Stephen Kaltenbach and Bruce Nauman from California; Bill Bollinger, Eva Hesse, Alan Saret, Richard Serra, and Keith Sonnier, all New York-based. There was also, as Lippard recalled, an uninvited but appropriate contribution from the Puerto Rican artist Rafael Ferrer, consisting in a pile of autumn leaves dumped in the entrance to the warehouse on the day of the opening.[8] Common to all works was a certain casualness of presentation. Most of them looked, and were supposed to look, temporary, fragile, fleeting. To this end they made use of raw materials with little structural integrity of their own, and bore the imprint of their immediate surroundings. A visitor would have encountered a striking variety of soft or flexible materials, and even liquids: aluminium, canvas, chickenwire, copper, cotton, felt, flocking, hydrochloric acid, latex rubber, lead, neon lighting, plastic, polythene, steel, and water. Some of these assemblages or accumulations were also extremely large, reaching a length of 40 ft in the case of a piece in chickenwire by Bollinger. The materials were extremely diverse, ranging from acids in liquid form, through to lead, to the tape recorder forming part of Nauman's work. There was also great variation in size between Bollinger's piece, the largest, to Nauman's, the smallest at 3 foot square and a few inches in height.

It was an eclectic show, and the critics had to work hard to discern some overall tendencies. There were a number of works which made use of their immediate surroundings, such that their removal would necessarily entail their destruction. Serra's untitled piece in splashed lead is a good example, comprising lead, heated until it became molten, and then splashed along a three-foot length of the junction of wall and floor, and left to cool, it could only have been removed by chipping and scraping it away, in the process destroying it. Sonnier's two works intervened less violently on the surface of the building, but they were nevertheless part of it in the same way: one, *Mustee* (Figure 33), attached a length of canvas to the wall, stretching it outwards, tent-like, by means of two wires. The area of wall directly underneath the stretched canvas was covered with a quantity of flocking, the

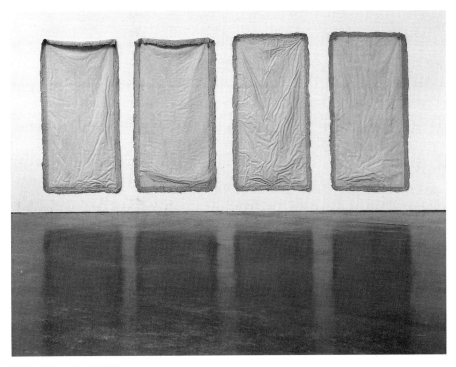

32 Eva Hesse, *Aught*, 1968.

33 Keith Sonnier, *Mustee*, 1968.

34 Keith Sonnier, *Untitled* (*Neon and Cloth*), 1968.

powdered textile used in the manufacture of wallpaper. As in the case of Serra, the removal of Sonnier's work would have involved chipping and scraping it away from the wall, ensuring that each installation was unique, temporary, and dependent on its immediate surroundings.

Another group of works appeared to make fragility the central term. Hesse's two contributions, consistent with other objects she had been making at the time, took the language of Minimal Art – its repetition of identical, solid forms, its concern for geometry – and softened it to the point of collapse. Minimal Art, in the example of an artist like Morris, was an art of physical engagement when a large, solid, and rather immovable object was supposed to encroach on the viewer's literal space (this idea, presented quite positively by Morris in the 1960s, was criticised by later art historians for being a physically aggressive, and hence overly masculine concept of sculpture).[9] Hesse presented the same forms at the point of collapse, through the use of soft materials softening their hard forms. *Aught* (Figure 32), one of many works whose titles appear to belong in an imaginary thesaurus, comprised four equal-sized rectangles of latex rubber, each measuring roughly 4 ft by 2 ft, and arranged in a horizontal series on the wall. The basis for such a work might have been one of Donald Judd's works: there are several, dating from the mid-1960s (such as the untitled piece exhibited at the Dwan Gallery, New York, in October 1966), which present a horizontal, wall-mounted series of identical forms. But here the material is so flimsy, so lacking in structural integrity, as to make the notion of series impossible. Each unit sagged and fluttered uniquely, dependent on the passing condition of the exhibition space. There were other works like this made by Serra, Saret, and Bollinger, which employed substances so fragile that the forms they were presented in at the warehouse could only be temporary: a pile of torn-up rubber strips, disintegrating as if from the act of looking; a flimsy ball of chicken-wire; casual arrangements of plastic and rubber.

A third category might comprise objects which were deliberately changed over time. Every day, for example, Dorothy Lichtenstein (wife of Roy, and the exhibition's attendant), was required to rearrange a large piece of rubber lying prominently in the middle of the warehouse, this being Kaltenbach's work. Or Anselmo's experiment in capillary action: a steel box filled with water, open at the top out of which spilled a large quantity of raw cotton, drawing, over time, all of the water out of the box. Nauman's *Untitled* (*Steel Beam*) was a work with an even more explicit duration. It consisted of a long I-section beam (such as might be used in the construction of the warehouse in which it was displayed); attached to this was a tape player with a recorded loop of a voice repeating the words 'steel beam' – or it could quite as easily have been an exhortation to 'steal beam'. It wasn't clear.

There were other works, and like the critics we could continue to divide them into formal categories. However, if the critics agreed about the great formal diversity in the show, they were agreed that it was also characterised by transience. Some works were, as we have seen, contingent on their surroundings. Others were presented as if in a state of decay, or at least disarray. Still others (like those of Anselmo

and Zorio) were very obviously in a state of evolution. The critic Max Kozloff therefore began his *Artforum* review by imagining the works' removal at the end of the exhibition. 'Instead of being dismantled, unhooked, dollied and crated', he wrote, 'these sculptures will have to be rolled up, swept into a pile, chipped and chiselled from a corner, and scraped and scrubbed away from a wall.' He went on to say that the works as exhibited were characterised for the most part by the absence of 'formal prejudice', by which he seemed to mean that their forms were not conceived in advance.[10] This idea, not surprisingly owing much to Morris's 'Anti Form' was an exaggeration of the actual condition of the sculptures on show, most of which were obviously thought of in advance. But such ideas were strongly stated in the critical discourse around the show. Therefore, if form was no longer at issue, what was left according to Philip Leider, Kozloff's editor at *Artforum*, was an investigation into the 'properties of materials'.[11]

Nine at Leo Castelli had strong material presence, and as the critics noted, it encouraged both physical and phenomenological responses, responses that in other words were to do with being there. The visitor was clearly encouraged to think about process: the physical acts of splashing lead, or scraping away part of the wall, or rearranging a piece of rubber, of the movement of moisture through an absorbent material. Many of the works also seemed to provoke questions around the immediate conditions of viewing. Works encroached on the viewer's space or provided obstacles. Sculptural debris was everywhere, including under the visitor's feet, and it was hard to tell where the works ended and real space began. And the building itself, perhaps more than anything else, would have engendered an unusual physical response to the exhibition. I say much more about this elsewhere, but let me say here that by the standards of the Castelli Gallery's usual premises, an elegant town house near the Metropolitan Museum, the warehouse was not a nice place. It was unheated – significantly in the New York winter – and it was barely altered from its previous existence as a place of storage. The lighting and paintwork were both very crude. And for the gallery's usual clientele, the opportunity to visit a crumbling neighbourhood on the fringes of Harlem would not have been exactly welcomed. If the show encouraged a physical, visceral response in these ways, this physicality was nevertheless understandable in the orbit of dematerialization. The critics were agreed that transience was the key term: what the show presented was a spectacle of transience, a spectacle, as it were, of material on the point of dematerializing.

However, there are stranger ways in which the materiality of the warehouse show was at issue, ways which were not easily accountable in terms of any contemporary theory. I am fairly certain, to begin with, that almost nobody visited the show, apart from the participating artists and a few critics. The spectacle of transience was not therefore widely perceived. Neither were phenomenological questions at issue in the critical discourse around the show. Critics described it as if it were the most natural thing in the world that an exhibition take place in a freezing, disused warehouse. But more curious is the unreliability of factual data, such that it is hard to say with authority what, if anything, actually happened. The dates of the exhibition vary by

up to four months. Most, including Morris's own account, favour January 1969, when all the exhibition reviews make clear that it happened at the beginning of the previous month. The catalogue to Morris's 1995 retrospective at Paris, however, describes it as taking place between February and April 1969, impossible as far as I understand it, in that Morris's own show occupied the warehouse in March. There is also confusion as to which artists actually exhibited: an account published in 1989 wrongly includes Claes Oldenburg in the list of participants (the writer was presumably thinking of Morris's essay 'Anti Form', thought by some critics to supply the concept for the show, and which did cite Oldenburg).[12] The mistake is repeated in the Paris catalogue. And the confusion spreads as far as the exhibition's title, which has appeared variously as the 'Warehouse Show', 'The Castelli Warehouse Show', 'Nine at Castelli', and 'Nine in a Warehouse'.

Neither does reference to the exhibition appear in either the archives of the Leo Castelli Gallery, or the Robert Morris Archive housed at the SoHo branch of the Guggenheim Museum, and the artist is equally reluctant to confirm the exact details of the show, writing to me once that now 'only gossip and legend remain'; on the second occasion that I questioned him about it, this time in person, he seemed to enjoy the fact that the project seemed to have vanished altogether.[13] These archival confusions and absences indicate another kind of dematerialization perhaps, but not the kind intended by Lippard and Chandler. How we account for this is what I want to turn to now.

The exhibition at the Castelli warehouse is legible in terms of dematerialization. It left no lasting physical trace, it showed highly ephemeral work; it barely received any visitors, and its existence, like that of the majority of the work in Lippard's book, was principally as idea. We can read the exhibition through the texts that surround it, and in doing so we simply reiterate concepts such as dematerialization which are, as Lippard's work ultimately shows, applied in such a broad way as to be meaningless. There is no sense in simply reiterating the rhetoric of dematerialization. Such an approach also glosses over the subtler aspects of the exhibition's circumstances. It was clearly an ephemeral show: but the curator, and other anonymous persons, seem to have worked hard to conceal the exhibition from the public, not only through location, but in various ways by preventing the dissemination of information about it such that it becomes difficult to say whether or not it actually took place. These efforts seem to have taken place from the beginning. The critic John Perrault, who had written favourably and often about Morris in his weekly column in the *Village Voice*, wrote that he had been actively discouraged from visiting the show.

> I received word via the art world that it might be better if I did not write about this show. It was supposed to be some sort of a secret ... If this show was supposed to be secret then I should never have received the expensive poster announcement. The show should not have been open to the public, and perhaps the art should never have been made in the first place.[14]

The scenario Perrault outlines is more complex than the rhetoric of dematerializa-
tion can accommodate. This is not simply a discourse around materiality, or lack of
it, but many other things: coercion (attempted by the curator), threat (implied, to
the critic), mystery (perhaps contrived, surrounding the whole project), conceal-
ment (on the part of the organisers), fear (on the part of the critic), anger (likewise,
and forming his response to the show). None of these things is exactly precise, but
they are certainly present in the discourse around the exhibition, and they are not
accounted for by either the concept of dematerialization or Morris's concept of
Anti Form – both of which are theories which account for a process without speci-
fying an end point. There is something else going on.

I think this something else is myth. Morris's statement about the history of the
show, 'now only gossip and legend remain', indicates its presence, describing a trans-
formation from a material reality to immaterial narrative. Such narratives are a
striking feature of Lippard's book *Six Years*, although it is not one she appears to
recognise. It contains countless stories, many of them very good, from the account of
John Latham's literal distillation of Clement Greenberg's art criticism, to Walter de
Maria's imagined 'art yard' in which an invited audience in evening dress witness a
great digging of holes using earth-moving equipment, to Keith Arnatt's burial of his
students from Manchester Art School on a Lancashire beach: there are hundreds
more. In some cases the narratives purport to describe real events; in others the
events are clearly imaginary or impossible; in many, the distinction is hard to make.[15]

The condition of this material is mythical, myth being a form of expression that
may include narrative, but differs from it in its relationship to events in the real
world. Its intent – if we can speak of intent at all – is to say something about the
world that can be believed to be true. The consumer of myth is supposed to accept
some intrinsic relationship between the narrative and the world, whether in terms
of the reporting of actually occurring events, or in the iteration of some cultural fact
or character which is supposed to be true. Theodor Adorno and Max Horkheimer
made precisely this point in their famous critique of the Enlightenment, writing
that 'myth intended report, naming, the narration of the beginning; but also pre-
sentation, confirmation, explanation; a tendency that grew stronger with the
recording and collection of myths'.[16]

Myth in these terms is a cultural form that accounts for the world in terms of
both the recording of events, and the iteration of belief. It is at the same time a form
whose relationship with reality is compromised, in that the things it accounts for
are (traditionally) in an unrecoverably distant past, and are themselves question-
able: Greek myths for example invariably have recourse to the fantastic. For these
reasons, Adorno and Horkheimer took myth as their starting point for their cri-
tique of the Enlightenment, for it represents for them everything that the
Enlightenment is not. Myths speak of magic, the impossible, the unknowable, the
irrational. Their origins are furthermore obscure, so we cannot attribute them with
clarity to one or another author. For these reasons, Adorno and Horkheimer wrote
of the 'mythic terror feared by the Enlightenment'.[17] They went on, as is well

known, to argue that myth itself was a product of Enlightenment thought, and that it remained strongly present in it, albeit in a repressed form. Freud's interest in myth is comparable: myths for him represented timeless models for the irrational (and by extension therefore, anti-Enlightenment) behaviours of his patients. And Roland Barthes writing in the mid-1950s returned to the idea of myth for similar reasons, to effect a critique of humanist thought. Myth, he wrote famously, was a type of speech: it was everywhere, in everyone's language and other modes of communication, revealed through the tools of semiology. The world was not therefore intelligible rationally in the way it was supposed to be; it was founded on myth.[18]

What I am suggesting here is that loss of materiality in art seems to be accompanied by mythologisation, and *Nine at Leo Castelli* seems to me a prime example. At the same time as it was an exhibition of highly ephemeral art, it was an exhibition that generates all kinds of narratives to explain its origin and purpose. The apparent rationality of purpose suggested by Morris's writings, and indeed the project of dematerialization, is perhaps not so rational after all. Sol LeWitt made precisely this point in 1969. 'Conceptual Artists', he wrote in 'Sentences on Conceptual Art', 'are mystics rather than rationalists. They leap to conclusions that logic cannot reach.'[19] This was not the first time LeWitt had connected his dematerialized art practice and irrationality, but it is a point that Lippard and Chandler underplayed. Perhaps the irrational held no appeal for them at this point.

If we make this connection between dematerialization and myth, it becomes clear that myth had been present in American and European art for some time, without being acknowledged to any great extent. In the remainder of this chapter, I want to show a few of the forms in which myth was present in so-called dematerialized art. These forms can be divided roughly into two categories: I discuss first of all a few examples of art events in which – as at *Nine at Leo Castelli* – the materiality of the event is confused, or put in doubt by myth, although myth in these cases is an obscure and apparently unintended consequence of events. I then discuss two cases where myth is very explicitly at issue.

In 1965 the artist Allan Kaprow showed that as an artist, it might be more effective to leave the materiality of one's activities in doubt. He published a book that year which documented, impressionistically rather than systematically, his activities during the previous five years. The book, *Assemblages, Environments and Happenings*, underlined his belief that art could now be made out of anything, could be done by anybody, and most importantly for the present discussion, could be done anywhere.[20] Kaprow is best associated with 'happenings', a term which in the artist's original sense meant a form of performance generated by specific instructions, but rarely with any specific outcome in mind. Kaprow's first published essay on the subject opened as follows:

> Everybody is crowded into a downtown loft, milling about like at an opening. It's hot. There are lots of big cartons sitting all over the place. One by one they start to move, sliding and careering drunkenly in every direction, lunging into one

another, accompanied by loud breathing sounds over four loudspeakers. Now it's winter and cold and it's dark, and all around little blue lights go on and off at their own speed while three large gunnysack constructions drag an enormous pile of ice and stones over bumps, losing most of it, and blankets keep falling over everything from the ceiling. A hundred iron barrels and gallon wine jugs hanging on ropes swing back and forth, crashing like church bells, spewing glass all over. Suddenly mushy shapes pop up from the floor and painters slash at curtains dripping with action. A wall of trees tied with coloured rags advances on the crowd, scattering everybody, forcing them to leave. There are muslin telephone booths for all with a record player or microphone that tunes you in to everybody else. Coughing, you breathe in noxious fumes, or the smell of hospitals and lemon juice. A nude girl runs after the racing pool of a searchlight, throwing spinach greens into it.[21]

What is curious about this account is the fact that it does not really refer to a real event. It could do so: the actions that Kaprow cited were a mixture from happenings that did take place, but the mixture itself is fictional. Kaprow was not specific about time or place, and the actions he refers to were described impressionistically, as if one could substitute an event for any other. 'You breathe in noxious fumes, or the smell of hospitals and lemon juice', the conjunction 'or' being of crucial importance. Hospitals or lemon juice: take your pick, it is the fact of smell that counts.

In fact Kaprow was rarely specific about his activities, preferring the mythological narrative to reportage. The remainder of the book continued in the same vein, Kaprow writing about events in such a way that it is impossible to say exactly what happened and where. There was relentless self-promotion, too, contributing to a more obvious mythologisation, of the self. Kaprow's contribution to a group show at the Martha Jackson Gallery, in which he filled a yard full of used car tyres appears in image in the book under construction, with the artist in the middle of the installation, swinging tyres about. The image was reproduced in the book alongside one of Hans Namuth's famous photographs of Jackson Pollock at work, flinging paint on a canvas outstretched on his studio floor. The inference is clear enough: we are to regard Kaprow's environmental work in the same terms as Pollock, an artist whose mythical status was by 1965 assured (indeed Kaprow had contributed to the formation of the myth with the publication of his highly regarded essay on Pollock).[22]

Why should he do this? He could have described an actual happening. In much the same way, Morris could have been specific about the warehouse project, ensuring that events were adequately documented, and the critical discourse around the show was controlled: he most effectively foreclosed discussion around other forms of his art, Minimal Art in particular. Is there in both these cases a value in myth? In relation to events, one increases their value the less specific one is about their materiality. The rhetoric of dematerialization declares the value of art to be in the idea rather than the execution, but it is not hard to see that those events with a possible actual realisation have greater value than those with no possible execution.

In this way, myth extends the value of dematerialization: it adds to the art of idea the possibility of realisation.

We can illustrate this idea with an example from a 1969 exhibition. That year several exhibitions took place in which the principal subject was new sculpture, but its material existence was left deliberately uncertain. Lucy Lippard was involved in one of these, and was herself responsible for the realisation of works ostensibly by other artists. Reviewing the show, *557,087* (the title referred to the number of inhabitants of Seattle, the first location on a tour or three cities. The second version at Vancouver was titled '955,000', the third, at Buenos Aires '2,972,453' for the same reasons), Peter Plagens wrote 'there is a total style to the show, a style so pervasive as to suggest that Lucy Lippard is the artist and that her medium is other artists'.[23] One of the ways in which the show's material existence was made ambiguous was through the catalogue, which took the form of a series of randomly ordered file cards, about a hundred in total, each one referring to a participating artist, or some other aspect of the show. Lippard requested that each artist fill out a card with details of a project, either corresponding to something that was exhibited, or something that existed only as a project. This catalogue form was common to the three exhibitions Lippard organised, as well as the various instalments of *When Attitudes Become Form*, and the closely related *Op Losse Schroeven*. At the latter, the catalogue was a mixture of projects, some of which were clearly realised according to plan, while others were outlandish. Richard Serra proposed, for example, that an unspecified quantity of molten lead be dropped from an aircraft travelling at an altitude of between fifteen and twenty thousand feet. The lead would then be dropped, over soft ground or water so that it did not shatter once it had solidified, and the resultant object be exhibited as a sculpture. How exactly one would melt lead in an aircraft, in safety, at altitude was not a problem that greatly concerned the artist or the curators, for there was little question of the project ever being realised: nevertheless, it was exhibited, without explanation, in project form in the catalogue along with many projects which were realised according to plan.

Serra's project was typical of many at the same show, and of the projects that appeared at the two European shows. It existed on one level simply as a project, an idea, an example of straightforwardly dematerialized art. But once the reader understood that Serra's project was part of a continuum, so to speak, of realised projects, and unrealised ones, it took on a different character: the question it seemed to pose was not simply of the order of what it would be like, but 'could it be done?', or even 'had it been done?' There is a desire here, perhaps multi-authored, to write things into existence, to start rumour, to create myth.

In Kaprow, and in this project of Serra's, if there is myth in play, it is in some ways a secondary part of the art. If mythologisation occurs, then so much the better perhaps, but it is not everything. The final remarks I make about myth concern the use of myth in a much more explicit way. Morris, perhaps after reading the mysterious reports of *Nine at Leo Castelli* – I speculate here – began to make myth an explicit part of his writing. His 1971 essay, 'The Art of Existence: Three

Extra-Visual Artists', was an ironic piece of self-mythologisation, although the actions it described were so plausible, and the figure of Morris that appeared in the essay so close to the Morris described by critics, that the irony was lost on many readers. It described the work of three non-existent artists, whose identities became progressively more extravagant. The third artist, 'Robert Dayton' – a producer of gases with a variety of aesthetic not to say phenomenological effects – was 'a fairly unnerving personality', Morris wrote.

> He keeps his head shaved which seems to accentuate the deep scars on his face and neck. He also wears a monocle around his neck which he occasionally peers through if he needs to see a detail or read a gauge. He seems to enjoy playing with a certain sinister ambience that surrounds the work. When I was with him he frequently squinted at me through the thick glass of the monocle and leeringly compared the venting systems of Buchenwald and Belsen.[24]

What is happening here has elements of self-parody that draw us back to the exhibition at the warehouse, and may provide, finally, a way of accounting for it. 'The Art of Existence' is on one level a piece of work that operated, like the activities of Lippard and others I have mentioned, between truth and fiction. There was myth at play here, the desire to create myths, the desire to make something believable out of fiction. The relationship with reality is one aspect of the project where it coincided with ideas of myth. It further resembled myth in the way in which it attempted to speak on behalf of a community or group: it fixed, or attempted to fix, Morris's position at the heart of this group, establishing him as a leader, responsible for the discovery of new artists and artistic tendencies. But it was ultimately parodic in form. About the time of the exhibition at the warehouse, Morris, as curator, and someone who had written extensively about sculpture, was presented in criticism as central to the New York arts scene: 'Morris presents "Anti Form"' was the subtitle of one review. This fact was resented by other artists, in particular those chosen for inclusion at the warehouse show: there are published remarks by Serra to this effect, and several instances in archived material where Alan Saret contested the value of such concepts as Anti Form. There was a widely held perception of Morris as a thief of other artists' ideas, a reputation with some durability: Roberta Smith described him as an 'artistic kleptomaniac' as late as 1991, an artist with a 'hypersensitive nose for the next new thing'.[25] Morris's discovery of three imaginary artists was one way of countering this, through ironic self-mythologisation. Morris's deeply serious investigation into Anti Form sculpture, and his extension of this into the curating of the Castelli warehouse show, both thus collapse into myth.

Such self-mythologisation was of course even clearer in Beuys. At the beginning of the book I stated that Beuys was for the most part outside of my concern, and the majority of his activities are outside the chronological and conceptual frame of the project. But Willoughby Sharp's interview with Beuys, conducted in 1969 and published in *Artforum* would have been widely read by American artists, and Sharp

ensured that it referenced contemporary sculptural debate.[26] As I noted in chapter 1, there was some discussion in the interview about Minimalism, and the extent to which Beuys's activities related (Beuys thought they did not). There was discussion too about Morris, his and Beuys's use of felt, their meeting in Düsseldorf in the early 1960s, and the Castelli warehouse show, to which Beuys had been invited. The interview began however with a short text by Sharp, followed by Sharp's reproduction of what he called 'Beuys's "official" biography.' It is not entirely clear who is the author of this, interviewer or interviewee, but what it certainly represents is a fictionalisation of the artist's life. 'Beuys's biography', wrote Sharp, 'indicates the scope of this extraordinarily prolific artist's life.'

> 1921 Exhibition of a wound patched with tape, Kleve. 1922 Exhibition of dairy cows near Kleve. 1923 Exhibition of a mustache cup (contents: coffee with egg). 1924 Exhibition of heathen children, Kleve. 1925 Documentation 'Beuys as Exhibitor', Kleve. 1926 Exhibition of a stag guide, Kleve. 1927 Exhibition of radiation, Kleve. 1928 Exhibition of a trench, Kleve.[27]

And so on through cryptic references to the artist's war record, to the actual occurrences of art exhibitions in the 1960s, concluding with '1969 Beuys pleads guilty in the case of the snow fall from February 15th to 20th'. Like Morris's later essay, this was a fictionalised biography. The events it described are plausible enough (Beuys's birth, apparently by caesarean section, his involvement in the war, his activities as an artist, the severe snowfall of early 1969), but Beuys declared most of them, a little provocatively, to be 'exhibitions', underlining the pronouncements he had already made to the effect that everything in the world was legible as sculpture, and everybody in the world was an artist. At the same time as Sharp's interview, Beuys was refining the persona he projected in public, appearing at exhibitions such as *When Attitudes Become Form* in the clothes that were becoming a trademark – the hat, the long coat, the jeans – and reiterating through performance and sculpture the narrative of his life with special emphasis on the aeroplane crash and his supposed rescue by nomadic tribesmen. The traces of felt and fat in Beuys's exhibited work at this time, as has been noted elsewhere, were references to the materials that the tribesmen allegedly used to save him, rubbing fat into his body to warm it, then wrapping him in felt to keep him warm. The reiteration of this story, in text, performance, and the sculptural object that resulted from such performance amounted to the making of a creation myth: a narrative from which Beuys emerged fully formed as an artist.

Morris's purpose in 'Three Extra-Visual Artists' was less grand than this, but the essay is still more than a simple narrative. It was grounded in the real world: Morris was, as he described, an artist, he had a track record by 1971 of involving himself as a curator with other artists, and the invisible art he described – as we have seen in this chapter – was perfectly plausible according to the rhetoric of dematerialization. Being so grounded, Morris asked the reader to believe something, to accept that something is true about him and his position vis-à-vis the art world of

the time. Morris's purpose was ultimately subversive, using myth to challenge the way his activities were perceived by his contemporaries. But his use of myth is typical of the art of the times, in which material practices are encouraged to degenerate through myth: sculpture as it were turns into narrative about sculpture. The irrational appears in this way and in doing so disrupts – albeit perhaps temporarily – the conventional means of transacting and valuing art.

Dematerialization was only lightly theorised by Lippard and Chandler in 1968. As I have argued here, their concept involved much more than the loss on materiality in art, and was accompanied by mythologisation, about art events, about the existence of objects, about the artists themselves. This was for the most part quite deliberate. This most well-educated and literate generation of artists were well aware, through the example of Jackson Pollock, of the value of myth, and the means by which myths could be created. And one way or another, most of the artists whose work I describe in the book were involved in some way with myth. I have said much about Morris again, and Beuys, and Kaprow. I could have said more about Smithson in this context, an artist whose work from 1970 onwards comes to illustrate myths associated with the geographical sites in which he worked. His best-known work, *Spiral Jetty*, took its spiral form from a legend held around Great Salt Lake that the lake was a drain for the Pacific Ocean, a legend that explained the appearance of spiral disturbances in the water. Smithson was a keen self-mythologiser too, as a contemporary interview indicates: speaking to Paul Cummings for the Archives of American Art, Smithson suggested that all American Smithsons might be related to the founder of the Smithsonian Institute, an institution that not surprisingly fascinated him.[28] The principal idea in this chapter has been the dissolution of materiality in sculpture under pressure from myth. In the next chapter, I keep up the pressure on materiality by discussing questions of space: such questions, as we shall see, make sculpture not much more than a function of its surroundings.

Notes

1 Bruce Altshuler, *The Avant-Garde in Exhibition* (New York, Harry N. Abrams, 1994). I refer especially to the chapter on 1960s exhibitions, 'Dematerialization: The Voice of the Sixties'.

2 Lucy Lippard and John Chandler, 'The Dematerialization of Art', *Art International*, 12:2 (February 1968), 31–2.

3 Pepe Karmel, 'Robert Morris: Formal Disclosures', *Art in America*, 83:6 (June 1995), 94.

4 Robert Barry, 'Interview with Arthur R. Rose', *Arts Magazine*, 43:4 (February 1969), 22.

5 Robert Morris, proposal to Whitney Museum for *Money*, New York, Robert Morris Archive, Solomon R. Guggenheim Museum.

6 Lucy Lippard, *Six Years: The Dematerialization of the Art Object from 1966 to 1972* (New York, Praeger, 1973), pp. 256–8.

7 Douglas Crimp, 'Redefining Site-Specificity', *Richard Serra: Sculpture* (New York, Museum of Modern Art, 1986), p. 40.

8 Lippard, *Six Years*.

9 Anna Chave, 'Minimalism and the Rhetoric of Power', *Arts Magazine*, 64:5 (January 1990), 44–63.

10 Max Kozloff, '9 in a Warehouse: An Attack on the Status of the Object', *Artforum*, 7:6 (February 1969), 38–42.

11 Philip Leider, 'The Properties of Materials: In the Shadow of Robert Morris', *New York Times* (22 December 1968), II, 31. The phrase is actually a quotation from 'Anti Form'.

12 Robert Morris, 'Anti Form', *Artforum*, 6:8 (April 1968), 33–5.

13 Robert Morris, unpublished letter to the author (June 1996), and conversation with the author, Leeds (July 1997).

14 John Perrault, 'A Test', *Village Voice* (19 December 1968), 19.

15 Lippard, *Six Years*, pp. 14–16, 50–1, 54–5.

16 Theodor Adorno and Max Horkheimer, *Dialectic of Enlightenment*, trans. John Cumming (London, Verso, 1979), p. 8.

17 Adorno and Horkheimer, *Dialectic*, p. 29.

18 Roland Barthes, *Mythologies*, tr. A. Lavers (London, Jonathan Cape, 1972).

19 Sol LeWitt, 'Sentences on Conceptual Art', in Lippard, *Six Years*, pp. 75–6.

20 Allan Kaprow, *Assemblages, Environments and Happenings* (New York, Harry N. Abrams, 1965).

21 Allan Kaprow, 'Happenings in the New York Scene' (1961), in Jeff Kelley (ed.), *Allan Kaprow: Essays on the Blurring of Art and Life* (Berkeley and Los Angeles, University of California Press, 1993), p. 15.

22 Allan Kaprow, 'The Legacy of Jackson Pollock', *Art News*, 57 (October 1958), 24–5, 55–7.

23 Peter Plagens, '557,087 at the Seattle Art Museum', *Artforum*, 8:3 (November 1969), 64–7.

24 Robert Morris, 'The Art of Existence: Three Extra-Visual Artists: Works in Process', *Artforum*, 9:5 (January 1971), 28–33.

25 Roberta Smith, 'A Hypersensitive Nose for the Next New Thing', *New York Times* (20 January 1991), II, 33.

26 Willoughby Sharp, 'Interview with Joseph Beuys', *Artforum*, 8:3 (November 1969), 40–7.

27 Sharp, 'Beuys', 40–1.

28 Paul Cummings, 'Interview with Robert Smithson for the Archives of American Art/Smithsonian Institute', in Nancy Holt (ed.), *The Writings of Robert Smithson* (New York, New York University Press, 1979), p. 142.

Space

Thus far I have accounted for late-1960s sculpture in terms of such discrete concepts as 'Anti Form' and 'Dematerialization', concepts which had clear material expression as much as expression in the form of published critical texts. In each case, I have tried to introduce new material work along with discussion of each concept, although these associations may be problematical in absolute terms. This chapter is different in two main respects: its subject, the nature of exhibition space for the new forms of sculpture, is not represented by any contemporaneous critical text, and neither does this subject help introduce any new work. I return to some material already covered in the book, such as *Nine at Leo Castelli*, the exhibition Robert Morris curated at the Castelli warehouse, and also some of Allan Kaprow's work. Fortunately for the reader, I do make a new argument based on this material. Put simply, I argue that the new forms of sculpture are accompanied by some new ideas about exhibition space; drawing on existing theorisations of space, I suggest that this is a shift from an aesthetic of leisure, to an aesthetic of work, *Nine at Leo Castelli* being one of the clearest material expressions of it.

Space has already been an issue in this book. In chapter 1, the first material I considered in depth was the critical response to the exhibition *American Sculpture of the Sixties*, held at the Los Angeles County Museum of Art in 1967. The critical assessments of it varied, but all the critics were agreed, whatever their final opinion of the show, that the building was problematical as an exhibition environment. A good deal of the criticism described the exhibition as a form of aesthetic warfare between the building and its surroundings (Kurt Von Meier: 'the only way to get even would have been to install a Boeing 727 in place of the silly little fountain out front, and one of those giant yellow earth movers in the Simon Sculpture Plaza').[1] The critics' objections were, I speculated, important, as they help identify two different forms of taste in sculpture, one (represented by the museum) which maintained sculpture essentially as a form of decoration, and another (represented by most of the critics) which saw sculpture as a much more serious, critical practice.

The fact that the critics objected so strongly to the building also indicates that the new forms of sculpture were highly dependent on their surroundings, even if this was implied rather than made explicit in the critical discourse around them. Morris stated in the second of his 'Notes on Sculpture' that sculpture had become simply 'one of the terms' in the new aesthetic, and here in the literature

around *American Sculpture of the Sixties* was some discussion about the nature of those other terms.[2] What I want to do here is investigate a little further what were the nature of the objections to the environment, and some of the precedents for those feelings. My contention, if it needs restating, is that the critics, mostly East Coast-based or working for East Coast journals, were increasingly of the mind that apprehending sculpture was hard work, and that exhibition conditions should reflect this. This meant a corresponding devaluing, or indeed rejection, of the idea of looking at sculpture as a leisure activity. Work, in other words, replaces leisure.

The Los Angeles County Museum of Art was designed by William Pereira Associates, and built at a cost of $11.5 million, a substantial figure reflecting the size and the opulence of the building. As stated elsewhere, the architects were already known for commercial buildings on the West Coast, rather than prestigious arts projects such as this, and there may well have been a feeling amongst the critics that they were an inappropriate practice for the job. The controversy around a later project in San Francisco, the Transamerica Building, seems to indicate a history of conflict between the practice and a sophisticated, intelligent public in the area where they built.[3] The Transamerica Building, completed in 1972, was an office tower built in the form of a very tall, very slender pyramid. Known pejoratively by some as 'Pereira's prick', it remains one of the most visible buildings in San Francisco's central business district, and although built without contravening existing planning regulations, its height and prominence provoked calls from well-organised groups for a moratorium on any new building over six stories in the city. A referendum, ultimately unsuccessful, was held on the matter, although the episode did have a lasting impact on the city's planning policy.[4]

Whether or not the Transamerica episode is representative of the architects' relations with their public, what is certainly true is that their buildings were highly decorative, both in terms of form and materials. A small project from 1963, a library in Santa Fe, made use of simple materials but produced a very rich, textured environment, with prominent decorative features including a fireplace and a patio: it was noticeably more decorative than other comparable projects.[5] As discussed in chapter 1, the Los Angeles County Museum was an extremely complex environment, not in terms of the basic forms of the building, the three pavilions, but the non-structural elements, the domed walkways, the lanterns, the ornamental moat, the little pedestrian bridges, the fountains, the flagpoles, and so on. Against this background, sculpture was in danger of becoming merely another form of decoration.

This seems to have been at the heart of the criticism of the building. Some critics complained about its 'authoritarian' appearance, but a more common sentiment – if not always directly expressed – was that the environment corresponded too closely to a place of leisure, preventing any serious looking from taking place.[6] Of course in the most general terms, art has always been associated with leisure, and the first art galleries in the modern sense were royal collections housed in former palaces or

buildings that looked like them. The first purpose-built art galleries maintained
elements of this grand, but still domestic, style.[7] If this is a generally accepted pat-
tern, then it continues into the modern period. As Christof Grunenberg has
written, the first purpose-built gallery of modern art, the Museum of Modern Art
(MoMA) in New York, took the upper-class New York apartment as its reference
point for the design of its interior.[8] Designed by Philip Goodwin and Edward
Stone, and completed in 1938, the structure referenced the Bauhaus and modern
European industrial buildings in its exterior, and there were spectacular, public
aspects to this. But the interiors were, by contrast, intimate and tasteful, repro-
ducing in some measure the sophisticated domestic taste of the museum's
founders.[9] The ceilings were only 12 ft to 14 ft in height, the layout of rooms was
varied, there were plenty of houseplants and comfortable chairs, and there were
receptionists available to answer questions about the art. More than one critic
noted the resemblance to a modern apartment on the building's opening.[10]
Grunenberg extends this to argue that it is not merely the form of the apartment
that the museum resembled, but a collector's apartment, and quotes Walter
Benjamin on the collector from his essay 'Paris in the 19th century'. The collector's
interior, Benjamin wrote,

> was the refuge of art. The collector dreamed that he was in a world which was not
> only far off in distance and time, but was also a better one in which, to be sure,
> people were just as poorly provided with what they needed in the world of
> everyday, but in which things were free from the bondage of being useful.[11]

These places, Benjamin's imaginary Paris, the early MoMA, and the Los Angeles
County Museum of Art, were all sites of leisure, and critics of the Los Angeles
show contended that such leisured environments were likely to circumscribe
sculpture's effectiveness as a critical practice. There were, however, types of exhibi-
tion space in which the aesthetic of work replaced that of leisure, and the critics of
American Sculpture of the Sixties had models of such spaces in mind when they
made their remarks. The most straightforward way to make a leisured space less so
is to make it less comfortable, and those critics were increasingly used to appre-
hending sculpture in galleries that had no place to sit, no plants, no decoration,
nothing in fact that would distract the viewer from the art. The artist and critic
Brian O'Doherty wrote about these places in the essay 'Inside the White Cube', the
title being his term for this kind of exhibition space. Synthesising his impressions
of various mid- and uptown New York galleries of the 1960s, he wrote that there
everything extraneous to the work of art was excluded, producing an attitude in the
spectator that was reverential, even devotional. 'The work of art', he wrote in a
famous passage,

> is isolated from everything that would detract from its own evaluation of itself ...
> Some of the sanctity of the church, the formality of the courtroom, the mystique
> of the experimental laboratory joins with chic design to produce a unique
> chamber of aesthetics.[12]

O'Doherty's gallery was a synthesis, and he wrote elsewhere that his description did not apply to any one gallery in particular.[13] But the Green, Dwan, and Fischbach galleries certainly had the characteristics of a 'chamber of aesthetics', as did to some extent Leo Castelli.[14] Certain public museums had also begun to adopt the style of the galleries, MoMA in the additions made by Philip Johnson in the early 1960s, and the new Whitney Museum of American Art by Marcel Breuer being good examples.[15] These places produced hard, utilitarian viewing conditions, and it rapidly became the dominant form of contemporary exhibition space, both in New York and elsewhere.

However much hard work it presupposed on the part of the viewer, the so-called 'white cube' space nevertheless assumed traditional relationships between the viewer and art objects. An art of 'dematerialized' stuff, of 'Anti Form', of undifferentiated matter implicitly questioned such relationships, and such art was frequently placed in different surroundings altogether. At the time of its production, questions of space were never adequately theorised, but what is clear in retrospect is that the new forms of art tended to be shown in spaces associated with work rather than leisure: old warehouses, office buildings, artists' studios, or galleries that increasingly looked like these places.

It is significant that one of the most discussed manifestations of so-called 'Anti Form', *Nine at Leo Castelli*, should appear in precisely such a place. I have already said a great deal about this exhibition, the temporary and fragile work it contained, the critical discourse around it, and Morris's rather mysterious involvement. But in some respects the most striking aspect of it – although almost completely absent from the criticism – was its location, an old textile warehouse at 103 West 108 St., New York. The warehouse itself was a plain, three-storey brick building erected in the late-nineteenth century. Built as a warehouse, it had retained this function, and to this end its interior surfaces were untreated, and no heating was installed. It was a bleak environment, a place of things rather than people, and when people were present, a place of physical labour, not leisure.

Its geographical situation is also striking: nearly 2 miles away from the main commercial galleries on West 57 St., and a similar distance from the museums on the Upper East Side, it was geographically isolated from any other art site. By the standards of the majority of the gallery-going public it was in a bad area. Two blocks south of Harlem, it was in a part of the city that had suffered wholesale structural and economic decline in recent years, losing perhaps a quarter of its population since the mid-1950s.[16] The continued existence of handsome apartment blocks on Central Park West was, and in fact remains, an unreliable indicator of the area's economic health. It was a very different kind of environment to Castelli's main premises, a handsome town house near the Metropolitan Museum, and it was a place which would have intimidated collectors such as Bob and Ethel Scull, among the gallery's best customers at the time.[17] *Nine at Leo Castelli* was extensively reviewed, and substantial claims for its importance have since been made.[18] Yet this literature rarely, if ever, treats the question of space: in contemporary

criticism it seemed the most natural thing in the world that this strange new sculp-
ture should inhabit the freezing, inaccessible space of the warehouse. And a great
many of the contemporary images of works by Morris, Richard Serra, Keith
Sonnier, and others were taken in the warehouse, so the assiduous reader comes to
recognise the untreated walls, the crudely divided spaces, the harsh lighting, the
unblanked sash windows.

The use of these former work spaces for art had a short history, beginning,
depending on how you define it, in the early 1960s in the United States. It has
since arguably become the dominant form of exhibition space for modern art.
During the 1970s in New York, a large number of modern commercial galleries
abandoned their traditional locations in the midtown commercial district and the
Upper East Side, and opened new premises around the lower end of Broadway, an
area of modest nineteenth-century warehouses and garment manufacture in
which artists had found homes and studios since the early 1950s. The buildings
they found there sometimes had elaborate cast-iron facades, but their interiors
were extremely plain, designed originally for storage or manufacture, not for
looking at. The practical advantages such spaces offered were partly economic, in
that they were very much cheaper than anything uptown (indeed art galleries
would traditionally locate themselves in the most expensive parts of the cities, to
be closer to their principal clients), but they would also offer much larger spaces
overall at a time when art objects themselves were getting bigger. Once galleries
such as Castelli and Sonnabend were established in SoHo, they were joined by
public institutions such as the Guggenheim Museum, which rented three floors of
a warehouse, and the New Museum of Contemporary Art.[19] Since the early 1970s,
art institutions worldwide have increasingly favoured the re-use of older build-
ings: the Fundació Antoni Tapies appropriates a late nineteenth-century pub-
lisher's office in Barcelona; the Tate Gallery Liverpool has occupied a large
section of the city's original dock complex; in London, the same institution has
selected a disused power station on the south bank of the Thames for its new
gallery of contemporary art.

The case for the re-use of older buildings has been stated in a number of ways,
and the ability to acquire a lot of flexible, enclosed space cheaply has clearly been
one of them. Public projects such as those developed by the Tate Gallery in the
United Kingdom have tended to emphasise the economic potential of such rede-
velopments. In a form of localised Keynesianism, they have argued that the rede-
velopment of older buildings as art galleries acts as an economic magnet,
encouraging economic growth in the immediate surroundings: one can, it is
argued, spend one's way out of a local recession. (New York's SoHo is clearly a
model in this respect, and indeed so successful that at the time of writing the
entire art community was in the process of moving to Chelsea in search of more
affordable space.)[20] And in virtually all Western countries, the disciplines of
architecture and planning now favour the re-use of older structures against
comprehensive redevelopment.

Such questions clearly have aesthetic and phenomenological dimensions. The 'chamber of aesthetics' imagined by O'Doherty was an environment that presupposed a form of work, but not the physical trial implicit in the use of former industrial spaces. The warehouse that Castelli rented on West 108 St. was anything but a 'chamber of aesthetics' – it was a warehouse, and looked like one (Figure 35). A temporary dividing wall, some lights and a coat of paint had been added, but the space was otherwise unaltered from its original condition. These facts alone would have distracted the visitor accustomed to more comfortable surroundings. The more sensitive ones suffered in the cold, and wondered nervously about the possibility (or lack thereof) of hailing a taxi home in this part of the city.[21] These distractions were not only a feature of the Castelli warehouse, but of other comparable art spaces, even those which were much more extensively refurbished. All the spaces mentioned above have made a feature of their past existence: walls remain bare, structural features such as columns remain in place, and a giant turbine remains as a feature in the new London gallery for the Tate. That the previous existence of such buildings should remain so physically present is significant: it is in marked contrast to popular practice in commercial architecture where an entirely new building is often created behind a retained facade, and it is a fact not accounted for in discourses of regeneration, which focus on perceived economic change.

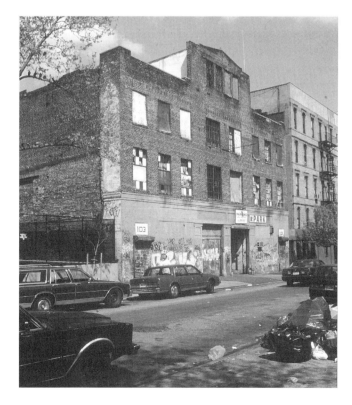

35 The former Leo Castelli warehouse at 103 West 108 St., New York, in 1996.

There are therefore aesthetic questions in relation to the re-use of former indus-
trial spaces. A useful account of the changing character of exhibition space appears
in an essay by Reesa Greenberg, 'The Exhibition Redistributed: The Case For
Reassessing Space', first published in 1993.[22] Greenberg describes in some detail
the migration of New York galleries from uptown (which is to say, roughly, 57 St. or
above) to downtown (roughly below 30 St.), and the related adoption of industrial
types of space for the showing of art. This, she argues, rapidly became the domi-
nant type of space for showing contemporary art, an assertion which would seem to
be confirmed by the decision of institutions such as the Guggenheim to set up in a
SoHo warehouse. She continues, arguing that the industrial aesthetic became so
important that even galleries that remained in midtown – she gives the examples of
Marion Goodman and Pace – imported concrete floors and other aspects of the
warehouse style to their office building sites. Greenberg accounts for these changes
in the New York art scene by quoting Paula Cooper, a gallery owner who, in 1968,
was among the first to establish a commercial gallery in lower Manhattan. Cooper
made statements to the effect that her move was a reaction to the perceived superfi-
ciality of the uptown arts scene, which as she perceived it had more to do with an
upper-class social life than an interest in art. Moving downtown was a way of
putting distance between the gallery and these superfluous elements. And Cooper
liked the fact that artists tended to work and live downtown, so that her gallery
would be physically closer to them. The experience of visiting her gallery would
therefore be, according to Greenberg, more 'alive'.[23]

To put it another way, the experience of visiting the Cooper Gallery, and others
like it was analogous to visiting an artist's studio rather than a collector's drawing
room. They had about them in other words an aesthetic of work: one had to work
hard to get to them in the first place, entering parts of an urban environment unac-
customed to receiving gallery-goers. There might be unfamiliar languages or cul-
tures to negotiate along the way, such as the Spanish which predominates in the
streets around the Castelli Gallery's warehouse. Entering the space might also
require work. Such buildings, she remarked, often seemed abandoned, such that
'uninitiated visitors felt like trespassers or explorers'.[24] And once inside the space,
the work continued: the spaces themselves maintained strong traces of their past
existence, and galleries often refused to install heating or seating, in other words
anything that might encourage leisured viewing. Along with this, Greenberg notes,
came the emergence of places in certain museums for the reading of material about
the art on display: 'the pleasure of sitting and looking at art has been replaced by the
task of reading about it. The work ethic prevails.'[25]

So the new spaces not only closely resembled the sites of work that they once
were, but they involved work on the part of the viewer in visiting them at all, a spe-
cial effort to reach them, to apprehend the art they contain, and to read about it.
The emphasis on work rather than leisure is quite consistent, for example, with the
emphasis on process in writings about sculpture. Let us turn once again to 'Anti
Form': in that essay, Robert Morris saw Minimal Art as an exhausted practice,

because it remained concerned above all with the finished object.[26] It was in danger, he wrote, of becoming a new classicism, in other words a practice of repeating a set of validated forms. Implicit in this is an exasperation with the elevation of form itself, and the leisured contemplation that it implied. Morris's solution, as we have seen, was the adoption of working methods which emphasised the processes involved in making sculpture, such as the use of flexible materials which impelled the viewer to think about their manipulation. To put this another way, 'Anti Form' sought to replace an aesthetic of leisure with an aesthetic of work: it was not the finished object that matters any more, but process. And as part of this, Morris discussed various artistic processes, writing approvingly of Pollock's dripping and splattering of paint.

Although 'Anti Form' illustrated one of Pollock's works (*One*) rather than the artist at work, the image of Pollock in his studio was certainly imaginatively present. It was the act of making that Morris wished to emphasise, the work, rather than the finished piece as an object of contemplation. Morris underlined this idea in the essay which followed 'Anti Form', 'Notes on Sculpture Part 4: Beyond Objects'.[27] A photograph of Pollock in the act of painting, one of a series by Hans Namuth, was reproduced in the essay, and the argument about process restated, this time extended to question the need for objects altogether. This argument seemed to be underlined by a photograph of a new work by Morris, *Threadwaste*, shown amongst the debris of the artist's studio. The piece, a highly indeterminate amalgam of several hundred pounds of cotton thread, copper wire, and asphalt, appeared surrounded by a paint can, various tools, spatterings of paint, and the skirting board of the room. It was, as I noted in the previous chapter, hard to say where the work ended and its environment began. It was no accident that Morris chose to show the piece for the first time in this way, for among the points he wanted to make about it, was that it was supposed to be a work about work, not something finished. The reclamation of the spaces of physical labour for art is clearly consistent with this idea. Looking at Morris's image of *Threadwaste*, it is also clear that such spaces were supposed to replicate the space of artistic labour, the studio.

If the use of the warehouse was ideologically consistent with the project of Anti Form, we might nevertheless expect some commentary from critics on the suitability of such places for showing art. But such expressions featured nowhere in the critical response to the show, whatever a writer like Douglas Crimp might want to say about the matter retrospectively.[28] It seemed, in other words, entirely natural that sculpture should be seen in a reclaimed industrial environment. I think the reason for this is that the likely public for Morris's activities in the Castelli warehouse was already accustomed to such places. However difficult they may have been to find, they were already quite used to having to find them, and however uncomfortable they were when they got there, they were used to the idea. A good deal of this public were artists anyway, and already inhabited such places, at least

during working hours. There were therefore precedents, of which I will mention three.

Some of the visitors to the Castelli warehouse may have been reminded of a much earlier project by Claes Oldenburg, the *Store*, made in 1961. The project, like the warehouse, involved the use of a space meant explictly for work rather than art, in this case a small shop at 197 East 2 St., New York. Oldenburg wrote in his journal of his desire to 'actually make a store, 14 St. or 6 Ave butchershop etc. The whole store an apotheosis! A sad happy hi(stor)ical store. A happy contemporary store too?'[29] Oldenburg's desires to have the project inhabit the ordinary world of work, and to have it geographically situated in one of New York's less salubrious areas, are both things that provide a possible rationale for Castelli's later use of the warehouse. Oldenburg's purpose was, even at this stage, however, much more legibly ironic, a desire that was confirmed in the project's realisation. Naming the store 'The Ray Gun Manufacturing Co.', Oldenburg opened it to the public and sold laughably crude replicas of everyday items (food, clothing, and so on) made from found materials. Much visited by artists, the *Store* remained open a month longer than originally envisaged.[30]

Allan Kaprow was another artist who made use of unconventional spaces in the early 1960s, and was, as we have seen, engaged with contemporary debate about sculpture. In the last chapter, I quoted an imaginary account of a 'happening' in a New York loft: nude girls, the smell of hospitals, and the rest.[31] Whether or not this event actually took place does not really matter, for what the piece communicates is the sense that already by 1961 there was in New York a public, however small, accustomed to strange events in former industrial spaces in marginal parts of the city.

Returning to Kaprow's book, *Assemblages, Environments and Happenings* (1965), we find plenty of evidence, albeit impressionistic, of a well-developed artistic culture in New York's marginal places. But Kaprow was never very specific about place: fonder of the expansive statement, he referred baldly to 'the street', 'the world', 'the city'; rather than anywhere identifiable, a lack of specificity which in chapter 5 I have discussed in terms of myth.[32] There is little sense in which location is considered in depth. The choice of place, one infers, has to do with two things: its availability, and its legibility as 'anywhere' (which is to say, not the art gallery). One instance, however, where place was more specific is in a series of photographs of an 'environment', installed by Kaprow at the Martha Jackson Gallery in the summer of 1961 (Figure 36). The occasion was a group show, *Situations and Environments*, the other contributors being Jim Dine, Claes Oldenburg, and Robert Whitman. Kaprow's contribution, called *Yard*, was arranged appropriately enough in the gallery's yard. It consisted of roughly 500 used car tyres of varying types and sizes, piled more or less at random, the results filling the courtyard to a depth of 3 ft to 4 ft. Amongst the tyres were two much more ambiguous objects: packages, roughly human-sized and shaped, poised upright and tied with string. It was in the words of one critic, 'Falstaff as staged by

36 Allan Kaprow, *Yard*, 1961.

Stanley Kubrick.'[33] Four pictures of the piece appear in the 1965 book, showing both the work under construction, and the completed work being experienced (which is to say, clambered over) by assorted visitors.

All of them are striking in the present context. In one of the early pictures, Kaprow glared out from the middle of the environment, pipe fixed in mouth; the tyres fill the frame. Immediately preceding was a photograph of Pollock at work, throwing paint on a horizontal canvas spread on the floor. Kaprow had already written about Pollock, describing with approval how his working methods seemed to open the way for an expansion of the possibilities of art, for it to take place anywhere and in any medium. The comparison is clearly made, for over the page, Kaprow was depicted similarly in action, throwing material, in this case a tyre, across the horizontal surface of the yard. I have already presented, through Morris, the idea of the recovery of work, of process being elevated above form. Here is more or less precisely the same thing seven years before Morris: indeed Kaprow subtitled this section of the book 'Recalling the Act', a phrase which resembles Morris's 'recovery of process'.[34]

Another kind of work is evident in the later photographs, the work expected of the participants. Two male visitors, dressed in suits, appeared tottering nervously among the tyres; one holding on to one of the upright objects for balance. It was clearly hard work maintaining one's dignity here, balancing among this unstable agglomeration of objects. The piece did not, on this evidence at any rate, encourage leisured contemplation, but instead sought a physical engagement on the part of the viewer. Neither was the work's immediate environment a particularly comfortable one. The *Art News* reviewer described it, rather grandly, as a 'patio', although the evidence of the photographs suggests that this was a marginal space not usually open to the public. We see the work enclosed by bare brick walls belonging to the backs of other buildings, while immediately outside we see a tangle of fire escapes and more bare brick walls. It is a typical back-street scene. This was not by any means an industrial space, but it is clearly secondary or marginal: a place of storage, refuse, escape. The title *Yard* – a word with connotations of leisure in American English – is nicely ironic.

Kaprow certainly deployed an aesthetic of work. Like Morris later on, he wanted to recover process, the physical act of making, and as a result had himself photographed endlessly in performance. He also wanted to make the audience work, making them physically uncomfortable and challenging their assumptions and expectations about their experience of art. But the spaces Kaprow used were highly variable: they tended to be marginal places, but they were not necessarily connected with labour, and they tended to change from one piece, or performance, to the next. For an example of a former industrial space that was used, and seen to be used on a more public basis, we could consider Andy Warhol's studio-cum-exhibition space, the 'Factory'. Until 1963, Warhol worked at his mother's apartment at the upper end of Lexington Avenue, where he also lived. In search of more space, he moved his operation into the first 'Factory' (his name, and one

which signals an allegiance to an aesthetic of work) in February 1963. The place was a disused hat factory on the fifth floor of a building which had been used for a mixture of warehousing and light industry; the address was 231 East 47 St., in an area close to the United Nations headquarters, and overshadowed by the Empire State building. It was therefore close to the established gallery infrastructure of the midtown office district, but it was an area dominated by industrial and commercial buildings. Despite the closeness of the midtown galleries, and the presence of the UN, this was not in any sense an area that encouraged a leisurely stroll. Warhol's space was a very large single room, measuring 100 ft by 40 ft. It had, like the Castelli warehouse later on, exposed brick walls and concrete floors, and the metal columns supporting the floors and ceiling were a major feature of the space. The main means of access was a freight lift. It was not, clearly, a space designed for the public, but in some respects this is what it became. Shortly after moving into the Factory, Warhol employed a young hairdresser to redesign it, a job which consisted mainly in painting it silver (in one account, Warhol wrote, 'Silver was the future, it was spacey – the astronauts ...')[35] The place quickly became the home for Warhol's entourage, a strange collection of would-be actors and actresses, prostitutes, and drug-dealers who assisted him with the making of his paintings and films. The Factory was not only the home of this group, but it was the place where all the work, including the films, was made, and the site – in numerous lurid accounts – of a more or less endless party through the 1960s. Visitors to the Factory certainly included many of the younger generation of artists, who like Warhol were regulars at the bar Max's Kansas City. Robert Smithson, for example, was photographed with Warhol at the Factory.[36] The second site of the Factory, an empty office space at 33 Union Square West, was adopted in February 1968; this space, like the earlier one, maintained the traces of its former existence, and received the widest publicity when it appeared as the scene of an extended party sequence in the John Schlessinger-directed film, *Midnight Cowboy*.

Of course not everyone visited the Factory, but it was a place that everyone knew about, not least those people connected with the Leo Castelli Gallery who represented Warhol. The Factory's presence in the New York art world and the social life connected with it helped, we might say, normalise the idea of an industrial site as an appropriate place to show art. Castelli's use of its uptown warehouse in 1968 as a gallery space was therefore not necessarily a surprise, and none of the critics responded to the space in that way – it was simply not commented on, as if it were the most natural thing in the world for an art critic to visit a freezing, bleak building a few blocks south of Harlem. Neither did Morris, the artist most closely connected with the warehouse, say anything very much about it: things were simply 'possible' there, he once wrote, implying that the Castelli Gallery's normal premises at East 77 St. were somehow restrictive. I want to argue in the following, however, that the choice of the warehouse space is nevertheless significant. It may not be a choice expressed in avant-garde terms, in other words, a choice to do with the subversion

of established norms of the display and consumption of art, but it is a choice that is supposed to mean something. Instead, its meaning may be expressed again in terms of work, or an aesthetic of work: at the warehouse, in both exhibitions I discuss, a concern for process replaced that of the finished object. The space resembled much more an artist's studio, in which all the objects presented were in some way tentative or unfinished. Many of them were part of their surroundings and could not be moved at all. Others, more finished and moveable were tentative in terms of ideas. Like sketches, they look like trial runs for something bigger (these characteristics are quite exaggerated in Morris's *Continuous Project Altered Daily* as we shall see). The warehouse was also more like a studio in that it was, consciously or not, a more private place. Entry was in various ways more restricted or controlled than at the gallery's usual premises. The critic John Perrault, for example – who reviewed virtually all of the exhibitions discussed in this book – complained that although he had been sent the poster announcement for *Nine at Leo Castelli*, he had been informed that the show was supposed to be 'some sort of a secret' and that it might be better if he did not attend.[37] The title of his review, 'A Test', made clear that the experience of the exhibition had cost him something: it had been, in other words, work.

The idea of work is legible in Philip Leider's review of the warehouse show. Writing for the *New York Times*, he described it as an investigation into the 'properties of materials.'[38] Leider had found the phrase in 'Anti Form', and his analysis of the warehouse show closely followed Morris's ideas. If we go back to that essay, we find Morris's phrasing quite revealing. The new work was about the 'properties of materials', but art was, as he put it, to take the form of an 'investigation'. An investigation: not something with a fixed end in mind, but a kind of purposeful play. This is not something one associates with commercial galleries, which are in effect little more than shops selling finished products like any other. Investigation one associates with the experimental laboratory, with police or legal activity, with the artist's studio. What I am suggesting here is that the choice of the warehouse for Morris's group exhibition had quite a serious, but subtle purpose, one which was nowhere stated clearly. Morris's typically enigmatic remark that 'things could be done there' which were impossible downtown does not explain it very far, and neither do statements about the size of the available space, and the increasing size of sculptures.[39] The purpose was therefore to find a space that was more congenial to the exhibition of process rather than finished product. The works at the warehouse have a tentative look about them – even Nauman's have the disposable, throwaway quality of the bad pun (which is what they are, after all). There is a sense in all of this of trying things out, without a particular end in mind. Such experimental activity would have been difficult at the Castelli Gallery's shopfront at East 77 St.

If Morris's purpose at the Castelli warehouse was to represent process over product, using a setting that was analogous to an artist's studio, it was not very

clearly stated. In fact in retrospect the show did not look very much different to the first survey of such work in an American museum, *Anti-Illusion: Procedures/Materials*, held at the Whitney Museum, New York in the middle of 1969. Comparing photographs, we see the same rather static works (the same works in some cases, such as Serra's lead piece), similar open spaces, the same lack of representation. The second exhibition Morris organised at the warehouse, part of a solo exhibition for the Castelli Gallery, provides a different perspective, and an exhibition which was much more legibly processual. Subtitled *Aluminium, Asphalt, Clay, Copper, Felt, Lead, Nickel, Rubber, Stainless, Thread, Zinc*, referring to the materials in the show, it consisted of five very large works and proposals for earth projects on paper. The East 77 St. gallery held an untitled work in felt strips and lead, occupying one room; the gallery's other room was filled with the piece known as *Threadwaste*, comprising six or seven hundred pounds of textile by-product, into which were inserted, at irregular intervals, rectangular mirrors and lumps of asphalt. (*Threadwaste* is discussed at greater length in chapter 4.) John Perrault noted, rather revealingly, that one was only allowed to observe this work from the entrance to the room: 'one was not allowed to smoke or to enter' – a mode of display that rather contradicted the artist's most recent writing on sculpture, which had argued that works of art should no longer be differentiated from their surroundings.

At the warehouse was a very different work, one whose title alone, *Continuous Project Altered Daily*, indicated its emphasis on process over product, work over leisure. What of the warehouse? As in the case of the group show that Morris curated at the end of 1968, the rationale for the use of this space is not stated, and the few critics who visited merely noted that *Continuous Project* took place there, and not at the usual gallery. Any remarks I make about space therefore have the character of speculation. That said, a decision, or decisions, must have been made to locate the piece in the warehouse, rather than downtown. Such decisions may have been made partly for commercial reasons, in that the pieces Morris made for the downtown gallery could, albeit with difficulty, have been sold in the normal way (as far as I can ascertain, this never happened). However temporary their installation at the gallery, they were at least finished, and could be contemplated at leisure: this was not really a possibility with *Continuous Project* given the instability of its materials, and the issues of impermanence attached to it. A simple decision, then, based on the varying commercial viability of Morris's latest works: keep the most saleable pieces at gallery headquarters, where all potential clients would be. *Continuous Project* also, it should be said, was messy: the clay and grease would have damaged the gallery's parquet flooring (although such considerations were not at play at the Dwan Gallery, which was quite happy to show Morris's amalgam of dirt and grease, *Dirt,* at its equally smart West 57 St. premises). There was, however, something else at work in the choice of the warehouse for *Continuous Project*. There was the emphasis on work over leisure, already seen at the group show, but in this case the act of working is emphasised further such that it

becomes most, if not all of the work. Part of the way this concern was expressed was the physical presence of Morris in the piece, working in the gallery as if it were a studio. This is ultimately what the piece is analogous to, and to reproduce the sense of studio work for a gallery audience clearly required a different kind of space.

What I have described in this chapter has been an exclusively New York-based phenomenon. In later years, the so-called alternative space became an international phenomenon, and the appropriation of former industrial sites for the showing of art has become in some respects the norm for new art galleries, or extensions to existing ones: the Musée d'Orsay in Paris, the Tate Galleries in Liverpool and at Bankside, London are all officially sanctioned, publicly funded versions of the alternative space. In its appearance in New York in the later 1960s, it is, I have argued here, associated with particular types of sculpture which attempted to foreground questions of process over product, work over leisure. A former warehouse such as that used by the Castelli Gallery on West 108 St. provided an appropriate context for such work, replicating for an interested public many of the conditions of the artist's studio. I want to say furthermore that such ideas, while not clearly stated in terms of sculpture, had nevertheless been present in contemporary art for some time. Kaprow's idea, the 'blurring of art and life', however vague or idealistic, reappears here. The art-going public were quite used to having to work for their art.

The reasons for the development of alternative spaces in New York cannot be understood, however, only in terms of an aesthetic of work, somehow autonomous. It also has to do with the scarcity of possible exhibition sites for new art: established commercial galleries were not initially willing to show work with the temporary and fragile character of works described here, and if they did, it was necessary to separate them physically from what they usually showed. Neither were there public galleries willing to show such work: the first exhibition of so-called process art in a public museum in the United States took place in 1969, and even then there was nothing of the highly ephemeral nature of *Continuous Project*.[40] The situation in most European countries was rather different: in West Germany, especially, commercial galleries such as Ricke in Cologne saw the commercial potential of (for example) Hesse, Sonnier, Walter de Maria, and Morris some time before their counterparts in New York, and for some years it was, according to the critic Phyllis Tuchman, easier to see contemporary American art in Germany than it was in New York.[41] There were also supportive public institutions. The Italian artist Piero Gilardi could therefore write approvingly of the role of the European museum in a piece for *Op Losse Schroeven* that was in every other respect a revolutionary tract.[42] And in countries such as Great Britain where such institutions were as reticent about showing contemporay art as their American counterparts, there were nevertheless publicly funded spaces such as the ICA which were willing to contemplate showing highly ephemeral, process-oriented work.[43] The consideration of space is

mainly an American concern, therefore, and it is intrinsically bound up with American conceptions of sculpture. The next chapter discusses forms of sculpture in which space was again at issue, but the space of landscape rather than the urban realm.

Notes

1 Kurt Von Meier, 'Los Angeles: American Sculpture of the Sixties', *Art International*, 11:6 (Summer 1967), 64–8.

2 Robert Morris, 'Notes on Sculpture Part 2', *Artforum* 5:2 (October 1966), 20–3.

3 This would need further research to prove, but the anti-Pereira sentiment expressed by the critics does seem to extend beyond the exhibition: it seems to have, in other words, a history.

4 Kenneth Halpern, *Downtown USA* (London, Architectural Press, 1978).

5 For a description of this project, see *Architectural Record*, 133:5 (April 1963), 162–3.

6 It was Von Meier who first described it as 'authoritarian'. Von Meier, 'Los Angeles', 64. I suspect, though cannot prove, that for a liberally minded cultural critic in late 1960s America almost all new architecture was likely to seem 'authoritarian', and the professions of the built environment were to be regarded (unfairly or not) with great suspicion. A position like this is articulated by Richard Sennett, for example, in *The Uses of Disorder* (London, Faber, 1996). .

7 For a readable summary of the history of museum form, see Carol Duncan and Allan Wallach, 'The Universal Survey Museum', *Art History*, 13:4 (1980), 448–69.

8 Christof Grunenberg, 'The Politics of Presentation: The Museum of Modern Art, New York', in Marcia Pointon (ed.), *Art Apart: Institutions and Ideologies Across England and the United States* (Manchester, Manchester University Press, 1994), pp. 192–211.

9 Mrs John D. Rockefeller, Lillie P. Bliss, and Mrs Cornelius J. Sullivan. They belonged to some of the wealthiest industrial families in the United States, and travelled regularly to Europe; their tastes were in large part formed by this familiarity with Europe.

10 E. Shaw, quoted in Grunenberg, 'Politics', p. 204. Reesa Greenberg also makes the same point in 'The Exhibition Redistributed: The Case for Reassessing Space', in Reesa Greenberg, Bruce W. Ferguson, and Sandy Nairne (eds) *Thinking About Exhibitions* (London, Routledge, 1996), p. 353, referring to a remark by William Rubin. It seems to have been widely felt.

11 Walter Benjamin, in Grunenberg, 'Politics', p. 209.

12 Brian O'Doherty, *Inside the White Cube and Other Essays* (Santa Monica, Lapis Press, 1976), p. 24.

13 Brian O'Doherty, 'The Gallery as a Gesture', in Greenberg, Ferguson, and Nairne, *Thinking*, pp. 320–40.

14 Although Castelli retained some of the mouldings and other features of its previous domestic existence.

15 Breuer's building, I concede, isn't a 'white cube', its textured grey concrete dominating impressions of the interior. But it is certainly austere and uncomfortable, and meant to produce the same feelings of reverence as the so-called 'white cube'.

16 Information from New York Historical Society, display about the history of the Upper West Side, May 1996.

17 Willoughby Sharp, interview with the author (17 May 1996). Sharp was a freelance curator at the time, knew the Castelli Gallery well, and visited the warehouse exhibition.

18 See, for example, Douglas Crimp: 'it defied our every expectation regarding the form of the work of art and the manner of its exhibition'. 'Redefining Site-Specificity', in *Richard Serra: Sculpture* (New York, Museum of Modern Art, 1986), p. 41.

19 For more information about the changing geography of the New York art world, see L. De Coppet and A. Jones, *The Art Dealers* (New York, Clarkson N. Potter, 1984).

20 For a journalistic account of the beginnings of this process, see A. Wallach, 'Overrun, SoHo's Art World Shifts Ground', *New York Times* (12 May 1996), 51, 54.

21 John Perrault, 'A Test', *Village Voice* (19 December 1968), 19–20.

22 Greenberg, 'The Exhibition Redistributed', pp. 349–67. This has been an important text for this chapter, and my suggestion of a shift from leisure to work in an aesthetic of display is a revision of her ideas: she discusses domesticity versus work.

23 Greenberg, 'The Exhibition Redistributed', p. 354.

24 Greenberg, 'The Exhibition Redistributed', p. 352.

25 Greenberg, 'The Exhibition Redistributed', p. 352.

26 Robert Morris, 'Anti Form', *Artforum*, 6:8 (April 1968), 33–5.

27 Robert Morris, 'Notes on Sculpture Part 4: Beyond Objects', *Artforum*, 7:8 (April 1969), 50–4.

28 Douglas Crimp, 'Redefining'. For comments on this text, see chapter 5.

29 Ellen H. Johnson, *Penguin New Art 4: Claes Oldenburg* (London, Penguin Books, 1971).

30 1 December 1961–31 January 1962. The project also resulted in a number of performances in the guise of the 'Ray Gun Theater'.

31 Allan Kaprow, 'Happenings in the New York Scene' (1961), in Jeff Kelley (ed.), *Allan Kaprow: Essays on the Blurring of Art and Life* (Berkeley and Los Angeles, University of California Press, 1993), p. 15.

32 See for example Allan Kaprow, 'The Artist as a Man of the World', in Kelley, *Allan Kaprow*.

33 J. K., 'Reviews and Previews', *Art News*, 60:5 (September 1961), 36.

34 Allan Kaprow, *Assemblages, Environments and Happenings* (New York, Harry N. Abrams, 1965), page not numbered. Morris, 'Anti Form'.

35 Victor Bockris, *Warhol* (London, Penguin Books, 1989), p. 225.

36 The evidence is reproduced in Nancy Holt (ed.), *The Writings of Robert Smithson* (New York, New York University Press, 1979).

37 Perrault, 'A Test'.

38 Philip Leider, 'The Properties of Materials: In the Shadow of Robert Morris', *New York Times* (22 December 1968), II, 31. The phrase is actually a quotation from 'Anti Form'.

39 Robert Morris, letter to the author (10 March 1996).

40 Whitney Museum of American Art, *Anti-Illusion: Procedures/Materials* (New York, 19 May–6 July 1969).

41 Phyllis Tuchman, 'American Art in Germany: The History of a Phenomenon', *Artforum*, 9:3 (November 1970), 58–69.

42 Piero Gilardi, 'Politics and the Avant-Garde', *Op Losse Schroeven: Situaties en Cryptostructuren* (Amsterdam, Stedelijk Museum, 1969), no page numbers. Gilardi wrote that museums were capable of 'impartial analysis of single sectors or situations of avant-garde research; today one-man shows [implicitly taking place in commercial

galleries] stand for cultural mystification that is a contradiction of the new environ-
mental content offered by the avant-garde'. I discuss this statement and other aspects
of Gilardi's essay at greater length in chapter 8.

43 In September 1969, the ICA showed a version of *When Attitudes Become Form*, curated
by Charles Harrison. Much of the work was extremely ephemeral. Harrison has
described the task of separating the work from its packaging when it arrived in London
as being almost impossible. (Interview with the author, 14 June 1995.)

7

Earth

The attention given to the spaces of sculpture in the 1960s had, among other consequences, the liberation of the idea that sculpture need be tied to interior spaces at all. By the late 1970s, it had become quite respectable for artists in the United States and Europe to make works of the earth, intervening in some way directly in the landscape. The results were sometimes gallery objects, although in most of these cases the implication was that the real work was elsewhere. Such work, 'earth' or 'land' art, was collected enthusiatically by museums, usually in the form of documentary photographs, and it was supported in surprisingly direct ways by public funds. In 1979, Robert Morris gave a lecture about earth works, in which he noted, with some uneasiness, that governments and large corporations had become increasingly interested in such projects, as a means of ameliorating the environmental damage being done in their name. It was a response to widespread and increasing public concern over such processes as strip mining, which, in places such as the Appalachian mountains in the eastern United States, resulted not only in the destruction of entire mountain ranges, but also the degradation of air and soil quality, affecting the quality of life for the areas' residents. Restoring such areas to their condition pre-exploitation was not an option, but improving their aesthetic condition was. 'Every large strip mine could support an artist in residence', Morris concluded. 'Flattened mountain tops await the aesthetic touch. Dank and noxious acres of spoils cry out for some redeeming sculptural shape. Bottomless industrial pits yearn for creative filling – or deepening.'[1]

The art Morris referred to was already a tradition in the United States, associated with Robert Smithson, Michael Heizer, Walter de Maria, and others including Morris himself. The occasion of the lecture was the completion of one of his own earth projects, a large, roughly oval-shaped depression in a former open-cast colliery in Washington State. As if to underline the point he had made about increasing government involvement in such projects of aesthetic reclamation, Morris noted that the United States Bureau of Mines had contributed $39,000 towards the cost of the work.

At the same time as land art in the United States seemed to be on the verge of becoming an offical art, British artists including Richard Long and Andy Goldsworthy were also intervening in the natural landscape, if on a smaller scale. Long's very consistent work comprised simple actions – the walking of a path, or

the arranging of stones – in a specific area, and the results were then photographed and displayed. The actions were of low impact. The paths Long trod in English fields in the 1960s quickly grew over, and similar ones made in various deserts of the world in later years were subject to different, but comparable erosion. Goldsworthy's work was formally more complex, involving the making of sculptures, or objects, from natural materials, but its impact was similarly minimal, and the results highly contingent on their surroundings. Both Long and Goldsworthy worked in the simplest of ways, working alone, and eschewing the use of machinery or special tools.

The work of these British artists was different from that of the Americans, and throughout his career Long has expressed some hostility to them.[2] That said, the impulse in both cases has been restorative: land art appears as an essentially humanistic project, directed at healing the perceived wounds left by industry in the natural landscape. Such attempts at healing have been directed literally at the wound in the case of the Americans, aestheticising the destruction left by (for example) the extraction of minerals; or it has been directed at drawing one's attention away from such sites, and towards the restorative powers of the natural world. There are parallels in both projects with the work of the German artist Joseph Beuys who both worked with natural materials, and saw the role of art as essentially redemptive.

These respectable earth works fall outside the frame of this book, but they are the consequence of the critical debate about sculpture in the 1960s. The subject of this chapter is the point at which that debate turns to the use of earth. My concern is to show how earth in this sense becomes a means of questioning sculpture, in much the same way that, elsewere, psychoanalysis does, or the politics of the New Left. The difference between this early material and later earth works is the fact that the former was still preoccupied with questions about the nature of sculpture; it was also for the most part an anti-redemptive art, concerned with delivering a further blow to what Morris would later call the 'rotting sack of humanism'.[3] Consistent with this, I argue that early earth art is legible, very usefully, as a critial response to 'Anti Form'.

The material covered in the chapter is quite varied, from documented walks, to grandiose plans for outdoor earth sculptures, to more conventional objects made of earth. I analyse two texts by Smithson in some detail, 'The Monuments of Passaic' and 'Towards the Development of an Air Terminal Site', two articles published in 1967.[4] I also describe in some detail two early exhibitions of earth works, both American, but taking place in contrasting locations. I say a lot about Smithson, his writings and his art, and something about Morris, an artist whose interests seemingly extended to virtually every possible area of sculpture. I also describe at some length the curatorial activity of the gallery owner Virginia Dwan, and the independent curator Willoughby Sharp.

At the end of 1969, Robert Smithson realised *Asphalt Rundown* (Figure 27), a work which suggested the new, and startling, possibility of working directly with the

earth. At the same time, it was clearly indebted to contemporary American debate around sculpture. Created as part of a solo exhibition at L'Attico Gallery, Rome, which opened on 15 October 1969, it comprised a truckload of asphalt released down a steep bank in an abandoned gravel quarry on the outskirts of the city. It was possible to visit the site – the gallery provided a map for visitors – although the piece is better-known as a series of photographs.[5] As exhibited at *L'Informe: Mode d'Emploi* in 1996, *Asphalt Rundown* comprised seven photographs documenting different states in the realisation of the piece, from the loading of the steaming asphalt into the truck, to its release down the slope, to various views of the results.[6] In its use of a single material in a liquid state, allowing the properties of that material, and considerations of chance and gravity to determine form, it resembled the work Morris had described in 'Anti Form', and it was arguably Smithson's clearest material response to Morris's project. Rosalind Krauss has written of the work that it was Smithson's own 'enactment of form's yield to gravity', an example of the way the artist's 'imagination was filled with the entropic production of Anti Form'.[7] This description indicates the work's close relationship to contemporary sculptural debate, a relationship that is much easier to see than through the tidy and contained *Non-Sites* for which Smithson was better known. Smithson went on to realize a similarly Anti Formal work in *Glue Pour* (Figure 28), made for *995,000*, a group exhibition crated by Lucy Lippard in Vancouver in early 1970. The work again began with a sort of performance, this time in which a drum of orange glue was emptied down a dirt slope on the outskirts of the city. There was again extensive photography, this time in colour, and the results have since been widely published.[8]

If such works were Smithson's response to Anti Form, by extension they addressed contemporary questions about sculpture as much as they proposed an entirely new kind of art. We can ground this response in Smithson's well-documented friendship with Morris. The Smithson papers deposited by Nancy Holt in the Archives of American Art indicate regular meetings with Morris, and this was confirmed in a 1994 interview with Morris.[9] The interviewer, Rosalind Krauss, remarked that in the late 1960s, the two artists were 'very close', and she asked Morris whether he still thinks about him. 'Of course I miss Smithson', Morris replied. 'We used to meet weekly at a sleazy bar on 42nd Street, have a few beers, run down our peers, and slouch off to a Roger Corman movie. I have no fellow anti-humanists to talk to since he has been gone.'[10]

We know also from Virginia Dwan's interview with Charles Stuckey for the Archives of American Art, that Morris was a regular participant in Smithson's mineral-collecting expeditions to New Jersey quarries.[11] There is photographic documentation of this in Jessica Prinz's 1991 essay on Smithson, in which she includes a photograph of the two artists by Nancy Holt climbing over a fence into the restricted area of the Great Notch quarry.[12] In a letter to the author, Morris has similarly described having 'many, many' discussions with Smithson, and described him as an artist of major importance, writing that 'he had a wit and intelligence that

was rare in the art world then (or now)'.[13] Finally, we could mention a 1995 interview with Morris by Pepe Karmel, in which a dialogue between the two artists is said to be represented in the work. About *Threadwaste* (Figure 15), a large distribution of cotton waste and mirrors, which in photographs resembled Smithson's early *Mirror Displacements*, Morris noted 'maybe it cited Smithson. One of the great artists of our time. He said to me once that he was citing my 1965 "Mirror Cubes" with his *Mirror Displacements*.'[14]

However, Smithson's sculpture rarely engaged with other contemporary work in this way. His work, especially the contained, ordered, and documented minerals he exhibited as 'non-sites', usually resembled a kind of collecting in which what mattered were the objects displayed, rather than sculpture. It better resembled a commentary on the museum, particularly on its conventions of display, an idea that was regularly discussed in criticism of his exhibited work. The artist's writing is a different matter. It is extremely wide-ranging, with references to geology, science fiction, architecture, psychoanalysis, eighteenth-century aesthetic theory, and natural history, to name six areas of regular concern, but it is also grounded in contemporary sculptural debate, both responding to and feeding that debate. Smithson's sometime editor at *Artforum*, Philip Leider, suggested, for example, that Morris's 'Anti Form' was indebted to two earlier essays by Smithson, albeit essays on ostensibly very different subjects.[15] Meanwhile Smithson's own essay, 'A Sedimentation of the Mind' referenced 'Anti Form' more than any other text, and can be, as we shall see, helpfully regarded as a commentary on it.

Smithson's commentary on sculpture frequently took the form of allegory, as Craig Owens has argued.[16] Allegory – the reading of one text through another, as Owens defined it – had been suppressed from Modernist art, and where it had been present it had been supplementary to the main emphasis of the work. Smithson's work by contrast made explicit use of allegory, and Owens registered its presence in the work in four ways: first, its site-specificity, in other words its reading of a particular site for meaning other than what was literally present. (Smithson's 'sites' were invariably meaningful, their names alone – *Pine Barrens*, *Line of Wreckage*, and so on – often suggesting a violent history, as Lawrence Alloway pointed out in a 1973 essay.)[17] Secondly, its use of photography: photography, wrote Owens, was allegorical because it recognised the transience of things, and desired to preserve them. Third was its sense of accumulation, the idea of endless extension (Franz Kafka's fiction was given as a pre-existing example, although, interestingly, these texts do not feature among the artist's reading matter as described by the list of books in the Archives of American Art).[18] Finally, Owens described the confusion of visual and verbal languages as allegorical, and on this matter he was eager to present Smithson's essays as equivalent to – that is, not supplementary to, or explanatory of – other parts of the artist's production.

In identifying Smithson's work as allegorical, Owens used it as part of a wider argument about the definition of a postmodern sensibility. Whether or not Smithson can be regarded as a prototype postmodern artist does not greatly

concern us here, but Owens's argument is useful because it establishes his writing as functionally different from the more straightforward art criticism of his contemporaries, and moreover, in situating it as basically allegorical, it directs us towards its linguistic imagery. Of specific interest is the way Smithson's writing described the indeterminate forms that appeared in sculpture from the mid-1960s in terms of the ruin. In his words, the anti-formal sculptures of Morris, or Hesse, were allegories of destruction, and this account begins to infect other accounts of such sculpture, including those of the artists themselves.

Let us consider three of Smithson's essays as contributions to specifically sculptural debates. The first, 'Towards the Development of an Air Terminal Site', which appeared in the June 1967 *Artforum*, accounted for the artist's involvement as an 'artist–consultant' for the firm of architects Tippets-Abbett-McCarthy-Stratton in their design for the Dallas–Fort Worth regional airport. Smithson's proposals for the project remained no more than that as the firm were not, finally, awarded the airport contract. When Philip Leider suggested the essay could be compared with 'Anti Form', he probably had in mind, first, the fact that Smithson's project included a contribution from Morris, an earth mound in the form of a circle. But he very likely also had in mind Smithson's ruinous vision of the airport. For what would become one of the United States' largest airports, a symbol of technological and commercial progress, Smithson envisaged the ruination of the symbolic condition of flight. As airspeeds increased with technological advances, he wrote, the streamlined form of earlier aircraft would become 'increasingly truncated and angular', and airflight would cease to be understood as the movement of form through space, but rather as form in 'instantaneous time'. The old meanings of airflight, 'conditioned by rationalism that supposes truths – such as nature, progress, and speed', would, in other words, collapse.[19] Meanwhile, as regards the airport structure, Smithson turned his attention to the by-products of its construction, rather than the finished product. His vision of the site was essentially a ruined one: 'The boring', he wrote, 'if seen as a discrete step in the development of the whole site, has an esthetic value … Pavements, holes, trenches, mounds, heaps, paths, ditches, roads, terraces, etc., all have an esthetic potential'.[20]

The ruinous vision of an existing site was the subject of 'The Monuments of Passaic', an essay with photographs published in December 1967. An ironic travelogue, it described a tour of Passaic, a New Jersey suburb less than half an hour's bus ride from New York City, and also Smithson's birthplace. 'Has Passaic replaced Rome as the Eternal City?' Smithson asked the reader at the end of an account of the place which had emphasised no conventional site of touristic interest, but the construction sites associated with the building of a six-lane highway along the banks of the Passaic river. Among the six 'Monuments' Smithson photographed with his Instamatic (retaining the distinctive square 126 format in the reproductions) were a pumping derrick in the middle of the Passaic river, a gigantic pipe about to become part of the drainage for the highway, six pipes spewing debris into the river, a child's sandpit, and the steel swing-bridge joining Bergen and Passaic

counties. None of these 'monuments' were at all permanent: the pipes, derricks, and pontoons Smithson photographed were all transitory elements in the construction of the new highway, and the swing bridge was itself photographed in one of its two transitory states. As it was a Saturday, Smithson wrote, 'many machines were not working, and this caused them to resemble creatures trapped in the mud, or better, extinct machines – mechanical dinosaurs stripped of their skin'.[21] The sense of entropic collapse contained in this image was repeated elsewhere: 'River Drive was in part bulldozed, and in part intact. It was hard to tell the new highway from the old road', he wrote. The images described an Anti Formal chaos: disorder confused with order, form with formlessness.

In turning his attention to the half-completed roadway along the banks of the Passaic river, Smithson described a city that was doubly ruined. The progress towards the completion of the fine highway was frozen at a moment at which it resembled collapse. As Robert Hobbs has pointed out in a catalogue raisonnée of Smithson's sculpture, the artist deliberately avoided any of the true monuments of Passaic, the sites in which its citizens took pride. He mentioned 'neither the historic Ackuackanonk Landing, an eighteenth century shipping point for products destined for New York, not the old brick burial vault dating back to 1690, nor even St Peter and Paul's Russian Orthodox Greek Catholic Church at Monroe and Third streets, said to have been built with money donated by the Czar in 1911'.[22] Instead Smithson directed his attention to the allegorial potential in sites of ordinary construction and decay. His interest in the dissolution of form, over form itself, has obvious parallels with 'Anti Form', and he framed the essay in artistic terms, beginning the travelogue with his account of John Canaday's art review in the *New York Times*.

A much clearer commentary on sculpture, and one that proposed earth as central to the critique of sculpture was 'A Sedimentation of the Mind: Earth Projects', first published in the September 1968 *Artforum*. Smithson referenced 'Anti Form' extensively here. He began by wondering about the limits of the concept: 'Morris sees the paint brush vanish into Pollock's "stick"', he wrote, 'and the stick dissolve into "poured paint" from a container used by Morris Louis. What then is one to do with the *container*?'[23] He went on to make four further references to the essay: Allan Kaprow's critique of the room as container, referred to shortly afterwards, is that artist's reply to 'Anti Form'; an account of French 'formal' and English 'picturesque' gardens was compared with the current debate 'between so-called "formalism" and "anti-formalism"';[24] he referred to the 'valuation' of industrial materials, an unusual word which may refer to Morris's phrase from 'Anti Form', 'the a priori valuation of the well-built';[25] finally, on his metal containers, the most visible components of the *Non-Sites*, he described them existing beyond either 'gestalts' (referring to Morris's theorisation of Minimal Art in the first part of the 'Notes on Sculpture') or 'anti form'.[26]

'A Sedimentation of the Mind' was a lengthy and complex essay, legible as both a manifesto of the new art of 'earth projects', and as a satire on Modernist

criticism. (Regarding the latter, a part of the essay was subtitled 'The Climate of Sight', and viewers of art were categorised as either 'wet-' or 'dry'-minded, and susceptible to different painterly effects.[27]) However, it is the transformation of Anti Form that detains us here, and we see it again transformed to provide an image of a ruined world, where construction was conflated, entropically, with destruction. A few examples must suffice. 'A bleached and fractured world surrounds the artist', wrote Smithson near the beginning of the essay. 'To organise this mess of corrosion into patterns, grids and subdivisions is an esthetic process that has hardly been touched.'[28] Meanwhile bulldozers and steam shovels turned 'the terrain into unfinished cities of organised wreckage. A scene of chaotic planning engulfed site after site.'[29] And the fundamental property of steel, was not strength or durability, but rust.[30] The process of thought, Smithson wrote, was equally ruined:

> One's mind and the earth are in a constant state of erosion, mental rivers wear away abstract banks, brain waves undermine cliffs of thought, ideas decompose into stones of unknowing, and conceptual crystallisations break apart into deposits of gritty reason.[31]

Anti Form for Smithson was not an attack on geometrical form, but the starting point for these entropic imaginings. The soft, dissolute, and indeterminate forms of contemporary sculpture predicted the entropic condition to come.

If we can establish a theoretical dialogue between Morris and Smithson located in a number of critical texts, then two contrasting exhibitions *Earthworks*, at the Dwan Gallery, New York, and *Earth Art*, occupying various sites in and around the Andrew Dickson White Museum of Art, Cornell University, Ithaca are of particular interest, as they showed the new work of both artists.[32] However, the material aspects of the artists' Anti Formalism was manifest in different ways. The exhibitions were themselves different in intent. The Dwan show was a commercial exhibition, financially supported by Virginia Dwan, and prominently displaying work from Smithson, an artist with which the commercial future of the gallery was closely bound. The Cornell show by contrast appeared in a university museum, was not organised on commercial lines, and was funded from a variety of sources including the university and the artists themselves. It was also organised by a freelance curator, Willoughby Sharp, whose interests at this point were not primarily commercial.

There were nevertheless important points in common. Both exhibitions showed new work by Smithson and Morris, which in different ways provided evidence of their responses to the critical dialogue in which they had been engaged. Smithson presented a new sculptural device, the *Non-Site*, a work employing a geometrically shaped bin or bins, containing loose accumulations of dirt or rock from a site indicated by an accompanying map or photograph. In the combination of formal order and disorder in the same piece, the *Non-Sites* bore conceptual, if not material

resemblance to Morris's early felt works. In Morris's case, the new works, one for each exhibition, were piles of heterogeneous materials, including earth and minerals, but also felt and metal, materials that had already appeared in the artist's sculpture. They have been described in a number of retrospective sources as a logical development of the work proposed by 'Anti Form'.[33]

However, both exhibitions represented more than a logical development of Anti Form, in effect proposing a new category of art making, having to do with the manipulation of earth, and possibly taking place out of doors, far from any conventional gallery space. The titles of both exhibitions quickly acquired a currency as labels for the putative new category, as David Shirey was to note the following year in *Art in America*: 'Dwan has virtually appropriated the term "earthworks"', he wrote, 'and "Earth Art" became an official category this year with a museum exhibition at Cornell University', meaning *Earth Art* curated by Willoughby Sharp.[34] The contemporary criticism of the exhibitions tended to emphasise the manipulation of earth – one of Grace Glueck's three notices about the Dwan exhibition was entitled 'Moving Mother Earth'; *Time*, likewise, referred to 'The Earth Movers'.[35]

In this connection, the absence of *Artforum* from the criticism of the two shows is of interest. It may of course have been coincidence – *Artforum* could not cover everything – but the journal had been the site of publication of most of Smithson's essays, including 'A Sedimentation of the Mind', in which 'earth projects' were first proposed. Its failure to review two shows at which such work was first publicly realised is therefore curious. Apart from publishing Smithson, *Artforum* did not in fact pay much attention to 'earth' art until September 1970, when it published Philip Leider's essay 'How I Spent My Summer Vacation, or Art and Politics in Nevada, Berkeley, San Francisco and Utah', by which stage the category was associated with monumental projects in remote locations, usually in the western United States.[36] Our treatment of *Earthworks* and *Earth Art* is therefore the one point at which *Artforum* is not intimately involved in the formation of the critical discourse.

Virginia Dwan was personally close to Smithson, and her intention at *Earthworks* was to realise his ideas materially. Her success in doing so was limited by practical considerations on the one hand, and the critical interest shown in Morris's contribution to the show on the other – Morris's work, although made of earth, stubbornly refused an allegorical reading. Part of Smithson's commentary on 'Anti Form' was its extension to mean the dissolution of the exhibition space. The 'earth projects' were envisaged as occupying outdoor sites, ideally a ruined, formerly industrial site. In conjunction with Smithson and other artists, Virginia Dwan began searching for such a site in New Jersey for the purposes of the exhibition, and an expedition to the potential site of the Pine Barrens in the company of Smithson, Morris, and Carl Andre had taken place as early as 1967.[37] Her 1984 interview with Charles Stuckey described several trips to such sites.

> We would go to McGraw Hill and get quarter maps, and then go out with these
> things and then try to figure out what this little hill really looked like. It was great
> fun. You should try it some time. You have like a little dirt road and it leads to a
> pond. Somehow we'd find the little dirt road and the pond, which was in this
> quarter map. It's something really quite wonderful.[38]

Nobody with even a passing interest in New Jersey topography would share her
surprise that its maps had a corresponding geographical reality – but what is clear
from her remarks is her enthusiasm for exploring such sites with artists such as
Smithson, and her consequent desire to move art out of the galleries. However, for
unstated practical reasons the exhibition ended up at the gallery's premises on
West 57 St., in a state which differed a great deal from her original intentions. In
the Stuckey interview she described the gallery space as 'very definitely our last
choice'. She continued: 'Nevertheless we decided while waiting to find some
proper land to build things on, we would go ahead and do a sort of anthology show
of what we were aware of as current earthworks at that point, or of projects which
were intended to be earthworks projects.'[39]

In the event, nine artists were shown at *Earthworks*: Carl Andre, Herbert Bayer,
Michael Heizer, Sol LeWitt, Walter de Maria, Robert Morris, Claes Oldenburg,
Dennis Oppenheim, and Robert Smithson. Andre showed photographs of *Rock
Pile* and *Log Piece*, simple accumulations of a single material in a rural setting, both
made in Aspen, Colorado in the summer of 1968.[40] Herbert Bayer, a former
member of the Bauhaus, was represented by photographs of 'earth mounds' in a
Colorado Springs park from 1955;[41] Walter de Maria showed photographs of the
Earth Room, a gallery filled with earth to a depth of several feet, recently installed at
the gallery Heiner Friedrich in Munich, and a yellow painting labelled 'This is the
color men use to attack the earth'; Michael Heizer was represented by photographs
of the *Earth Liners* project along a 520-mile stretch of dry lake bed running between
Las Vegas and Oregon, described by Grace Glueck as 'eight five-part clusters of
light-catching trenches – 12 in. deep, 12 in. wide, 12 ft long – positioned according
to the sun's east–west trail';[42] Sol LeWitt showed *Report on a Cube that was Buried
at the Visser House in Bergeyk, Holland on July 1, 1968*, which documented eight
stages of the burial of a stainless-steel cube of unknown contents cast in concrete;[43]
Robert Morris showed *Dirt*, a mixture of felt, earth, metal, and grease (Figure 37);
Oldenburg produced *Worm Earth Piece* which was a plexiglass cube filled with
earth and worms (the latter did not survive the exhibition); Dennis Oppenheim
exhibited a photograph of a scattering of aluminium chips in a Connecticut field,
and a model of the Cotopaxi Volcano, Ecuador, a full-size version of which he
threatened to build in Smith Center, Kansas, the geographical centre of the United
States. Finally, Smithson showed *Non-Site, Franklin, New Jersey*, five geometrical
bins containing minerals from a New Jersey quarry, with accompanying photo-
graphic documentation.

Dwan's concept of 'earthworks' proposed that sculpture could not only be made
out of doors, but that it could also be consumed in the form of photographs or other

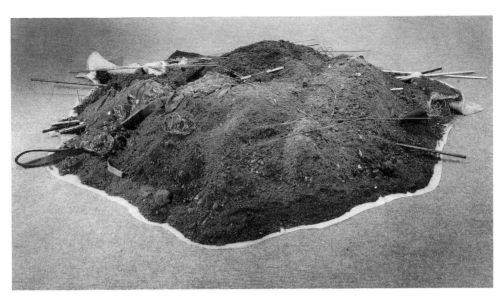

37 Robert Morris, *Dirt*, 1968.

documentation, and numerically over half of the works in the show took this form. Where contemporary criticism described the show's concept, it was this aspect that tended to be emphasised. John Perrault, for example, wrote in the *Village Voice* that most of the works in the show were technically not present, while James Mellow in *Art International* described *Earthworks* as a documentary show which presented works whose size 'precluded gallery showing'.[44] John Gruen (*New York*) wrote, more sensationally, that in theory *Earthworks* was so big as to destroy the sense of the art object, and that art had become so vast as to require the use of a helicopter for viewing.[45]

Most critics tended to conflate the photographs or other documentation with the material they represented. 'Earthworks', Gruen noted, were 'perishable commodities (one sand or rain storm will do them in)'.[46] Perrault, similarly, compared Smithson's *Non-Site* (which was present in material form in the gallery) with LeWitt's documentation of the buried cube (which was not).[47] Recent accounts of *Earthworks* have tended to maintain the confusion, so for example the text on Morris's *Dirt* in the Guggenheim catalogue has described Smithson's *Non-Site* as a photograph, when it also had sculptural elements, and has implied that de Maria's *Earth Room* was actually installed at Dwan, when what was shown was a photograph of its installation at Munich.[48]

Earthworks in some ways moved a long way from 'Anti Form', from an investigation of the properties of materials to the presentation of work in the form of documentation. Yet critical attention focused on the two works in the exhibition that were materially present, and both had clear anti-formal origins. The first, Smithson's *Non-Site, Franklin, New Jersey*, was formally a complex work,

comprising seven distinct elements: five trapezoidal wooden bins, of decreasing size, each filled with chunks of limestone, in the configuration of a truncated triangle, an aerial photograph in the same configuration as the bins, identifying the sites from which the contents of each bin came, and a text describing the work. The bins were placed on the floor, with the photograph on the wall just behind them, so the connection between the two was clear. Smithson's intention for this and later *Non-Sites* was that the work existed between the 'non-site', in other words the minerals contained in a geometrical bin, and the 'site', as represented by the photograph. As regards the site of Franklin, Hobbs has described it as important to Smithson as one of the few places in the world where one might find smithsonite, a mineral named after the founder of the Smithsonian Institute, whom the artist claimed (not necessarily truthfully) as an ancestor.[49] Franklin was also famous for the two hundred mineral ores that could be found there, and again according to Hobbs, supposedly forty-two minerals were discovered there.[50] Smithson's accompanying text also remarked of the form of the piece that its vanishing point, in other words the non-existent apex of the triangle, culminated in a dead-end street in the town of Franklin; a photograph of this site existed, but had been 'deposited in a bank vault'.[51] The vanishing point of the work was therefore literally an end: Hobbs has described this as a continuation of the punning quality of the work as a whole, playing on the homonyms 'non-site' and 'non-sight', and in doing so effecting a critique of the emphasis on the visual in art.

Smithson's intentions for *Non-Site, Franklin, New Jersey* were extremely complex, in which the artist not only amalgamated several modes of representation, but made reference to specific places and things, and implicated himself in the work. At the same time, the form which the work took – the irregularity of the contents of the bins, and the indeterminacy of their placement – suggest a response to 'Anti Form,' but one that, like the writings, read 'Anti Form' allegorically.

Morris's *Dirt*, was both the most legibly Anti Formal work, and the site of greatest critical interest.[52] Virginia Dwan seemed to recognise that the piece resisted her overall conception of the show: 'it was really a gallery piece. It really wasn't a reference to an earthwork or whatever. I mean they were all gallery pieces in a certain sense, but this was like an object. It had more object-ness ... it was a wonderful, amorphous sculpture.'[53] Comprising 1,200 lb of dirt, excavated from a construction site in New York, as well as peat moss, felt, copper wire, and industrial grease, the components were mixed up by Morris on site, and piled on a plastic liner on the gallery floor, occupying an area approximately 12 ft by 12 ft. A plant unexpectedly took root in the mixture during the exhibition, but was left to grow. *Dirt* was priced to sell, at $3.00 per lb, according to the review in *Time*, but no customers were recorded.[54]

It is not hard to situate *Dirt* in a continuum with the artist's earlier work, and critics including Perrault, when they were describing the work as an individual case, acknowledged this as a possibility. *Dirt* was much the same size as both the Minimal and the felt works, occupying a similar floor area to the works recently

shown at Castelli, such as *Nine Fiberglass Sleeves*, and it was likewise a work whose main axis was horizontal. And like the felt works, *Dirt* was conceptualised in terms of formal indeterminacy: *Time*, for example, quoted the artist's statement that he had 'no idea' how the piece would turn out. The felt component of the piece, seen most clearly in the photograph printed in *Time*, actually resembled the form of one of the felt works shown in April 1968, suggesting that Morris began as if he were making one of the felt works, before heaping the dirt on top of the material.[55] Finally, the plastic sheet, on which the piece was built, was visible as a narrow border around the work. Its visibility established a separation between the object and the gallery space, making clear that there was both a limit to its own indeterminacy – in much the same way that the felt works maintained their geometrical origins – and a limit to the extent the exhibition represented the transgression of institutional space.

That barely anyone saw *Earth Art*, the exhibition organised by Willoughby Sharp at Cornell University in early 1969, is fairly certain, and little of the work exhibited survives. More people may have seen *Earthworks*, but *Earth Art* was the bigger critical event: There were a similar number of accounts of both exhibitions, but those of the Cornell show were longer, better-illustrated, and suggested more clearly the existence of a critical project to do with making works on or of the earth. Indeed, for the New York art press, and amongst those making advanced art in the city, *Earth Art* was the first major event of early 1969. In more recent literature on art of the 1960s, the exhibition has been accorded a significant role. The exhibition symposium, involving five of the participating artists, was reproduced along with copious illustrations in Smithson's collected writings.[56] More recently Giles Tiberghien used the exhibition, along with *Earthworks*, to signify a critical break with Minimalism, and the emergence of what he termed 'land art'. He quoted extensively from the catalogue, and provided two pages of valuable illustrations.[57] However, our interest in the exhibition here is not only because it is prominent in accounts of art of the 1960s, but also because it offered another re-presentation of Anti Formal ideas. Kozloff's remarks indicate that at *Earth Art*, Anti Form could be interpreted politically; it could even (as we shall see) be given a pantheistic dimension.

Earth Art was distinctly unlike the other events described here, and before proceeding to describe its unusual critical reception, the facts of the exhibition should be set out. It took place from 12 February to 16 March 1969, in and around the Andrew Dickson White Museum of Cornell University at Ithaca, some 200 miles to the north-east of New York City. It was a largely rural location, as photographs of the exhibition show, and the artists made use of distinctly non-urban features such as a frozen waterfall, a salt mine, and a forest. Twelve artists from five countries were invited – Carl Andre, Michael Heizer, Neil Jenney, Robert Morris, Dennis Oppenheim, Robert Smithson, and Walter de Maria from the United States; Jan Dibbets from Holland; Hans Haacke and Gunter Üecker from Germany; Richard

Long from England; and David Medalla from the Philippines (via England) –
making this an unusually international event for one initiated in the United
States.[58] The exhibition budget was minimal, Sharp recalled. He managed to nego-
tiate a $1,000 fee from Cornell for himself, but all the artists, including those travel-
ling from Europe, were required to pay their own travel costs, and once at Cornell,
most artists used whatever materials came to hand.[59] Local transport, meanwhile,
took the form of the museum curator's station wagon. The use of Cornell's private
aircraft to ferry critics from New York City to view the show was an extravagance
uncharacteristic of the show as a whole.

At least two accounts of *Earth Art* describe it as the work of Tom Leavitt, the
curator of the White Museum.[60] That Leavitt was closely involved is beyond doubt,
but the project was initiated by the independent curator and critic Willoughby
Sharp, and about him something needs to be said. To begin with, Sharp should be
added to the list of independent curators who emerged in New York at the end of the
1960s. In interview with this author he perceived a rivalry between himself and Lucy
Lippard. 'She was in it for the long term', he stated, 'and there wasn't anyone else
who was an independent curator dealing with the same general body of people that I
was.'[61] Up to 1969, Sharp's best-known American project had been *Air Art*, a touring
exhibition largely of inflatable sculptures including work by the Architectural
Association, Akira Kanayama, Hans Haacke, Preston McClanahan, David Medalla,
Les Levine, Keith Sonnier, John Van Saun, Andy Warhol, and others – the exact
composition of each show is difficult to establish.[62] The exhibition visited
Philadelphia and Cincinnati in the first part of 1968, but several later instalments of
the show were cancelled. Sharp nevertheless managed to achieve a reasonable
amount of critical exposure, including an article in the British journal *Studio
International*.[63] Sharp had also contributed to Gregory Battcock's *Minimal Art: A
Critical Anthology*, originally published in 1968,[64] and among other activities he
would go on to publish the first American interview with Joseph Beuys, and set him-
self up as editor (or 'artist in residence' as he described himself) of the journal
Avalanche.[65]

The inclusion of so many European artists in Sharp's projects was unusual, and
can be attributed directly to the curator's background. A student at Brown
University in the 1950s, Sharp went on to study at the universities of Paris and
Lausanne, before marrying Renata Hengler, the deputy director of the Düsseldorf
Kunsthalle. During this period, by his own account, he met and got to know Yves
Klein, Arman, Marcel Raysse, Pierre Restany, and Gunter Üecker, and met Eva
Hesse long before she was known in New York. He was in the United States perma-
nently from the mid-1960s, ostensibly studying for a Ph.D. at Columbia
University, although increasingly distracted by curatorial projects. Sharp's rela-
tions with certain European artists were good, and his role in introducing not only
Beuys, but Richard Long and Hans Haacke to the American public was certainly
important. However, his relationship to the New York art world was in some
respects a marginal one: several artists, as we shall see, withdrew from *Earth Art* at

short notice, there is evidence of a difficult relationship with Morris,[66] and for a time in the 1970s Sharp identified himself closely with artists such as Alan Saret, an artist who had publicly severed his links with the commercial art world.[67]

Earth Art also differed from other American projects in its presentation. Sharp's interest in Beuys and other European artists indicates a non-formalist agenda, and this had been made explicit in the catalogue to *Air Art*, which had situated the exhibition as one of four inspired by the elements of classical philosophy, earth, air, fire, and water. *Earth Art* was the second of the series; fire and water were never realised. Our knowledge of the conceptualisation of the show comes mainly from the catalogue, published by Cornell in 1970, which included essays by Sharp and William C. Lipke, and the transcript of a symposium held on 6 February 1969, featuring Haacke, Jenney, Long, Oppenheim, Smithson, and Uecker.[68] Although the catalogue was published retrospectively, in 1970, it can be taken as a good indicator of the exhibition's presentation, as *Air Art* (1968) presented a similar conceptualisation.

In common with other exhibitions discussed here, *Earth Art* was intended as a critique of Modernist aesthetics, or as Sharp put it, 'the longstanding esthetic preoccupations with color, composition, illusion, and the internal relation of parts'.[69] However, Sharp intended the exhibition to do much more than this, situating it as a project of both political and spiritual renewal. 'The new works', he wrote, would not only 'proclaim the artists' rejection of painting and previous sculptural concerns', but also 'the production of artifacts; the commercial art world and its consumer ethos; the urban environment'.[70] The work of Heizer and de Maria was seen as 'religious', other unspecified earth works were described as 'pantheistic', and Stonehenge and Native American art were situated as precursors of *Earth Art*. Elsewhere Sharp described the artists' 'pervasive conception of the natural order of reality'. In the event, few of the artists apart from Uecker shared Sharp's concept of the exhibition, but it is clear from the critical reception that Sharp's pantheistic and political view of it generally prevailed.

Most of *Earth Art* was built on site, using locally available materials. It was a project that entailed a certain amount of risk, and *Cornell University News* reported Leavitt's mild anxiety about the show: 'We won't really know what many of the artists are going to create until they actually arrive in Ithaca the week before the exhibition opens', he was reported as saying, 'it should be a memorable time for us all'.[71] In the event, *Earth Art*, succeeded in showing the work of nine of the twelve artists invited, in sites that ranged from the museum's interior and its grounds, through the wider university campus, to frozen lakes and salt mines nearby. Consistent with the invitation to produce work in response to the site, Long and Medalla produced work in the museum grounds. Dibbets marked out on the floor of woodland some miles from the museum the shape of a large V by simply turning over the earth; Haacke's *Grass Grows*, installed in the sunniest part of the gallery, was a 3-foot-high mound of earth sown with two varieties of rye, yielding 'luxuriant growth' during the exhibition;[72] Jenney's indoor installation

comprised a scaffolding made of scrap wood, exhibiting light bulbs, dirt, and ash-trays at various levels; Long arranged twenty-six fragments of grey schist on the sloping lawn in front of the museum; Medalla shifted several tons of earth to the south side of the museum grounds, where it was watered and then left to weather; Oppenheim's *Beebe Lake Ice Cut* was a 200-foot-long trench dug in a frozen lake at the edge of a waterfall; Üecker's *Sandmühle* was a mound of white sand con-taining two spinning metal blades, just visible at the top.

Meanwhile Smithson visited the local Cayuga Salt Mine, excavating over a ton of material, and taking photographs to be used in work he made in the White Museum. His work at Cornell was the most extensive and sophisticated of any, con-sisting of four large rock-salt and mirror constructions: *Mirror Displacement: Cayuga Salt Mine*, *Rock Salt and Mirror Square*, *Slant Piece*, and *Closed Mirror Square* (Figure 38). As part of the project, Smithson entered the mine with mir-rors, and photographed them in various locations. On the walls around the installa-tion he presented maps of the site, the photographs of mirrors in the mine, and photographs of mirrors leading from the mine to the museum, linking the 'site' and the 'non-site'. The work resembled the Dwan *Non-Site* in that it asserted that the art lay between the gallery construction and the site it documented; but the works were formally less contained, the mirrors being generally inserted in piles of min-eral material, rather than containing them. The minerals, not the mirrors, were emphasised.

38 Robert Smithson, *Rock Salt and Mirror Square*, 1969.

The relationship of the remaining four artists to the show was more problematic: Carl Andre simply did not appear, although invited. Walter de Maria arrived at his allocated space in the White Museum shortly before the exhibition opened, spread earth on the floor, and slowly traced the words 'GOOD FUCK', which led to the immediate closure of the room by the museum authorities.[73] De Maria's friend Michael Heizer 'withdrew' his work in sympathy, although as the work was a hole in the ground, 'withdrawal' was a difficult concept.

Meanwhile, Morris's contribution was unusual in that the artist did not actually make the work, never visited the show, and consequently never saw the work except in photographs. These curious circumstances might seem to be reflected in the inaccuracy of retrospective accounts: for example the 1994 Guggenheim catalogue confused it with Morris's contribution to *Earthworks*, when it lacked the metal, grease, and felt that made that piece so distinctive.[74] There was formally very little in common between the two. Meanwhile, Tiberghien's *Land Art* identified Morris in a photograph of the participants at the symposium, confusing him with Tom Leavitt.[75]

The official version of events has the artist delayed in New York by a blizzard, whereupon he telephoned the museum with instructions, the work being carried out by Sharp and the students of Cornell University.[76] The result was *Untitled*, which occupied a gallery 28 ft by 18 ft, and comprised 1,000 lb of dirt arranged in five piles; 500 lb of anthracite, again arranged in five piles; finally 200 lb of 'long fiber' asbestos in a single pile.[77] The materials were all locally available, and the dirt was apparently dug from Heizer's (withdrawn) hole in the ground.[78] Photographs of the piece show the piles to be regular in form, but placed irregularly in the gallery space. The large piles of dirt were widely dispersed, but the one close to the corner of the space was bordered by the asbestos, and one of the piles of coal. As regards the final appearance of the work in the museum, its materials, size, and placement, it resembled other works in the exhibition. But most retrospective accounts of the exhibition suggest that the blizzard story was simply a device to enable the artist to respond to the exhibition on his own terms; that in other words, Morris's response to *Earth Art* had less to do with the theme of earth, than the further removal of the sign of the artist's hand from the work, the process initiated by 'Anti Form'.

Morris's own view of the piece confirms his interest in increasing the physical distance between him and the work, rather than the theme of earth. In conversation with the author he described it as a 'telephone piece', made with the same intent as a work for *Art By Telephone* in Chicago in late 1969.[79] Morris's case indicates some tension between the conceptualisation and realisation of *Earth Art*. To underline the point, we can be certain that Sharp's pantheistic leanings were not shared by Smithson or Jenney, to name two artists, the latter remarking at the symposium that his interest in earth was mainly economic – the stuff was cheap.[80] We have the sense therefore of artists working broadly within the project of Anti Form having their work co-opted into something much grander. Nevertheless, the critical

response to the exhibition tended to emphasise this grander conceptualisation. Two critiques may be taken as representative, by Perrault, for the *Village Voice*, and Max Kozloff, a contributing editor at *Artforum*, but in this case writing for the left-wing journal, *The Nation*.

Perrault's response to the exhibition was to make a structural change in his criticism. On 13 February he declared he would be abandoning the convention of describing exhibitions as if disembodied, and would thenceforth include details of the circumstances of the visit to the exhibition. In this he explicitly followed the example of his colleague Jill Johnston, whose dance criticism was by 1969 mainly an account of her exploits at New York parties. The first, and last, examples of this mode of criticism were his two accounts of *Earth Art*, focusing as much on the circumstances of the exhibition as the art.

Cornell University was out of range of critics reluctant to leave the Upper East Side, let alone Manhattan, so *Earth Art* was faced with a problem of public relations. The solution was to invite a select group of critics to the site, transporting them in the university's private aircraft, and the extraordinary trip that resulted was the main subject of Perrault's two articles for the *Village Voice*. The plane ('exactly like an executive airplane is supposed to look (vintage 1950): funny little draw-string curtains, leathery seats, a fold-out card-table'[81]) carried the critics Lucy Lippard, Dore Ashton, David Bourdon, Max Kozloff, Howard Junker, John Margolies, and John Perrault, the dealers John Gibson and John Weber, the artists Dan Graham, Hans Haacke, Les Levine, and Neil Jenney, and finally, Willoughby Sharp, fourteen in total, most of whom we can assume knew each other. It was clearly a splendid and unusual day out: Perrault described not only the exhibition, but everyone in the group, the coach trip to Teterboro airport, Cornell's plane, card games, and other antics during the flight, the arrival at the museum, long walks in the country, snowball fights, a meal ('stroganoff') and drinks at the end of the day, and the return to New York City. Perrault's contributions to the *Village Voice* discussed the visit to *Earth Art*. However, the mode was short-lived: Perrault subsequently returned to a more conventional form of criticism.

Max Kozloff's account for *The Nation* appeared as part of a longer discussion of earth sculpture in which it was situated as an expressly political project. We have already seen part of this review in chapter 4, in which Kozloff described the presentation of 'muzzy stewings and fragmented chips' as analogous to the present condition of American society. He had described already 'time running out, political conflict nationally polarized, government institutions paralysed, municipal services falling apart, congested urban life blackmailed'.[82] Anti Formal accumulations of debris were therefore to be taken as a warning. 'But melded with this psychological warning', he wrote, ' is a nostalgia to get free, to break loose to the open plains that is unprecedented in American art exactly because the artistic dimension had never, until now, taken for its arena a whole continent.'[83] Sculpture, he hoped offered a 'comment and an escape', but further, had become an active subversion of the art market. 'Values of scarcity, concentration and prestige', he wrote 'no longer

obtain – partly, one guesses, because they are the accoutrements of a culture discredited overall by its manifest oppression'.[84]

Kozloff's remarks resemble Germano Celant's original concept of Arte Povera, in which the use of low materials by sculptors was situated as an act of defiance against the consumer society.[85] Whether Kozloff had seen Celant's article is not so much the point here, as the fact that his article evidences an attempt to re-position Anti Form, taking it a long way from what Morris had described in April 1968. The value of *Earth Art* is, finally, this: the fact that Willoughby Sharp, and critics such as Kozloff and Perrault, could offer such new readings of Anti Form, and even be inspired to change their mode of writing, indicates how far the discourse around sculpture had moved in a year in the United States. The following chapter looks at similar activity elsewhere, specifically Arte Povera, and its material application.

Notes

1 Robert Morris, 'Notes on Art as/and Land Reclamation', *October*, 12 (Spring 1980), 87–102.

2 *Earth Art* Symposium, in Nancy Holt (ed.), *The Writings of Robert Smithson* (New York, New York University Press, 1979), pp. 160–78.

3 Robert Morris, *Continuous Project Altered Daily: The Writings of Robert Morris*, (Cambridge, Mass., and London, MIT Press, 1993), p. ix.

4 Robert Smithson, 'Towards the Development of an Air Terminal Site', *Artforum*, 6:10 (June 1967), 36–40; Robert Smithson, 'The Monuments of Passaic', *Artforum*, 7:4 (December 1967), 48–51.

5 The map appears in Robert C. Hobbs, *Robert Smithson: Sculpture* (Ithaca, Cornell University Press, 1981), p. 178.

6 Rosalind Krauss and Yve-Alain Bois, *L'Informe: Mode d'Emploi* (Paris, Centre Georges Pompidou, 1996), pp. 36–7.

7 Rosalind Krauss, 'The Mind/Body Problem: Robert Morris in Series', *Robert Morris: The Mind/Body Problem* (New York, Guggenheim Museum, 1994), p. 14.

8 Krauss, *Informe*, pp. 118–19.

9 Roll 3832, Robert Smithson Papers, New York, Archives of American Art. From this it seems they met about twice a month during the years 1967–68.

10 Rosalind Krauss, 'Robert Morris: Autour du Problème Corps/Esprit', *Art Press*, 193 (July–August 1994), 29–30.

11 Charles Stuckey, Interview with Virginia Dwan (21 March–7 June 1984), New York, Archives of American Art.

12 Jessica Prinz, 'Words en *Abîme*: Smithson's Labyrinth of Signs', *Art Discourse/Discourse in Art* (New Brunswick, Rutgers University Press, 1991), p. 82.

13 Morris, letter to the author (1995).

14 Pepe Karmel, 'Robert Morris: Formal Disclosures', *Art in America*, 83:6 (June 1995), 117. Morris's *Threadwaste* and Smithson's *Mirror Displacement* from the Cayuga Salt Mine project were illustrated side by side in 'Notes on Sculpture Part 4: Beyond Objects', and this has been maintained in the version of the essay in Morris, *Continuous Project*, pp. 62–3.

15 Robert Smithson, 'A Sedimentation of the Mind: Earth Projects', *Artforum*, 8:1 (September 1968), 44–50.

16 Craig Owens, 'Earthwords', *October*, 10 (Fall 1979), 121–130; 'The Allegorical Impulse: Toward a Theory of Postmodernism', in Brian Wallis (ed.), *Art After Modernism: Rethinking Representation* (Boston, Godine 1984), pp. 202–35. These well-known essays use Smithson's work to make an argument about the character of postmodern art. Owens is important reading, although his essay seems to have encouraged (many) hagiographies of Smithson.

17 Lawrence Alloway, 'Robert Smithson's Development', *Artforum*, 11:3 (November 1972), 52–61.

18 The same list appears in MAC Galeries Contemporaines des Musées de Marseilles, *Robert Smithson: Le Paysage Entropique 1960–1973* (Marseilles, MAC Galeries Contemporaines des Musées de Marseilles 1994), pp. 246–67.

19 Holt, *Writings*, p. 41.

20 Holt, *Writings*, p. 44.

21 Holt, *Writings*, p. 53.

22 Hobbs, *Smithson Sculpture*, pp. 89–90. Hobbs's view was confirmed by the author in May 1996 on a mainly successful attempt to trace Smithson's footsteps. Passaic is an established New Jersey suburb, not overly wealthy, but far from the industrial wasteland some writers have described. Its ordinariness is what seems to have attracted Smithson. Apart from the building of the highway, there has been little change in the built environment since 1967, so a meaningful comparsion between Smithson's essay, and the place as it exists today is still possible.

23 Holt, *Writings*, p. 84.

24 Holt, *Writings*, p. 85.

25 Morris, 'Anti Form', p. 35.

26 Holt, *Writings*, p. 90.

27 'The artist or critic with a dank brain is bound to end up appreciating anything that suggests saturation, a kind of watery effect, an overall seepage, discharges that submerge perceptions in an onrush of dripping observations. They are grateful for an art that evokes general liquid states and disdain for the desiccation of fluidity.' See Holt, *Writings*, p. 89.

28 Holt, *Writings*, p. 82.

29 Holt, *Writings*, p. 83.

30 Holt, *Writings*, p. 86.

31 Holt, *Writings*, p. 82.

32 New York, Dwan Gallery, *Earthworks* (5–30 October 1968); Ithaca, Andrew Dickson White Museum of Art, *Earth Art* (12 February–16 March 1969).

33 See, for example, the account of the *Earthworks* piece in Guggenheim Museum, *Robert Morris*, p. 230.

34 David L. Shirey, 'Impossible Art: What It Is', *Art in America*, 57:3 (May–June 1969), 33–4.

35 Grace Glueck, 'Moving Mother Earth', *New York Times* (6 October 1968), 38; 'The Earth Movers', *Time* (11 October 1968), 52.

36 Philip Leider, 'How I Spent My Summer Vacation, or Art and Politics in Nevada, Berkeley, San Francisco and Utah', *Artforum*, 9:1 (September 1970), 40–9.

37 Paul Cummings, 'Interview with Robert Smithson for the Archives of American Art', in Holt, *Writings*, p. 153.

38 Stuckey, Dwan Interview.

39 Stuckey, Dwan Interview.

40 Best documented in Gilles A. Tiberghien, *Land Art* (Princeton, Princeton University Press, 1995), pp. 43–4.

41 Stuckey, Dwan Interview. Bayer's much earlier work provided a historical precedent. Dwan stated: 'He had done a park which was basically a work of art in itself, a sculpture. So it was nice to be able to write to him after all these years and a very long period of silence, I'm sure for him, getting feedback about his work as art, and "May we just have a photograph?" That's all it amounted to; we had two from him actually, two different things that he'd done.'

42 Glueck, 'Moving'.

43 A photograph of one of the later stages appears in Hobbs, *Smithson: Sculpture*, p. 108.

44 John Perrault, 'Long Live Earth!', *Village Voice* (17 October 1968), 17; J. Mellow, 'New York Letter', *Art International*, 12:9 (20 November 1968), 64.

45 J. Gruen, 'Art in New York', *New York* (1968).

46 Gruen, 'Art'.

47 Perrault, 'Earth'.

48 Guggenheim Museum, *Robert Morris*, p. 231.

49 There is more on this idea in chapter 5.

50 Hobbs, *Smithson: Sculpture*, pp. 105–8. This is by far the most detailed account of the piece, containing much information on the character of the site, Smithson's reasons for choosing it, and the texts he wrote to accompany it.

51 Hobbs, *Smithson: Sculpture*, p. 106.

52 Most reviews emphasised the piece. 'The Earth Movers', *Time* (11 October 1968), p. 84, illustrated the exhibition with a photograph of Morris brandishing a shovel in front of the uncompleted *Dirt*.

53 Stuckey, Dwan Interview.

54 'Earth Movers'.

55 'Earth Movers'.

56 T. W. Leavitt, (moderator), 'Earth', Symposium at Cornell University (6 February 1969), in Holt, *Writings*, pp. 160–7. Illustrations of the event appear throughout the volume.

57 Tiberghien, *Land Art*, pp. 40, 46–7.

58 *Nine at Leo Castelli* was also an international exhibition, although the fact that all the criticism ignored this fact indicates that it was still unusual. See chapters 5 and 6.

59 Willoughby Sharp, Interview with the author (28 April 1997).

60 Tiberghien, *Land Art*, p. 40. Guggenheim Museum, *Robert Morris*, p. 230.

61 Sharp, Interview.

62 Sharp published the catalogue under the imprint Kineticism Press: Willoughby Sharp, *Air Art* (New York, Kineticism Press, 1968).

63 Willoughby Sharp, 'Air Art', *Studio International* 175 (May 1968), 265.

64 Willoughby Sharp, 'Luminism and Kineticism', in Gregory Battcock (ed.), *Minimal Art: A Critical Anthology* (New York, E. P. Dutton, 1968), pp. 317–58.

65 Willoughby Sharp, 'Interview with Joseph Beuys', *Artforum*, 8:3 (November 1969), 40–7. See chapter 5 for discussion of this.

66 From correspondence in the Robert Morris Archive, Solomon R. Guggenheim Museum, dated December 1969 and January 1970, we know Morris demanded that his

Steam, built by Sharp, be withdrawn from the travelling show *Air Art*, as it had not been properly realised in the artist's estimation, and also that the film of his *Quarter Horses* from *Place and Process* be destroyed. However, when I asked Morris about Sharp, he said that although they had not stayed in touch, he had liked him and approved of his activities. (Conversation with the author, Leeds, 20 May 1997.)

67 Willoughby Sharp, Interview with the author (17 May 1996).

68 Andrew Dickson White Museum of Art, *Earth: Earth Art at Cornell, Catalog of the 1969 Exhibition* (Ithaca, White Museum of Art, 1970).

69 White Museum, *Earth Art*, no page number.

70 White Museum, *Earth Art*, no page number.

71 *Cornell University News* (23 January 1969).

72 White Museum, *Earth Art*, no page number.

73 No published account of the incident exits: this is Willoughby Sharp's recollection from 'Earth Art: The Untold Story', lecture given at the City University of New York on 5 May 1995. He could not say why de Maria had written 'GOOD FUCK' in the earth, although it is consistent with provocative gestures the artist had made at other exhibitions; his 1968 show at Goldowsky (along with Richard Serra and Mark di Suvero) included a sculpture in the form of a swastika. The artist has worked hard to maintain as enigmatic a public face as possible, refusing, for example, practically all requests for interviews.

74 Guggenheim Museum, *Robert Morris*, p. 230.

75 Tiberghien, *Land Art*, p. 55.

76 Sharp, CUNY lecture.

77 Details of quantities from Robert Morris Archive, Solomon R. Guggenheim Museum, New York.

78 Perrault, 'Earth', p. 17.

79 Robert Morris, conversation with the author, Leeds (20 May 1997).

80 Holt, *Writings*, p. 163.

81 John Perrault, 'Earth Show', *Village Voice* (27 February 1969), 16.

82 Max Kozloff, 'Art', *The Nation* (17 March 1969), 347–8.

83 Kozloff, 'Art', p. 347.

84 Kozloff, 'Art', p. 348.

85 Germano Celant, 'Appunti per una Guerriglia', *Flash Art*, 5 (November–December 1967), 3.

8

Revolution

This chapter is about politics, or to be more specific, the belief that sculpture could be a vehicle for a politics of the radical Left. This is not the first time that political questions have been discussed here: see the treatment of Marcuse in chapter 4, and my speculation that sculptures by Robert Morris and Robert Smithson from the years 1968–69 were in some measure a representation of Marcuse's critique of modern societies. Their sculptures of this time, I suggested, were legible as desublimatory, or to put this in Freudian terms, giving expression to the Eros, the instinct harmfully repressed by the society in which they were produced. Of course if this is a radical politics, it is a rather abstract one, and neither artist at this point was politically active in any meaningful sense. Morris, for example, whatever his later feelings about the American involvement in Cambodia, declared as late as 1968 that he had no real interest in politics.[1] What I am interested in here is a less ambiguous politics, a politics of direct actions, of events, of targets, of material objectives. The expression of such a politics might be, for example, the extraordinary events around the 1968 Venice Biennale. In a protest against the allegedly conservative and unfair Academy of Fine Arts, a group of approximately five hundred students set about disrupting the enormously prestigious international event. Their activities included sit-ins at the Academy, grafitti on every available wall, and numerous clashes with the police. David L. Shirey, *Newsweek*'s commentator, quoted one protestor:

> Art is here only for the dealers who show only artists who will make them money. Because of these Machiavellis, art is only for the rich and a cultural elite. The Biennale is nothing but a monstrous international showcase for these cheats. Art should be for everybody.[2]

Among the consequences of the actions were the closing of several pavilions, the official withdrawal of Sweden, the cancellation of displays on Futurism and art from 1950–65, and the resignation *en masse* of the judging committee. The 1968 Biennale was, to put it mildly, a disaster. None of the ideas I discuss in the chapter had quite these dramatic effects, but it is this very material sense of a radical politics that has expression in, say, 'Arte Povera'. This chapter outlines some differences over the meaning of politics, as they appeared in European exhibitions of sculpture, and the critical texts associated with them. I begin with an account of Arte Povera,

as it appeared in exhibitions and critical texts at the time; I continue with a discussion of two simultaneous and related European exhibitions, *When Attitudes Become Form* (Bern Kunstalle, 22 March–27 April 1969) and *Op Losse Schroeven* (Stedelijk Museum, Amsterdam, 15 March–22 April 1969), both of which presented contemporary art as inherently revolutionary. The fact that both exhibitions, as we shall see, included many American artists, indicates the extent to which the presentation of sculpture could vary in the later 1960s: there were no political overtones to American exhibitions, other than the implicit support of the establishment.

'It is forbidden to be free', wrote the Italian critic and curator Germano Celant in 1967. 'Once you create an object you have to remain by its side. That's what the system commands … To exist apart from the system amounts to revolution.'[3] By 'system' Celant meant capital, and the implicit demands on artists to involve themselves in the same mechanisms of promotion and distribution as those employed by any other producer of luxury goods. The artist, he wrote, was no longer 'a stimulator, a technician, a specialist of discovery', but only a 'cog in a mechanism.'[4] The only solution was 'guerrilla war' against the system, by means of an art that resisted recuperation by the market, a temporary art made from materials of low cultural value. Celant made these assertions in a short article, 'Arte Povera: Notes for a Guerrilla War', published in an early issue of the Roman journal *Flash Art*. The article was on the one hand a polemic directed against the art market, and on the other an attempt to promote the work of Celant's artist friends, grouped under the heading of 'Arte Povera' (or 'Poor Art'). They included Giovanni Anselmo, Alighiero Boetti, Piero Gilardi, Jannis Kounellis, Mario Merz, Giulio Paolini, Emilio Prini, and Gilberto Zorio. As a promotional exercise, the article was unquestionably a success. The artists Celant described went on to critical and commercial success, while the category he described has been the subject of numerous retrospective exhibitions in Europe and the United States.[5] The work made by the artists in Celant's group was, as we shall see, formally similar to the work done by New York-based artists from 1966 onwards, and there is a substantial literature locating Arte Povera in an international context. Some of this was produced by Celant, anxious to give his group international prominence, but the argument has been restated by more recent writers, including the Roman art critic Carolyn Christov-Bakargiev, the British artist and curator Jon Thompson, and the New York-based artist and critic Dan Cameron.[6] One way or another, this literature described Arte Povera as a fraction of a much larger international phenomenon which included such categories as Land Art, Postminimalism, and Conceptual Art.

Yet as both Cameron and Thompson have described, contemporary cultural relations between the United States and Europe were somewhat strained. Part of this may have simply been a matter of pride: in 1964, an American artist, Robert Rauschenberg, had taken first prize at the Venice Biennale, and by the later 1960s, American artists were achieving great critical and commercial success in European galleries. By far the largest group of artists at the 1968 *Documenta* exhibition, for

example, were Americans, and they brought with them critics who tended to gloat on American success.[7] Such numerical domination provoked the withdrawal of most of the French artists in the show. But tension was also ideological. I begin this chapter with 'Arte Povera: Notes for a Guerrilla War' because it represents a very clear point of divergence on the meaning of 'politics' between European and American art. Celant wrote of art as if it could be a tool in the service of macropolitical change, even revolution, a word he in fact used. No American artist or critic at this time – 1967 – was making this kind of claim for the purpose of art. American exhibitions, whether in commercial galleries or museums, tended to be restricted to formal themes, or they were single-artist shows. The critics most sympathetic to the Left – such as Lucy Lippard or Max Kozloff – gloomily accepted the persistence of capital, and focused their efforts on improving the institutional structures within which they worked.[8] Meanwhile, in Europe – whether Italy, or Switzerland, or Holland – if a new generation of curators and critics were to be believed, revolution was just around the corner.

The existence of Arte Povera as a movement was denied by a number of its supposed members. It nevertheless strongly existed as a concept in the activities of Germano Celant between 1967 and 1970, and my account of Arte Povera is an account of his work. Celant was born in 1940 in Genoa, and studied partly at the University of Puerto Rico. By 1967 he was an active critic and journalist, contributing regularly to publications such as the Italian architectural journal *Casabella*. He was also teaching at the University of Genoa, and was the curator of the Museo Sperimentale d'Arte Contemporaneo in Turin. A 1969 publication listed all these activities, as well as two books (one planned, one not yet realised), and described the author living and working simultaneously in Turin, Genoa, and Milan. Celant's interests ranged from contemporary architecture, to concrete poetry (manifest in an anthology), to contemporary sculpture, the subject of 'Arte Povera'. Celant was also active as a curator of contemporary art, not just at the Turin museum, but at smaller commercial galleries throughout Italy: the history of Arte Povera as a tendency is in some respects the history of such exhibitions. He was energetic, developing international networks of communication, someone who had a range of interests, who made things happen. Charles Harrison describes him, for example, as the south European point of contact in a flourishing international art scene, the others being Lucy Lippard in New York, Harald Szeeman in Bern, and Harrison himself in London.[9] I will say more about these figures in due course. But Celant's activities remained as a form of journalism, which is not to devalue them, but to say that they were of a particular type, distinct in some ways from those of, say, Morris in the United States. Celant's writing at this point – the book on Marcello Nizzoli aside – comprised relatively short, journalistic pieces on new phenomena in Italian visual culture. His adopted role was explicitly journalistic, to find out what was current, and report it, and this was in effect also the function of his curatorial work.

The history of Arte Povera is therefore described here as the history of Celant's activities from 1967 to 1970. The relevant aspects are, in chronological order: *Arte*

Povera – Im Spazio, two simultaneous exhibitions held at the Bertesca Gallery, Genoa from 27 September to 20 October 1967; the article 'Arte Povera: Notes for a Guerrilla War', published in the November 1967 edition of *Flash Art*; an exhibition, *Arte Povera*, at the de Foscherini Gallery, Bologna during March 1968, accompanied by an essay 'Arte Povera e Azioni Poveri'; a book, *Art Povera: Conceptual, Actual or Impossible Art?*, published in 1969; finally, an exhibition at Turin, curated by Celant, called *Land Art – Arte Povera – Conceptual Art*. Of these events I will concentrate on the Bertesca exhibtion of 1967, and the manifesto that followed shortly afterwards, and the later essay 'Art Povera' which appeared in the 1969 book of the same title – the loss of the 'e' from 'Arte' by this stage is not only a consequence of the book's translation into English, but also, as we shall see, evidence of a distinct change in Celant's views as regards how the tendency might be defined.

Arte Povera – Im Spazio were in fact two distinct exhibitions held at the Bertesca Gallery, and later at the Instituto della Storia d'Arte at the University of Genoa The former – which concerns us here – consisted of works by Alighiero Boetti, Luciano Fabro, Jannis Kounellis, Giulio Paolini, Pino Pascali, and Emilio Prini. The exhibition was the first to make use of the description 'Arte Povera', although most of the artists had already exhibited similar work. The works themselves – in contrast to the Minimalist sculpture from the United States and elsewhere that was filling the pages of art journals, and European commercial galleries – resisted verbal description. The works included sculpture, deploying an unusually wide range of materials: coal, steel, newspaper, earth, wood, air – and more conceptual works taking the forms of diagrams, or descriptions: Paolini's *Lo Spazio* was eight diagrams of a cube drawn on white plywood, with the letters of the words 'Lo Spazio' depicted, in a jumbled form, inside. The eight forms were mounted on the walls. Among the better-documented sculptures were Kounellis's *Carboniera*, a low, geometrical, steel bin containing a quantity of coal, and reminiscent in retro-spect of the *Non-Sites* that Robert Smithson would exhibit in New York from 1968. Placed on the floor, the piece reached a height of about 1 ft, and would be viewed from above. Kounellis went on to make a number of similar works using the same elements, sometimes including multiple bins, with living plants as well as minerals. Similarly horizontal was Fabro's work, the *Pavimiento Tautologia*, which consisted in newspapers spread over several square feet of the gallery floor. Pascali showed *Due Metri Cubi di Terra*, literally that, a cubic lump of earth. Prini's *Perimetro d'Aria* defined the gallery space by placing lights at its corners and in the centre. Celant noted retrospectively that all the artists, whatever media they employed, emphasised the character of the materials themelves, and of the given space, so the viewer's attention was focused as much on the 'corporality' of the events and on 'natural' elements as on the artificial nature of the art.[10] Or to put it another way, the exhibition was an attempt, to paraphrase Allan Kaprow, to close the gap between art and life.[11]

A visitor to *Arte Povera* might have been struck by the lack of permanency of the exhibits: Fabro's newspapers clearly had a limited life, especially if they were

walked over by people in the gallery, and even a relatively durable piece such as Kounellis's was characterised by a more or less random arrangement of coal that was likely to change with each new installation. Likewise Prini's earth piece would have been subject to decay through loss of moisture and the action of microscopic organisms. But *Arte Povera* was not well documented, and Celant noted in retrospect that it was limited to a small number of Italian artists, omitting Giovanni Anselmo, Piero Gilardi, Mario and Marisa Merz, Michelangelo Pistoletto, Gilberto Zorio, and other artists whom he saw as central to Arte Povera. The principal text of this phase of the tendency is not therefore the Bertesca Gallery show, but Celant's manifesto 'Arte Povera: Notes for a Guerrilla War', published in the November edition of *Flash Art*.

I have already provided some sense of this article's inflammatory rhetoric, and its conviction of the possibility of social revolution through art. In its presentation of artists as fighters in a guerrilla war against capitalism, it has, as several writers have pointed out, something of the romantic spirit of Che Guevara. Or it is a document as idealistic and romantic as films such as *Easy Rider* or *Zabriske Point*, as the art critic Jean-Christophe Amman noted.[12] But we should say a little more about it, how it functions, and in particular the way it uses contemporary Italian sculpture to justify its argument.

Celant began with assertions about the capitalist 'system', and the place of art within it. The 'system' was, as we have heard already, all-encompassing; it was 'forbidden to be free'.[13] More specifically, it required of its participants a certain consistency in terms of the types of goods or services that are transacted within it. 'Once an individual has assumed a role', wrote Celant, 'he continues to perform it until death.'

Of itself, this critique of artistic consistency would have been familiar to readers of the American art journals. A number of American artists had been thinking along the same lines for some years, including Robert Morris, who had – to the confusion of critics and dealers – been simultaneously the producer of Minimalist sculptures, small, punning objects derived from the work of Marcel Duchamp and Jasper Johns, and performance works. Celant went on to posit an opposition between implicitly 'rich' art, integral to the system, and tradeable as any other luxury item, and 'poor' art ('Arte Povera') which he declared, lay outside. 'Poor art', he asserted, was contingent on its immediate surroundings, committed to the present rather than the historical past. It was radically opposed to consistency, believing consistency to be a dogma 'that has to be transgressed'. And if the new art lay outside the 'system', the artist's role was transformed from the mere producer of goods, to a role something like a 'guerrilla fighter, capable of choosing his places of battle and with the advantages conferrred by mobility, surprising and striking rather than the other way around'.

The possibility of being outside of the system could not be more clearly stated. Celant wrote a little further on of the need to refuse any kind of dialogue with it, in order to forestall any possible integration. Those outside the system therefore held

positions of radical individualism; Celant modified Mashall McLuhan's notorious
catchphrase 'the medium is the message' to declare 'the man is the message', that
the 'human being' was the centre of research, rather than the system, or for that
matter any kind of system. Celant's guerrilla warrior therefore has a long pedigree,
beginning perhaps with Fyodor Dostoevsky's 'Underground Man', to Joseph
Conrad's South American revolutionaries who make their appearance in *Nostromo*,
through to more contemporary and obvious hero figures such as Ernesto ('Che')
Guevara. These romantic revolutionaries, secure in the knowledge of the possi-
bility of existence outside of capital, differed from those figures active on the New
Left, informed by the application of structuralism to the social sciences, and
unconvinced that the revolution would be a straightforward battle between capital
and everything else.[14]

Thus far, Arte Povera can be understood as a concept with two clearly intelli-
gible strands: opposition to capital, and radical individualism. It was supported
with reference to the work of ten contemporary Italian sculptors, who, wrote
Celant, turned the 'revolutionary way of existence … into a Reign of Terror'. The
main problem which concerned these artists, he continued, was the recovery of a
free mode of being in the world, or 'self-detemination'. He began with an account
of Paolini's highly conceptual work, of which *Lo Spazio*, exhibited at the Bertesca
show would be a good example. Celant wrote of this and works like it that they
returned art to a pre-systematic condition, so that these paintings were not legible
as paintings, but were simply objects in the world. They recovered their 'aniconic'
condition, as he put it, through their refusal of the normal languages of painting. It
is doubtful if any of the visitors to the Bertesca show were convinced by this, as
Paolini's piece still very much had the appearance of art, even if it declared itself to
be not painting. Celant's argument about it, at least on the evidence of 'Notes for a
Guerrilla War', was less sophisticated than contemporary writing on conceptual
art in the United States, especially by Sol LeWitt and Joseph Kosuth. The point
was nevertheless clearly made, even if it remained at the level of assertion: Paolini's
work was to be seen as itself, an object in the world like any other, art but at the same
time not art.

Celant continued with the works of Pascali and Kounellis, stating that both
attacked conventional 'rich' notions of art by refusing consistency. Both used an
enormous range of materials, sometimes simultaneously. Pascali had begun by
modelling female torsos, but now deployed variously 'cannons, mythical animals,
boats, the sea, puddles, blocks of earth, and ploughed fields'. Celant went on to
describe Kounellis's work, which had amongst other disparate elements included
live animals. An untitled work of 1967 included a live macaw perched amidst an
elaborate installation involving cacti, steel boxes, and propane gas flames. This
apparent lack of consistency was accounted for as part of the artist's refusal of all
'conceptual reductions' of his work (Celant's phrase): the very difficulty of
describing such disparate and changeable installations as Kounellis's in words
seems to have been a deliberate strategy. What was important was not therefore the

conceptualisation of the work, but 'concrete knowledge' – again Celant's term – and seemingly the demand that one experience objects as far as possible on their own terms, uncorrupted by any pre-existing conceptual framework. 'The important thing for Kounellis is to focus on the fact that Kounellis is alive and the rest of the world can go to hell.'

About Fabro's work, also exhibited at Bertesca, Celant wrote of tautology, describing it as an efficient means of 'taking possession of the real'. In doubling an existing space – as in the case of the Bertesca piece – by covering it with some unexpected material, in that case newspaper, Fabro drew attention to a reality usually ignored. Celant declared that knowledge of everyday things was limited in that we simply do not tend to perceive our everyday environment; Fabro rectified the situation by making the real visible again. Celant described further works by Anselmo, an artist not represented at the Bertesca show, but among the group most closely identified with Arte Povera: his works drew attention to their surrounding reality by using temporal elements, rather in the same way that Kounellis did, but more explicitly so (Figure 39). A 1968 sculpture comprised a sort of granite sandwich, in which two unequally sized blocks of granite, with a lettuce in the gap between them, were held together by a containing wire. As the lettuce decayed, the wire lost tension, and the smaller block fell to the ground. Similar works were made which substituted meat for the salad. Gilberto Zorio's experiments were also described, his work tending to describe simple chemical experiments or physical concepts such as capilliary action, as were, in different ways, works by Gilardi, Boetti, Prini, Piacentino, and Merz. Celant concluded the essay by remarking that he had just met two other artists (Icaro and Ceroli) who confirmed that they were working in a similar vein, and then supplied the names of thirteen more. He ended with the somewhat incendiary statement 'the guerrilla war, in fact, has already begun'.

The basic premises of the essay are, as we have seen, individualism and opposition to capital, themes which were exemplified in the materially diverse work of the artists Celant described. At heart was a declared opposition to the special status of the artwork. All Celant's examples were of works which in some way subverted this status: through the use of poor materials (all of them), works which were liable to change

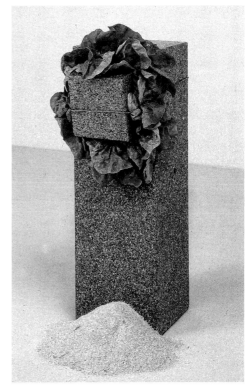

39 Giovanni Anselmo, *Structure that Eats Salad*, 1968.

over time (Anselmo, Zorio, Kounellis), works which drew attention to their specific surroundings, including the specific time in which they existed (Anselmo, Fabro, Zorio). Materials were ordinary, not of themselves normally associated with art. Neither had they any great economic value, usually the reverse (Figure 40). And virtually all the works illustrated a certain wilfulness on the part of the artist, that in other words certain materials and procedures were chosen because the artist simply liked them, and that this simple, individualistic act of choosing was more than enough justification for the results. This was especially true of Celant's account of Kounellis. To these statements about this early version of Arte Povera we should add the observation that all the artists Celant referred to were Italian, with a notable concentration based around Turin, where the author was already working. There is a clear sense too at this stage that the target of Celant's anger is the United States, as several writers have pointed out.[15] It was the location of the most heavily conceptualised art – he was thinking perhaps of Minimalism – and it was also the site of the richest art in that it had the greatest art market, and greatest number and size of galleries showing contemporary work. 'Rich' art versus 'Poor' art can be characterised at this stage in nationalistic terms, a battle in which Celant had seemingly enlisted all Italian contemporary artists as 'guerrilla fighters' in the battle against the dominance

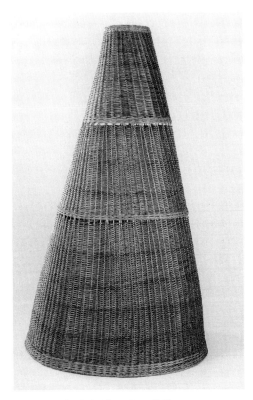

of the United States. The importance of this for Celant was short-lived; at the end of 'Arte Povera: Notes for a Guerrilla War' he listed thirteen Italian artists whom he considered to be working in the same manner as the main group. This is as far as I can ascertain the first and only time they appear in his writing. After 1967, Arte Povera became a distinctly international phenomenon.

After the publication of 'Notes for a Guerrilla War', Celant evidently began to revise what he meant by 'Arte Povera'. His first curatorial activity was an exhibition at the De Foscherini Gallery, Bologna in March 1968, titled straightforwardly, *Arte Povera*, which expanded the definition of the group to include such artists as Anselmo, Merz, Pistoletto, and Zorio, none of whom had been included in the show at Bertesca. The show nonetheless was consistent with the earlier one in the object-centred nature of the work presented, and its exclusively Italian origin. Celant's next curatorial project, *Arte Povera e Azioni Povere*, staged

between 4 and 6 October 1968 in the southern resort of Amalfi, he described in 1976 as 'almost a continuation of the Bologna show', although there were some significant revisions to the concept.[16] Celant permitted, for a start, the inclusion of non-Italian artists for the first time, namely the British artist Richard Long and the Dutch artists Ger Van Elk and Jan Dibbetts. Furthermore, the works of these three, and the others, did not consist in objects to be shown in conventional gallery spaces – as was the case with the previous conception of Arte Povera – but something more akin to performance. Long, for example, drew a long line on a nearby hillside above the town, visible from the centre. Others staged works in the streets of the town. The results of the three days' work were published in 1969 as the *Rassegna di Amalfi*, a publication which included a short essay by Celant himself, 'Azioni Povere'; the essay identified in the clearest terms a critical shift away from the production of objects, towards 'process' (a word Celant used). Objects would henceforth be treated as the residue of some, implicitly more important, action. Celant's interest in process at this point exactly parallels that of American artists such as Robert Morris, whose essay 'Anti Form' had already been published, and about which Celant certainly knew.[17] ('Process' was without question the dominant concern of the New York avant-garde in late 1968. Aside from the criticial literature on the subject appearing in the pages of *Artforum* and other journals, the Whitney Museum of American art hired two young curators, James Monte and Marcia Tucker, in late 1968, precisely to curate a 'process' show; this emerged in May 1969 as *Anti-Illusion*, discussed briefly in chapter 5.[18]) And it is no coincidence that Celant's text should appear in the same part of his chronology of the period, *Precronistoria*, as his discussion of such American events as *Anti-Form*, an exhibition held at the John Gibson Gallery, and *Nine at Leo Castelli*, Morris's well-known curatorial project at the gallery's New York warehouse, at which two Arte Povera artists, Anselmo and Zorio, were present.[19]

The events at Amalfi indicate a new inclusiveness in the conception of Arte Povera, not only in the admittance of foreign artists for the first time, but in the apparent receptiveness to American concerns for process. Such inclusiveness was confirmed by the book Celant published in 1969, simultaneously in Italian and English versions. *Art Povera: Conceptual, Actual or Impossible Art?* was a substantial publication, illustrating in detail the work of thirty-six artists, and including an essay by Celant himself.[20] The selection of artists was explicitly international: of the 36, only 12 were Italian, while 16 were based in the United States. Celant's change of heart about American art could not have been more clearly represented than by the book's cover which illustrated on the front Walter de Maria's drawn lines in a west American desert, and on the back, Bruce Nauman's neon sculpture reading 'the true artist helps the world by revealing mystic truths'. Each artist was represented by five works and a text written or chosen by them.

Celant's essay, towards the end of the book, confirmed the revision of the Arte Povera concept. Considering the essay as a whole, change is mostly represented by the exaggeration of individualism, about which I will say more. But the most

dramatic change was the revision of Arte Povera's political position, a change which amounts to outright contradiction. As we saw in the 1967 essay, Celant regarded the employment of poor materials as a revolutionary act, directed specifically at capitalism. At this point, he identified Arte Povera unambiguously with a traditional leftist position: man good, capital bad. The objects and materials of the tendency were employed with a specific moral and political purpose. In 1969, Celant's argument was rather different. 'What the artist comes into contact with', he wrote,

> is not re-elaborated; he does not express a judgement on it, he does not seek a moral or social judgement, he does not manipulate it. He leaves it uncovered and striking, he draws from the substance of the natural event ... he identifies with them in order to live the marvelous organisation of living things.[21]

In other words, the materials of the artist were no longer chosen for their ability to carry a political charge, 'poor' materials to represent opposition to capital. Arte Povera no longer carried any 'moral or social judgement' as Celant put it. Instead, materials and objects were (declared to be) withdrawn from any conceptual framework, including politics, and art, in favour of their somehow being themselves. Art became a matter of making interventions in the real world, rather than engaging with any pre-exisiting language, including the languages of art. Celant went on therefore to register his opposition to a series of contemporary art tendencies. He wrote of the failure of 'pop, op, minimal and funk artists' for their interpretation of reality rather than their intervention in it; they worked in effect towards the 'clarification' of the social system, 'but block the crushing energy of life, nature, the world of things, and do away with the sensory significance of any kind of work'. [22]

There is a residue here of Celant's opposition to the United States, but it appears only in the form of a distaste for (dominant) American forms of art. His principal theme is art as intervention, or intervention over representation. Precisely what form such 'intervention' might take was nowhere made clear, although it is clear enough to the reader what it was not: it opposed any formal activity involving language, museums, galleries, or any other institutional spaces, or any activity that required the artist or the viewer to perform conventional roles. (Celant admitted that the artist might from time to time return to make work in the gallery.) Celant went further to suggest that the artist abolish 'his role of being an artist, intellectual, painter or writer' and learn again 'to perceive, to feel, to breathe, to walk, to understand, to make himself a man'. And it was made clear that 'interventions' – whatever they were – would take place outside of any normalising institutions. The artist therefore went 'down to the public places, crosses forests, deserts, fields of snow to appraise a participating intervention'. (The final phrase 'to appraise a participating intervention' suggests well the aim to abolish the traditional role of the artist, up to and including the point of abolishing the creation of objects. The (post?) artist would come across things, perhaps serendipitously, in the landscape.)[23]

'Art Povera' differed from the earlier essay in its refusal of a specific political goal, and it differed also in its application, which was now international. However, it

continued its wildly libertarian and individualistic programme. This aspect marks a considerable distance from any contemporary American debates on the same subject: virtually all writing on art at this point, even about the least object-centred tendencies such as conceptual art, is characterised by a sense of limits, of what may or may not be possible at a given moment. Even the most politically active critics such as Lucy Lippard exhibit – as I have already noted – an acceptance of capital, and the power of the institutions which they, in their role as critics or curators, had to negotiate.[24] What we witness in 'Art Povera' is one side of a transatlantic battle over the meaning of contemporary sculpture, with the European side, represented by Celant, imposing libertarian meanings on American works, made to very different ends. Needless to say, the battle had another side: at precisely the same time, Robert Morris was curating his exhibition at the Castelli Gallery's warehouse, including a work each by Anselmo and Zorio. As the extensive contemporary literature on the show makes clear, their work was recuperated into Morris's extremely austere concept of 'Anti Form', which at this point simply questioned the extent to which sculpture could be made out of temporary or fragile materials. 'Art(e) Povera' and 'Anti Form' are at this point radically opposed views of the same material.

This transatlantic debate was represented on a much more public scale in an exhibition *When Attitudes Become Form*, held initially at the Bern Kunsthalle in spring 1969. Celant collaborated with the exhibition, which presented on an international stage many of the artists he had included in the category Arte Povera, but the exhibition was more ambitious than anything he himself had yet done. The impact of the Bern exhibition extended further than usual in that it went on to tour to three other European cities (Krefeld, Essen, and London), and that it ran concurrently with a similar exhibition at Amsterdam, *Op Losse Schroeven: Situaties en Cryptostructuren* (Figures 41–5).[25] The Bern and Amsterdam

41 Giovanni Anselmo, *Le Cotton Blanc qui Mange l'Eau*, from the exhibition *Op Losse Schroeven*, 1968.

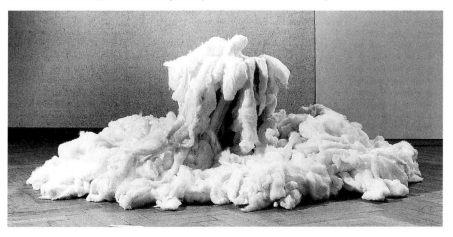

exhibitions were in fact organised simultaneously, with well-documented collaboration between their respective curators, and such collaboratorial spirit extended to artists, many of whom showed similar works in each place, and to critics, who tended to review both shows together.[26] Whatever their success or failure, at issue in the critical discourse around them is politics. In retrospective accounts, *Attitudes* will often appear as a symbol of failed idealism: in Harrison and Wood, it is only the statement by the sponsor, the tobacco company Philip Morris, that makes an appearance, to make the point that revolutionary politics of the participants were underwritten by one of the capitalist world's major corporations.[27] This notion of failure is central to critical accounts, notably the extensive description by Bruce Altshuler in *The Avant-Garde in Exhibition*. If the concern to demonstrate the project's failure is new, the interest in politics is not, for it is central to the exhibitions' presentation and reception.

Let me consider *Attitudes* first. The Bern Kunsthalle lacked a permanent collection, and was the venue for temporary exhibitions. Since 1961, its director had been Harald Szeeman, who curated between ten and fifteen exhibitions every year, and succeeded in turning a relatively small and unadventurous institution into a dynamic venue for contemporary art. *Attitudes* was the culmination of this project. It was highly ambitious, bringing together 120 works by sixty-nine artists from Belgium, Germany, Great Britain, Holland, Italy, and the United States. The works were located not only in the museum itself, but in and around the city, and the accompanying catalogue provided plans for even more work, mostly unrealisable, courtesy of

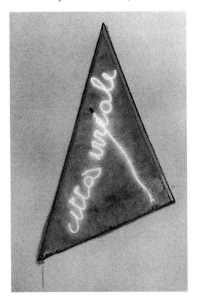

42 Mario Merz, *Città Irreale*, from the exhibition *Op Losse Schroeven*, 1968.

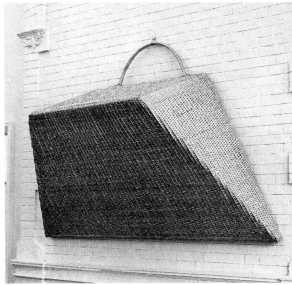

43 Mario Merz, *Overzicht Tent*, from the exhibition *Op Losse Schroeven*, 1968.

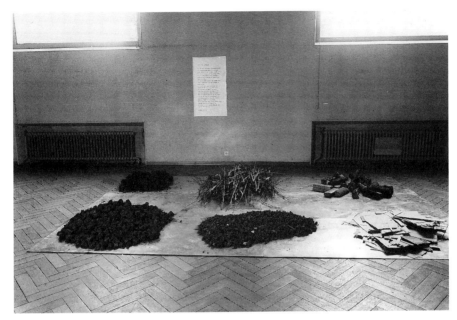

44 Robert Morris, *Amsterdam Piece*, from the exhibition *Op Losse Schroeven*, 1968.

45 Gilberto Zorio, *Lampe avec Amianto*, from the exhibition *Op Losse Schroeven*, 1968.

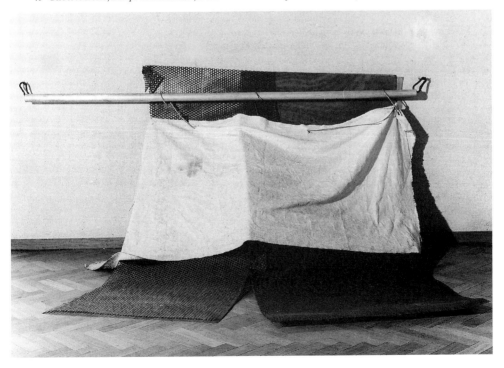

the participating artists. By the normal standards of the Kunsthalle, Szeeman's exhibition was overambitious, and it became clear early during the installation that there was not enough space to show all the works satisfactorily, if at all: the catalogue contained far more work than could ever be physically realised at Bern. Chaos and confusion, wrote one Italian critic, were 'inevitable'.[28] Szeeman wrote of the installation itself that it resembled a 'construction site' with every conceivable part of the museum taken over with activity.[29] The result was, by the normal standards, a mess, with far too many works displayed together in the exhibition spaces, normally unsuitable parts of the museum being used for display purposes, works not installed properly (or not installed at all), works wrongly attributed.

Harry Shunk's photographs of the exhibition show – in contrast to the highly restrained practice of New York galleries – an extremely crowded installation. At several points, this seemed to make visitors participants by default. In one photograph, three large works by Bruce Nauman appear in close proximity to an equally large felt piece by Robert Morris, between them occupying virtually all the available wall area. Meanwhile works by Barry Flanagan and Alighiero Boetti took up nearly all of the floor space in the same room, and it is hard to see how the visitor could enter the room without stepping on them. The installation of Richard Serra's *Splashing* – a version of which was also made for the Amsterdam show – likewise seemed to interfere with the gallery's circulation space, with one photograph of it showing a female visitor standing amongst the fragments of lead, rather than at a respectful distance. Furthermore it was installed directly below the piece generally known as *Belts* (Figure 9), consisting of nine harness-like structures suspended in a horizontal series. It would have been hard for the visitor to tell exactly where one work finished and the other began.

Chaos was the theme of the majority of the reviews, some contrasting the Bern exhibition with the well-ordered, spacious show at Amsterdam, which provided a room each for nearly all of the artists. Tomasso Trini writing in the Italian journal *Domus* was not alone, however, in writing that the contradictorariness of the Bern exhibition made for an attractive spectacle.[30] The idea of confusion is maintained in the critical discourse around later instalments of the show: at Krefeld the director is supposed to have inverted a wall-mounted sculpture by Nauman in the belief that it looked better upside down. At London, Charles Harrison was in charge of a hurriedly organised showing at the Institute of Contemporary Arts, a hopelessly inadequate space for the exhibition's needs, being smaller than the already cramped Kunsthalle, and made worse by the inclusion of even more artists than at Bern. Harrison's task was not made any easier by his not personally having seen the original show, and the absence in London of anyone who had. Nearly all the work arrived by post, rarely with any kind of installation instructions. Harrison's first task was therefore to decide on what was art and what was packaging, an extraordinarily difficult task which involved some time spent, as he put it, deciding which decisions to take.[31]

The chaotic nature of *Attitudes*, wherever it was installed, was matched by the confusion of the opening night at Bern. Szeeman reported a crowd of over a

thousand, far in excess of the capacity of the museum, extensive media interest, and later, local controversy over some of the exhibits resulting in protests which included leaving bags of excrement on the steps of the museum, and threatening letters to the director. The controversy over the exhibition which began on the opening night led ultimately to the cancellation of Szeeman's next curatorial project (a survey of the work of Joseph Beuys) and, finally, after pressure from the board of directors and Bern's municipal government, his resignation from the museum.[32]

Chaos is, we could say, the principal theme of the critical discourse around the exhibition. And it is seen, generally speaking, as a positive force. If Trini wrote of the chaos of the exhibition being attractive, Gregoire Müller, writing more gener-ally about the exhibitions at Amsterdam and Bern, went further, describing chaos as liberating. 'Avec ce nouveau mouvement', he wrote 'l'art c'est libéré de tous ces carcans' ('with this new movement art can throw off its chains').[33] No comparable claim was made for any contemporary American exhibition, so we can consider *Attitudes*, regardless of the fact that it included American artists, as presenting a specifically European point of view. Let us consider three ways in which this is manifest: the manner of presentation of work, the attitude to institutions, and the political orientation of the project. About the first point: the installation – or rather, re-presentation – of existing works in new situations tells us a great deal about the precise view of art that is promoted. A case particularly worth citing is the piece *Splashing* by Richard Serra. In all its various installations, this comprised molten lead, splashed crudely along a few feet of the junction between wall and floor. The lead was left to harden, and no further actions were performed. There was a devel-oping literature about this work, since its first public installation at the Leo Castelli Gallery's warehouse in December 1968. The literature concerned the question of what would later become known as 'site-specificity', in other words the concept that the work was a response to one particular site, and could not be removed in the mannner of conventional art, a position articulated in the clearest fashion by Robert Morris. Yet by the time of the Bern exhibition, *Splashing* had only been shown at the Castelli warehouse, an environment which by its crudeness and lack of ornament allowed such singular questions to be articulated. To put it another way: in the bleak space of the warehouse, the lead did not in any real sense look out of place (it could pass for a minor industrial accident) allowing the viewer to concen-trate on the question of its impermanency.

The installation of the piece at both Bern and Amsterdam presents rather dif-ferent questions. At Bern, *Splashing* was installed on the elegantly tiled flooring of the museum, an act which visibly harmed a valued environment. The contrast between the lead and the tile is something of a shock: the piece looks like an acci-dent at best, but more like an act of deliberate vandalism. The contrast between the work and its environment is much greater than at the earlier installation in New York, and it is hard not to read it as a form of provocation – a provocation entirely consistent with other parts of the exhibition and the events surrounding it. The Amsterdam exhibition was in general much tidier and more spacious, but the

installation of the Serra piece left it open to similarly anti-institutional readings. The work was made by splashing lead across the facade of the Stedelijk Museum, an act of apparent aggression against one of the city's most valued cultural institutions. It is again hard not to read this as a physical attack on the piece's immediate surroundings, and the fact that the piece was stolen almost immediately after its installation is an indication that it was indeed regarded as an act of transgression – which is to say at this point that it could be stolen because it had no obvious aesthetic value. It is not known the extent to which Serra collaborated in the selection of these sites, and there is little or no commentary on these works as realised in Europe. The transformation nevertheless is great, turning the thoroughly aestheticised act of violence seen at the Castelli warehouse into something with greater social resonance.

Serra was not the only artist whose work seemed to be transformed in Europe. Michael Heizer was known as the maker of interventions in remote American landscapes, so far from human habitation that they could only be transacted in the form of photographs. At Bern however, his project titled *Bern Depression*, albeit officially sanctioned, had the appearance of a direct attack on the Kunsthalle itself. Directly outside the museum's entrance, Heizer used a wrecking ball to destroy a section of the pavement, creating a sizeable crater in the process. It was one of the least well-received works in the show, responsible for a number of the protests already mentioned, and confirming its legibly anti-institutonal intent. We might also mention at this point the small work by Lawrence Weiner, which involved directly damaging the museum building: Weiner removed a small square area of the interior wall, to a depth of about an inch, and did the same thing at Amsterdam.

For one further example of the transformation of American art in Europe, we might consider the two identical works Robert Morris made, or more accurately proposed, for the exhibitions at Bern and Amsterdam. Both (titled *Bern Piece* and *Amsterdam Piece* respectively) proposed that the respective curators collect as many combustible materials as possible in each city, adding a new material to the allotted space at an interval determined by the number of exhibition days (minus one) and by the number of materials. On the final day of the exhibition, the entire mass was to be ignited outside the museum. Morris did not visit either Bern or Amsterdam, although there is photographic evidence that both works were realised. It was not the first time that he had realised a work by sending instructions: for the near-contemporary *Earth Art*, Morris telephoned instructions for the creation of a work, which when realised consisted of piles of various minerals. The European works are in many ways similar, involving a simple task of accumulation, carried out by a third party. But the act of burning the materials outside of the museum on the final day (Morris's instructions were carried out in each case) was a destructive act of a kind that was never seen in the United States. Morris made many works at this time that were temporary in nature, or deployed unpleasant materials, or substances: but his experiments in this field were safely confined to the Castelli warehouse (barely a public venue as we saw in chapter 6), or when they were given over

to public inspection at Castelli's usual premises, they were invariably cordoned off so the viewer was kept at a distance. At Bern, the destruction was a very public act, and a somewhat dangerous one; and it was destruction that, by its location (outside of an important art museum in each case), seemed to have a specific institutional target. For an event that took place less than a year after the dramatic events of Paris in 1968, any form of public burning would have been charged with symbolism. Morris cannot have been unaware of such meanings.

Yet if these works of Morris, Heizer, and Serra are in Europe newly legible as anti-institutional acts, the attitude of Szeeman and his peers to the institution of the museum was far from straightforward. As we have seen, both the Stedelijk Museum in Amsterdam, and the Bern Kunsthalle, were, one way or another, opened up to acts which would have been difficult in a comparable American institution – and to Bern and Amsterdam we could add the Fridericianum in Kassel, the site of *Documenta*, the exhibition of international avant-garde activity most recently held in 1968. These institutions had sanctioned, willingly or otherwise, molten lead splashed across their facades, and on their antique floor tiles, collections of everyday rubbish to be burned defiantly outside them, parts of their internal infrastructures to be vandalised in the name of sculpture, and the same done to the public space at their entrances. There are no comparable acts in any American museum: *Anti-Illusion: Procedures/Materials*, held at the Whitney Museum of American Art shortly after the European shows, contained works by many of the same artists, but rejected poured polyurethane works by Lynda Benglis on the grounds that they would damage the floor. This occurred in spite of the fact that the recently built Whitney galleries were large, hangar-like spaces ideal for showing very large items of sculpture. Work that was likely to damage its immediate environment tended to be shown elsewhere: the Castelli warehouse has already been mentioned as one venue that could take some abuse (Robert Morris once remarked that 'things could be done' there that would have been impossible at the gallery's usual premises. Well away from the usual circuit, it was a place where otherwise threatening events could be said to be officially sanctioned). And when commercial galleries in New York did install temporary work of the kind that characterised *Attitudes*, it made sure that public behaviour was carefully policed. One was not allowed to smoke, or to enter the room where Morris's *Threadwaste* was displayed in 1969, for example. And an earlier piece by the same artist, *Dirt*, an amalgam of earth, copper wire, axle grease, and a live plant, when shown at the Dwan Gallery, appeared discretely mounted on a piece of cellophane, so that the carpet should not be soiled.

It would seem that certain acts were possible in European museums at this stage that were inconceivable in their American counterparts. This was to an extent theorised: Szeeman remarked later that the Kunsthalle became more like a laboratory – with all the mess and lack of certainty that that implies – than a 'collective memorial'.[34] At the time, in a long and fascinating essay for *Op Losse Schroeven*, Piero Gilardi saw a special role for the (European) museum.[35] Its most important role was

'that of impartial analysis of single sectors or situations of avant-garde research; today one-man shows stand for cultural mystification that is a contradiction of the new environmental content offered by the avant-garde'.[36] In this context, by 'museum' Gilardi meant museums in both the United States and Europe, but the view he put forward of the museum's role is an exclusively European one. As the critical discourse around American exhibitions testifies, the response to museum shows there was more often negative than not: the tone is often one of weary resig-nation to their inadequacy, in particular their failure to innovate. The critical reac-tion to *Anti-Illusion* was one of indifference, largely because the type of work it showed was by then old hat. What Gilardi's statement elided was the fact that in the United States, most, if not all, of the innovative exhibition work was being done by commercial galleries, and much of this included his despised one-man shows: there is no question that serious critical attention was directed here. There is a clear sense too in American criticism that it is the galleries that are – if anything can be – 'impartial' as Gilardi puts it. The museums were tied: to conservative acquisition and display policies (the Metropolitan Museum), by self-aggrandising local poli-tics (the then new Los Angeles County Museum of Art), or by an overly defined role, which in the case of the Whitney Museum prevented it from showing any art from outside of the United States. The idea that the museum might provide a safe home for the avant-garde, a putatively neutral space for experimental art, free of commercial presures, is a specifically European idea at this point. But it is one that we must not, finally, take too far: Gilardi's sentiments are one thing, as are the re-positioning of artists such as Serra and Morris to make anti-institutional state-ments. These gestures had their limit: the museum could only take so much experimentation when that experimentation came in the form of apparent abuse. The result of *Attitudes* was not further experiments in the same direction, but the removal of the exhibition's curator, and the cancellation of any similar activity in the future, at least as far as Bern was concerned. The divergence between American and European museums, if that is what we see here, was short-lived.

Gilardi's text 'Politics and the Avant-Garde' articulated in the greatest detail a rad-ical politics of sculpture. Its sophisticated, Marcusian, analysis rejected 'guerrilla warfare' in favour of 'revolutionary praxis', whose target was not the crudely drawn capitalist 'system', but modern 'technocratic and consumer structures', which the author described as both global, and common to capitalist and communist economies alike.[37] 'Revolutionary praxis' included not only forms of contemporary art that might be seen as resistant to market recuperation, but contemporary polit-ical events or situations. In his definition of 'avant-garde' Gilardi refused to be bound by traditional artistic categories. Minimal Art, eccentric abstraction, the Situationist International, the Berlin Free University, anti-Vietnam demonstra-tions in the United States, the hippy life styles in the Haight-Ashbury district of San Francisco were all in equal measure revolutionary, acts of resistance against technocratic authoritarianism.

Gilardi approved of all of these activities in aesthetic as much as political terms, and presented them as continuous with more conventional artistic activity. I will conclude with the most striking example of this, his account of the Cultural Revolution. 'The most serious error committed by Western observers', he wrote,

> has been that of assigning too much importance to symbolic and ritual factors. In schools, factories and hospitals, work is suspended for the choral repetition of Mao's verses with complete disregard for the pressing needs of the moment or for the demands imposed by technological rhythms. Only if we succeed in looking beyond the symbolic content of this action do we get a clear idea of its function as a 'horizontal' emotive relationship and a psychic decontamination from structural and technological work.[38]

To put this another way, the importance of the Cultural Revolution was the fact that it enabled a society to disengage from work, the tyranny of work being common to all societies – as Gilardi had already noted – whether they were organised around capital or collectivist models. This disengagement from work was far more significant in itself than the means by which it was achieved: the chanting of Mao's works was therefore simply a pretext to enable the disengagement to take place. It was not to be seen, as was more usual in Western circles, as a means of reinforcing state power. Communist China in this passage is rather incredibly identified as an agency of the avant-garde. Mao was not without Western admirers at this point, and this is not the only place that such a peculiar constellation of views can be identified. At roughly the same time, a rock group from Detroit, the MC5, were advocating a utopian programme based on adherence to Mao, the use of whatever psychotropic drugs came to hand, and public fornication.[39] But American art can almost never be identified with any coherent political programme, and this was one of few occasions when a connection was made.

We might consider, finally, the use of the word 'horizontal' in the passage. I should make clear that Gilardi's text was originally written in Italian, and a commercial translation was then made for the catalogue (the translator's identifying stamp appears on the final version) so we need to be cautious about overinterpreting his language. That said, Gilardi's use of the concept of horizontality marks out a final important difference between American and European approaches. Gilardi writes of the disengagement from work, and the subsequent establishment of 'horizontal' emotive relationships. 'Horizontal' here undoubtedly has positive connotations, connotations of shared values, communal action, collective resistance to corrupting work. It implies a levelling of social values, and a challenge to hierarchical systems. These are in Gilardi's world view unquestionably good things, forming part of what he termed the 'revolutionary praxis'. Horizontal as both a word and a concept is also extremely present in the discourse around American art, both at the time referred to here and subsequently ('horizontalité' was one of the categories of the exhibition *L'Informe: Mode d'Emploi*, for example, drawing heavily on Bataille's use of the word).[40] But in all of this

literature, 'horizontal' has a purely negative charge: the subtext to Minimalist use of low materials is to present the stuff repressed from high cultural practice, and in doing so make a critique. The heaps of stuff Morris and others showed were not meant to be beautiful, but were supposed to provoke, to affront existing notions of what might constitute art. As part of this scheme, it was important that they be culturally, as well as spatially, low, base in every sense of the word. There is no sense in which the American view could accommodate the horizontal as a force for positive change in the way Gilardi proposed. In this most direct way, we see the ideological tensions over the same material: two claims for 'horizontality', one a call for direct political action, the other a modified formalism.

Conclusion

Like any academic history, this one depends not only on its primary subject matter, but on a range of existing historical perspectives. It could not have been written without long familiarity with the work of Germano Celant, Michael Fried, Rosalind Krauss, Lucy Lippard, and Robert Morris, to give examples of five writers who, one way or another, dominate historical accounts of sculpture of the later 1960s. The book nevertheless stands in relation to those sources, and is intended as a commentary on them as much as on the material they describe. Perhaps the most important sense in which this book differs to earlier ones is in its relation to art criticism. The five writers I cite above were all, to begin with, critics, or artist–critics, and in the preceding chapters I have described a lot of their critical writing. Their task in that writing was primarily advocacy: the validation of the art they felt to be of quality. However, their later historical writings have in large part continued this task, Lippard, for example promoting conceptual art through *Six Years* or Fried continuing to support Modernist sculpture in the introduction to his anthology *Art and Objecthood*, or Krauss placing Hesse, Morris, Nauman, and Serra et al. centre stage in *L'Informe: Mode d'Emploi*, her revisionist history of Modernism. The problem might be expressed in a more academic way as a confusion between primary and secondary sources. The people responsible for the primary material of art criticism are more often than not the same as those writing the secondary historical material. This would not matter if there was a clear distinction between the two kinds of material, but there is not: those histories are themselves a form of criticism.

In so many histories of 1960s art, the principal task remains a critical one, and in the desire to judge, however furtively, there is a tendency to simplify. One way this is apparent is in the constuction of narratives, narratives which are basically substitutive, aiming to replace a great old story with a great new one. In Lippard's work of the 1970s, especially *Six Years,* a phenomenal range of artistic activity, from Minimalism, to Conceptual Art, to Arte Povera, to Beuys, is interpreted through the logic of 'dematerialization', or the loss of material form. In Krauss *informe* performs a comparable role, but extended further to encompass the whole

of twentieth-century art. Addressing Krauss about her use of *informe*, Hal Foster wrote specifically on this problem: 'you have collaborated on a history that feels almost as claustrophic, almost as hermetic, as the old narrative. Only now, rather than a heroic history of form-givers, we have a heroic history of form-undoers.'[41]

Of course this book does not escape narrative, its very title presupposing a story with a linear development. It has nevertheless attempted a history made of competing narratives, in the belief that a single master-narrative cannot really account for the range of possible debate about 1960s art. To return to an idea from my first chapter, there were by 1968 any number of artists in the United States and Europe using felt as a sculptural material, yet the range of possible legitimisations of this material is astonishingly wide. It is in Morris's view, a material that lends itself to a challenge to preconceived form, nothing more; for Joseph Beuys, it is, notoriously, a trace of an autobiographical trauma of the distant past; for Germano Celant, felt and 'poor' materials like it posed a challenge to consumer society; for Lippard, it was evidence of the reduced importance of the art object. What is striking to me about these, and other ideas is that they all refer to the same basic material, yet they could scarcely be more different from each other. This confusion was, I felt, quite apparent in contemporary art criticism, yet it had been lost for the most part in subsequent historical accounts, written as they have been for the most part by writers with a stake in just one of these critical positions. The main task I set myself was to try to recover that sense of confusion for a reader now, and in doing so establish a historical, rather than art-critical, perspective on 1960s art. If such art now seems more contradictory and incoherent than it did, less certain in its relationship to its legitimising texts, and less assimilable to a single narrative, then this book will have done its job.

Notes

1 Paul Cummings, 'Interview with Robert Morris for the Archives of American Art' (10 March 1968). Smithson was always highly ambiguous about his political views: see his response to an *Artforum* questionnaire about the political role of the artist in Charles Harrison and Paul Wood (eds), *Art in Theory 1900–1990: An Anthology of Changing Ideas* (Oxford, Blackwell,1992), pp. 896–900.

2 David L. Shirey, 'Venetian Carnival', *Newsweek* (1 July 1968), 93. There was extensive coverage of the events in the specialist and non-specialist press.

3 Germano Celant, 'Appunti per una Guerriglia', *Flash Art*, 5 (November–December 1967), 3.

4 Celant, 'Appunti', 3.

5 For example *Gravity and Grace: The Changing Condition of Sculpture 1965–1970*, curated by Jon Thompson at the Hayward Gallery, London in 1993. In France the CAPC Musée d'Art Contemporain de Bordeaux has had several exhibitions representing Arte Povera since the ealy 1980s, while in the United States, a retrospective exhibition of Arte Povera was held at PS1 in Long Island City in the mid-1980s.

6 Carolyn Christov-Bakargiev, 'Arte Povera 1967–1987', *Flash Art*, 137 (November–December 1987), 52–69; Dan Cameron, 'Anxieties of Influence, Regionalism, Arte

Povera and the Cold War', *Flash Art*, 164 (May–June 1992), 75–81; Jon Thompson, 'New Times, New Thoughts, New Sculpture', *Gravity and Grace: The Changing Condition of Sculpture 1965–1970* (London, Hayward Gallery, 1993).

7 'You have to admit it', wrote the critic Grace Glueck, 'the best work here is American.' See Grace Glueck, 'Documenta: It Beats the Biennale', *New York Times* (7 July 1968), D20.

8 'Paris and the various European cities are in the position that New York was in around 1939. There is a gallery and museum structure but it is so dull and irrelevant to the new art that there's a feeling that it can be bypassed, that new things can be done, voids filled. Whereas in New York, the present gallery–money–power structure is so strong that it's going to be difficult to find a viable alternative to it.' Lucy R. Lippard, in conversation with Ursula Meyer, in *Six Years: The Dematerialization of the Art Object from 1966–1972* (New York, Praeger, 1973), p. 8.

9 Charles Harrison, Interview with the author (14 June 1995).

10 Germano Celant, *Precronistoria* (Florence, 1976), p. 33.

11 A favourite theme of Kaprow's, hence the title of his collected writings *Essays on the Blurring of Art and Life*. Robert Rauschenberg made comparable statements.

12 Jean-Christophe Amman, quoted in Didier Senin, *L'Art Povera* (Centre National d'Art Moderne Georges Pompidou, Paris, 1992), p. 11

13 This and all following quotations from Celant, 'Appunti'.

14 My understanding of the term 'New Left' comes from David Caute, *Sixty-Eight: The Year of the Barricades* (London, Paladin, 1988).

15 See Cameron, 'Anxieties', Thompson, 'New Times'. Both note however that Celant does not mention the USA by name.

16 Celant, 'Appunti', 101.

17 Robert Morris, 'Anti Form', *Artforum*, 6:8 (April 1968), 33–5.

18 Whitney Museum of American Art, New York, *Anti-Illusion: Procedures/Materials* (19 May–6 July 1969).

19 John Gibson Gallery, New York, *Anti-Form* (5 October–7 November 1968); Leo Castelli Gallery Warehouse, New York, *Nine at Leo Castelli* (2–28 December 1968). Both exhibitions are extensively discussed elsewhere in this book.

20 Germano Celant, *Art Povera: Conceptual, Actual or Impossible Art?* (London, Studio Vista, 1969).

21 Celant, *Art Povera*, p. 225.

22 Celant, *Art Povera*, p. 228.

23 Celant, *Art Povera*, p. 227.

24 See for example Lippard's remarks to Ursula Meyer made in a 1969 interview. Meyer asked if tendencies such as Conceptual Art posed any threat to the functioning of the art world. Lippard doubted very much if it did, and thought that Conceptual Art would be absorbed by the system almost immediately. Any change in the political role of art was, she thought, possible, but would only come about through an 'immense educational process to get people to look at things to say nothing of look at things the way artists look at things'. Lucy Lippard, 'Interview with Ursula Meyer', *Six Years*, p. 893.

25 The original intention behind *Attitudes* was even more ambitious, involving a tour of ten or more cities, in both Europe and the United States. In the event only four exhibitions, at Bern, Krefeld, Hamburg, and London, were realised.

26 For example Harald Szeeman's diary, showing the process of organizing *Attitudes*, was published as part of the catalogue to *Op Losse Schroeven*.

27 Part of the statement reads: 'We at Philip Morris feel it is appropriate that we participate in bringing these works to the attention of the public, for there is a key element in this "new art" which has its counterpart in the business world. That element is innovation – without which it would be impossible for progress to be made in any sector of society'. See John A. Murphy, 'Sponsor's Statement for *When Attitudes Become Form*', in Harrison and Wood, *Art in Theory*, p. 885.

28 FFSS, 'Avantgardia a Berna', *Casabella* (1969).

29 Szeeman's diary, published in the catalogue to *Op Losse Schroeven* (1969), no page reference.

30 Tomasso Trini, 'Quando le Attitudini Diventano Forma', *Domus*, 478 (September 1969), 47.

31 Charles Harrison, Interview with the author (June 1995).

32 The best account of the events surrounding the show is Bruce Altshuler, *The Avant Garde in Exhibition* (New York, Harry N. Abrams, 1994).

33 Gregoire Müller, Gregoire, in Stedelijk Museum, *Op Losse Schroeven: Situaties en Crypto structuren* (Amsterdam, Stedelijk Museum, 1969), no page numbers.

34 Hans-Ulrich Obrist, 'Mind over Matter: Hans-Ulrich Obrist Talks with Harald Szeeman', *Artforum*, 35:3 (November 1996), 77.

35 Piero Gilardi, 'Politics and the Avant-Garde', in *Op Losse Schroeven*, no page numbers.

36 Gilardi, 'Politics'.

37 This critique of capitalist and communist societies alike probably derives from Marcuse. See Herbert Marcuse, *Eros and Civilization*, (London, Routledge, 1998) and the discussion of it in chapter 4 above.

38 Gilardi, 'Politics'.

39 The MC5's live performances in some ways resembled political rallies. The live recording *Kick Out the Jams*, Elektra Records (1969), provides entertaining evidence.

40 Rosalind Krauss and Yve-Alain Bois, *L'Informe: Mode d'Emploi* (Paris, Centre Georges Pompidou, 1996).

41 Yves-Alain Bois, Benjamin H. D. Buchloh, Hal Foster, Denis Hollier, Rosalind Krauss, and Helen Molesworth, 'The Politics of the Signifier II: A Conversation on the *Informe* and the Abject', *October*, 71 (Winter 1994), 3–22.

Bibliography

Selected published sources

Alberro, A., Yves–Alain Bois, Benjamin H. D. Buchloh, Martha Buskirk, Thierry De Duve, and Rosalind Krauss, 'Conceptual Art and the Reception of Duchamp', *October 70* (Fall 1994), 127–46.

Alloway, Lawrence, 'Art', *The Nation* (9 June 1969), 740.

Alloway, Lawrence, 'Robert Smithson's Development', *Artforum*, 11:3 (November 1972), 52–61.

Alloway, Lawrence, *Topics in American Art*, New York, Norton, 1975.

Altshuler, Bruce, *The Avant–Garde in Exhibition*, New York, Harry N. Abrams, 1994.

Ammann, Jean-Christof, 'Schweitzer Brief', *Art International*, 13:5 (May 1969), 47–50.

Andre, Carl, 'Robert Smithson: He Always Reminded Us of the Questions We Ought to Have Asked Ourselves', *Arts Magazine*, 52:9 (May 1978), 102.

Antin, David, 'Another Category: Eccentric Abstraction', *Artforum*, 5:3 (November 1966), 56–7.

Antin, David, 'Exclusionary Tactics', *Art in America*, 70:4 (April 1982), 35–41.

Argikos, J., 'The New Sculpture 1965–1975', *Flash Art*, 23:153 (Summer 1990), 138–9.

Artforum, 'Artforum '62–'79', *Artforum*, 32:1 (September 1993), 117–24, 190, 192, 195.

Art News, 'Americans Triumph in Kassel', *Art News*, 67:4 (June 1968), 9.

Art News, 'Anti–Form Bernoise', *Art News*, 68:2 (April 1969), 8.

Ashton, Dore, 'Art', *Arts and Architecture*, 83:11 (December 1966), 4–5.

Ashton, Dore, 'Jeunes Talents de la Sculpture Americaine', *Aujourd'hui* (January 1967), 159.

Ashton, Dore, 'Exercises in Anti-Style – Six Ways of Regarding Un, In and Anti-Form', *Arts Magazine*, 43:6 (April 1969), 45–7.

Bachelard, Gaston, *The Poetics of Space*, tr. M. Jolas, Boston, Beacon Press, 1969.

Baigell, Matthew, 'A Ramble Around Early Earth Works', *Art Criticism*, 5:3 (1989), 1–15.

Baker Sandback, Amy, *Looking Critically: 21 Years of Artforum Magazine*, New York, Bowker, 1984.

Barrette, Bill, *Eva Hesse Sculpture: Catalogue Raisonné*, New York, Timken, 1989.

Barthes, Roland, *Mythologies*, tr. A. Lavers, London, Jonathan Cape, 1972.

Barthes, Roland, *Image/Music/Text*, tr. R. Miller, London, Fontana, 1977.

Battcock, Gregory (ed.), *Minimal Art: A Critical Anthology*, New York, E. P. Dutton, 1968.

Battcock, Gregory, 'Robert Morris, New Sculptures at Castelli', *Arts Magazine*, 42:7 (May 1968), 30–1.

Béar, Lisa, and Willoughby Sharp, 'A Continuous Flow of Fairly Aimless Movement', *Avalanche*, 3 (Fall 1971), 64–75.

Beardsley, John, *Earthworks and Beyond*, New York, Abbeville Press, 1984.

Benedikt, Michael, 'New York Letter', *Art International*, 10:10 (December 1966), 64–9.

Benezra, Neal, 'Bruce Nauman: Raw Material', *Art Press*, 184 (October 1993), 14–21.

Berger, Maurice, 'Conceptualiser le Minimalisme: Notes sur ce Problème en Histoire d'Art', *Art Press*, 139 (September 1989), 31–5.

Berger, Maurice, *Labyrinths: Robert Morris, Minimalism and the 1960s*, New York, Harper and Row, 1989.

Berger, Maurice, *Modern Art and Society*, New York, Icon, 1994.

Bern Kunsthalle, *When Attitudes Become Form: Works – Processes – Concepts – Situations – Information (Live in Your Head)*, Bern, Kunsthalle, 1969.

Bickers, Patricia E., 'Serra: Interview', *Art Monthly*, 161 (November 1992), 3–6.

Blok, Cor, 'Minimal Art at the Hague', *Art International*, 12:5 (May 1968), 20–4.

Blok, Cor, 'Letter From Holland', *Art International*, 13:5 (May 1969), 51–3.

Bochner, Mel, 'Eccentric Abstraction', *Arts Magazine*, 41:1 (November 1966), 57–8.

Bois, Yves-Alain, Benjamin H. D. Buchloh, Hal Foster, Denis Hollier, Rosalind Krauss, and Helen Molesworth, 'The Politics of the Signifier II: A Conversation on the *Informe* and the Abject', *October*, 71 (Winter 1994), 3–22.

Bongartz, R., 'It's Called Earth Art – And Boulderdash', *New York Times Magazine* (1 February 1970), 16–30.

Bordeaux CAPC Musée d'Art Contemporain, *Sculpture/Nature*, Bordeaux, 1978.

Bordeaux CAPC Musée d'Art Contemporain, *Antiform, Arte Povera*, Bordeaux, 1982.

Bordeaux CAPC Musée d'Art Contemporain, *Art Minimal 1: De La Ligne au Parallélépipède*, Bordeaux, 1985.

Bordeaux CAPC Musée d'Art Contemporain, *Attitudes/Sculptures*, Bordeaux, 1995.

Borgeaud, B., 'Les Feutres de Robert Morris', *Pariscope* (4 December 1968), 56.

Brett, Guy, 'Art – Works In Progress', *The Times* (30 August 1969), v.

Bruggen, C. van, *Bruce Nauman*, New York, Rizzoli, 1988.

Buchloh, Benjamin H. D., 'Twilight of an Idol: Preliminary Notes for a Critique', *Artforum*, 18:5 (January 1980), 35–43.

Buchloh, Benjamin H. D., 'Conceptual Art 1962–1969: From the Aesthetic of Administration to the Critique of Institutions', *October*, 55 (Winter 1990), 105–43.

Buchloh, Benjamin H. D., Hal Foster, Denis Hollier, Silvia, Kolbowski, Rosalind Krauss, Annette Michelson, 'The Reception of the Sixties', *October*, 69 (Summer 1994), 3–21.

Buchloh, Benjamin H. D., 'Three Conversations in 1985: Claes Oldenburg, Andy Warhol, Robert Morris', *October*, 70 (Fall 1994), 33–54.

Burchard, H., 'Fragile Artist's Agonized Life', *Washington Post* (23 October 1992), N51.

Burnham, Jack, 'Robert Morris: Retrospective in Detroit', *Artforum*, 8:7 (March 1970), 65–75.

Burnham, Jack, '10 Years Before the *Artforum* Masthead', *New Art Examiner*, 4:5 (February 1977), 1, 6–7.

Burton, Scott, 'Time on Their Hands', *Art News*, 68:4 (Summer 1969), 40–3.

Calas, Nicholas, 'The Illusion of Non-Illusion – Poets Against Aesthetes', *Arts Magazine*, 43:8 (Summer 1969), 28–31.

Calas, Nicholas, 'The Wit and Pedantry of Robert Morris', *Arts Magazine*, 44:5 (Summer 1970), 44–7.

Cameron, Dan, 'Anxieties of Influence, Regionalism, Arte Povera and the Cold War', *Flash Art*, 164 (May–June 1992), 75–81.

Canaday, John, 'What Do You Mean You're Against Order?', *New York Times* (22 November 1970), D23.

Cash, S., 'The Art Criticism and Politics of Lucy R. Lippard', *Art Criticism*, 9:1 (1994), 32–40.

Caute, David, *Sixty-Eight: The Year of the Barricades*, London, Paladin, 1988.

Celant, Germano, 'Appunti per una Guerriglia', *Flash Art*, 5 (November–December 1967), 3.

Celant, Germano, *Art Povera: Conceptual, Actual or Impossible Art?*, London, Studio Vista, 1969.

Celant, Germano, *Precronistoria 1966–69*, Florence, 1976.

Chave, Anna C., 'Minimalism and the Rhetoric of Power', *Arts Magazine*, 64:5 (January 1990), 44–63.

Christov–Bakargiev, Carolyn, 'Arte Povera 1967–1987', *Flash Art*, 137 (November–December 1987), 52–69.

Colpitt, Francis, *Minimal Art: The Critical Perspective*, Seattle, University of Washington Press, 1990.

Cornell University News (23 January 1969).

Coxhead, D., 'Growing Up', *Art Monthly*, 32 (1979–80), 4–9.

Crane, Diana, *The Transformation of the Avant-Garde: The New York Art World 1940–1985*, Chicago, University of Chicago Press, 1987.

Crespo, A., 'Los Eventos Morris en el Campus de Mayagüez', *Revista de Arte*, 3 (December 1969), 10–17.

Crimp, Douglas, 'Richard Serra: Sculpture Exceeded', *October*, 18 (Fall 1981), 67–78.

Crow, Thomas, 'The Simple Life: Pastoralism and the Persistence of Genre in Recent Art', *October*, 63 (Winter 1993), 41–67.

Crow, Thomas, 'Yo Morris', *Artforum*, 32:10 (Summer 1994), 82.

Crow, Thomas, *The Rise of the Sixties*, London, Everyman, 1996.

Cyr, D., 'A Conversation with Robert Morris', *Arts and Activities (The Teacher's Arts and Crafts Guide)*, (December 1968), 22–4.

Daley, Jane, 'Pseudo-Revolutionaries', *Art and Artists*, 4:11 (February 1970), 4, 6.

Danieli, Fideli A., 'Los Angeles Commentary: American Sculpture of the Sixties at the Los Angeles County Museum', *Studio International*, 173:890 (June 1967), 320–1.

Danieli, F. A., 'The Art of Bruce Nauman', *Artforum*, 6:4 (December 1967), 15–19.

Danto, Arthur C., 'Growing Up Absurd', *Art News*, 88:9 (November 1989), 118–21.

De Coppet, L., and A. Jones, *The Art Dealers*, New York, Clarkson N. Potter, 1984.

Den Haag Gemeentemuseum, *Minimal Art*, Den Haag, 1968.

Durand, R., 'Richard Serra: Bâtisseur d'Éspaces', *Art Press*, 150 (September 1990), 36–42.

Ehrenzweig, Anton, *The Hidden Order of Art: A Study in the Psychology of Artistic Imagination*, London, Weidenfeld and Nicholson, 1967.

Eindhoven Stedelijk Van Abbemuseum, *Robert Morris*, Eindhoven, 1968.

Ellis, S., 'Eccentric Abstraction at the BlumHelman Warehouse', *Art in America*, 74:5 (May 1986), 160–1.

Faure Walker, James, 'Activity of Criticism Part II: Interviews with Roberta Smith and Lucy R. Lippard', *Studio International*, 189 (May–June 1975), 184–6.

Fer, Briony, 'Bordering on Blank: Eva Hesse and Minimalism', *Art History*, 17:3 (September 1994), 424–49.

Fer, Briony, *On Abstract Art*, New Haven and London, Yale University Press, 1997.

Flam, Jack (ed.), *Robert Smithson: The Collected Writings*, Berkeley and Los Angeles, University of California Press, 1996.

Foster, Hal (ed.), *The Anti–Aesthetic: Essays on Postmodern Culture*, Cambridge, Mass. and London, MIT Press, 1983.

Foster, Hal (ed.), *Dia Art Foundation: Discusions in Contemporary Culture*, New York, 1987.

Foster, Hal, *The Return of the Real*, Cambridge, Mass., and London, MIT Press, 1996.

Foucault, Michel, *The Archaeology of Knowledge*, tr. A. Sheridan, London, Tavistock, 1972.

Foucault, Michel, *Discipline and Punish: The Birth of the Prison*, tr. A. Sheridan, London, Penguin, 1977.

Francblin, Catherine, 'Barry Le Va: Art Work in Expansion', *Art Press*, 193 (September 1993), 30–3.

Frascina, Francis, and Charles Harrison (eds), *Modern Art and Modernism: A Critical Anthology*, Oxford, Blackwell, 1982.

Frascina, Francis (ed.), *Pollock and After: The Critical Debate*, New York, Harper and Row, 1985.

Freud, Sigmund, *The Standard Edition of the Complete Psychological Works of Sigmund Freud*, ed. J. Strachey, London, Hogarth Press, 1953–74.

Freud, Sigmund, 'Delusions and Dreams in Jensen's *Gradiva*', in Albert Dickson (ed.), *The Penguin Freud Library*, vol. 14: *Art and Literature*, London, Penguin Books, 1985, pp. 27–118.

Fried, Michael, 'Art and Objecthood', *Artforum*, 5:10 (June 1967), 12–23.

Fried, Michael, *Art and Objecthood: Essays and Reviews*, Chicago, University of Chicago Press, 1998.

Gilardi, Piero, 'Primary Energy and the "Microemotive Artists"', *Arts Magazine*, 43:1 (September–October 1968), 48–51.

Glueck, Grace, 'ABC to Erotic', *Art In America*, 54:5 (September–October 1966), 105.

Glueck, Grace, 'A Feeling for Felt', *New York Times* (28 April 1968), D35.

Glueck, Grace, 'A Weakened Biennale Ready to Open', *New York Times* (27 June 1968), 29.

Glueck, Grace, 'Documenta: It Beats the Biennale', *New York Times* (7 July 1968), D20.

Glueck, Grace, 'More from the Documenta Front', *New York Times* (14 July 1968), D18.

Glueck, Grace, 'Moving Mother Earth', *New York Times* (6 October 1968), 38.

Glueck, Grace, 'Venice Student Protests Are Disrupting Biennale', *New York Times* (21 June 1968), 47.

Glueck, Grace, 'Air, Hay and Money', *New York Times* (25 May 1969), II, 42.

Goldberg, RoseLee, *Performance Art from Futurism to the Present*, London, Thames and Hudson, 1988.

Goossen, E.C., 'The Artist Speaks: Robert Morris', *Art In America*, 58:3 (May–June 1970), 104–11.

Gosling, Nigel, 'Chasing Hares', *Observer* (31 August 1969).

Gosling, Nigel, 'The Have-a-Go Show', Observer (2 May 1971), 29.

Graziani, Ron, 'Robert Smithson's Picturable Situation: Blasted Landscapes from the 1960s', *Critical Inquiry*, 20:3 (Spring 1994), 419–51.

Greenberg, Clement, *Clement Greenberg: The Collected Essays and Criticism*, ed. John O'Brian, 4 vols, Chicago, University of Chicago Press, 1993.

Greenberg, Reesa, Bruce W. Ferguson, and Sandy Nairne (eds), *Thinking About Exhibitions*, London, Routledge, 1996.

Grey Art Gallery and Study Center, *Robert Morris: The Felt Works*, New York, Grey Art Gallery and Study Center, 1989.

Gruen, John, 'What A Dump!', *New York* (24 March 1969).

Harrison, Charles, 'Against Precedents', *Studio International*, 178:914 (September 1969), 90–3.

Harrison, Charles, and Paul Wood (eds), *Art in Theory 1900–1990: An Anthology of Changing Ideas*, Oxford, Blackwell, 1992.

Haskell, Barbara, *Blam! The Explosion of Pop, Minimalism and Performance Art 1958–1963*, New York, Whitney Museum of American Art, 1984.

Hatton, Brian, 'The Work of Robert Morris 1961–1971: A Criticism', *Issues in Architecture, Art and Design*, 2:2 (Winter 1992–93), 15–30.

Hayward Gallery, *Gravity and Grace, The Changing Condition of Sculpture 1965–1975*, London, Hayward Gallery, 1993.

Heizer, Michael, Dennis Oppenheim, and Robert Smithson, 'Discussions with Heizer, Oppenheim, Smithson', *Avalanche*, 1 (Fall 1970), 48–71.

Henry Moore Institute, *Robert Morris: Recent Felt Pieces and Drawings*, Leeds, Henry Moore Institute, 1997.

Hindry, Ann, 'Rosalind Krauss: Images and Words', *Art Press*, 183 (September 1993), 42–7.

Hindry, Ann, 'L'Informe: Mode d'Emploi', *Art Press*, 213 (May 1996), 34–41.

Hobbs, Robert C., *Robert Smithson: Sculpture*, Ithaca, Cornell University Press, 1981.

Holt, Nancy (ed.), *The Writings of Robert Smithson*, New York, New York University Press, 1979.

Instituto Valenciano de Arte Moderno, *Eva Hesse*, Valencia, Instituto Valenciano de Arte Moderno, 1993.

Instituto Valenciano de Arte Moderno, *Robert Smithson: El Paisaje Entrópico*, Valencia, Instituto Valenciano de Arte Moderno, 1993.

Judd, Donald, 'Specific Objects', *Arts Yearbook*, 8 (1965), 74–82

Junker, Howard, 'Down to Earth', *Newsweek*, 73:12, (March 1969), 101.

Kaprow, Allan, *Assemblages, Environments and Happenings*, New York, Harry N. Abrams, 1965.

Kaprow, Allan, 'The Shape of the Art Environment: How Anti Form is 'Anti–Form'?', *Artforum*, 6:10 (Summer 1968), 32–3.

Karmel, Pepe, 'Robert Morris: Formal Disclosures', *Art in America*, 83:6 (June 1995), 88–95, 117, 119.

Kelley, Jeff (ed.), *Allan Kaprow: Essays on the Blurring of Art and Life*, Berkeley and Los Angeles, University of Californa Press, 1993.

Kimball, Roger, 'The October Syndrome', *New Criterion*, 7:2 (October 1988), 5–15.

Kosuth, Joseph, *Art after Philosophy and After*, Cambridge, Mass., and London, MIT Press, 1991.

Kosuth, Joseph, and Seth Siegelaub, 'Joseph Kosuth and Seth Siegelub Reply to Benjamin Buchloh on Conceptual Art', *October*, 57 (Summer 1991), 152–7.

Kozloff, Max, 'New York', *Artforum*, 7:6 (February 1969), 64.

Kozloff, Max, '9 in a Warehouse: An Attack on the Status of the Object', *Artforum*, 7:6 (February 1969), 38–42.

Kozloff, Max, 'Art', *The Nation* (17 March 1969), 347–8.

Kramer, Hilton, 'Primary Structures: The New Anonymity', *New York Times* (1 May 1966), II, 23.

Kramer, Hilton, 'And Now Eccentric Abstraction: It's Art, but Does It Matter?', *New York Times* (25 September 1966), D27, D29.

Kramer, Hilton, 'A Stunning Display of Radical Changes', *New York Times* (28 April 1967), 38.

Kramer, Hilton, 'Eva Hesse', *New York Times* (23 November 1968), 54.

Kramer, Hilton, 'An Appetite for the Absolute', *New York Times* (22 December 1968), II, 31.

Kramer, Hilton, 'The Emperor's New Bikini', *Art In America*, 57:1 (January–February 1969), 48–55.

Kramer, Hilton, 'Art: Melting Ice, Hay, Dog Food Etc.', *New York Times* (24 May 1969), 31.

Kramer, Hilton, 'The Triumph of Ideas over Art', *New York Times* (25 January 1970), II, 27–8.

Kramer, Hilton, *The Age of the Avant-Garde*, New York, Secker and Warburg, 1973.

Krauss, Rosalind, 'A View of Modernism', *Artforum*, 11:1 (September 1972), 48–51.

Krauss, Rosalind, 'Notes on the Index: Seventies Art in America', *October*, 3 (Winter 1976–77), 68–81.

Krauss, Rosalind, *Passages in Modern Sculpture*, Cambridge, Mass., and London, MIT Press, 1977.

Krauss, Rosalind, 'Sculpture in the Expanded Field', *October*, 8 (Spring 1979), 31–44.

Krauss, Rosalind, *The Originality of the Avant-Garde and Other Modernist Myths*, Cambridge, Mass., and London, MIT Press, 1983.

Krauss, Rosalind, 'The Cultural Logic of the Late Capitalist Museum', *October*, 45 (Fall 1990), 3–17.

Krauss, Rosalind, *The Optical Unconscious*, Cambridge, Mass., and London, MIT Press, 1993.

Krauss, Rosalind, 'Around the Mind/Body Problem', *Art Press*, 193 (July–August 1994), 24–32.

Kristeva, Julia, *Powers of Horror: An Essay in Abjection*, tr. Leon S. Roudiez, New York, Columbia University Press, 1982.

Kubler, George, *The Shape of Time: Remarks on the History of Things*, New Haven and London, Yale University Press, 1962.

Kurtz, Bruce, 'Last Call at Max's', *Artforum*, 19:8 (April 1981), 26–9.

Leider, Philip, 'American Sculpture at the Los Angeles County Museum of Art', *Artforum*, 5:10 (June 1967), 6–11.

Leider, Philip, 'The Properties of Materials: In the Shadow of Robert Morris', *New York Times* (22 December 1968), II, 31.

Leider, Philip, 'For Robert Smithson', *Art in America*, 61:6 (November–December 1973), 80–2.

Leo Castelli Gallery, *Bruce Nauman*, New York, Leo Castelli Gallery, 1968.

Levin, Kim, *Beyond Modernism: Essays on Art from the 70s and 80s*, New York, Harper and Row, 1988.

Lippard, Lucy R., 'Eccentric Abstraction', *Art International*, 10:9 (November 1966), 28, 34–40.

Lippard, Lucy R., 'Eros Presumptive', *Hudson Review*, 20:1 (Spring 1967), 91–9.

Lippard, Lucy R., *557,087*, Seattle, Seattle Art Museum,1969.

Lippard, Lucy R., 'Eva Hesse: The Circle', *Art In America*, 59:3 (May–June 1971), 68–73.

Lippard, Lucy R., *Changing: Essays in Art Criticism*, New York, E. P. Dutton, 1971.

Lippard, Lucy R., *Six Years: The Dematerialization of the Art Object from 1966 to 1972*, New York, Praeger, 1973.

Lippard, Lucy R., *Eva Hesse*, New York, New York University Press, 1976.

Lippard, Lucy R., *Get the Message: Activist Essays on Art and Politics*, New York, 1983.

Lippard, Lucy R., *The Pink Glass Swan*, New York, New Press, 1995.

Lippard, Lucy R., and John Chandler, 'The Dematerialization of Art', *Art International*, 12:2 (20 February 1968), 31–6.

Livingston, Jane, 'Barry Le Va: Distributional Sculpture', *Artforum*, 7:3 (November 1968), 50–4.

Long Beach Foundation of the Arts and Sciences, *Letters*, Long Beach, New Jersey, Foundation of the Arts and Sciences, 1969.

Los Angeles County Museum of Art, *American Sculpture of the Sixties*, Los Angeles, Los Angeles County Museum of Art, 1967.

Los Angeles County Museum of Art, *Bruce Nauman: Works From 1967 to 1972*, Los Angeles, Los Angeles County Museum of Art, 1972.

Los Angeles County Museum of Art, *Robert Smithson: Photo Works*, Los Angeles, Los Angeles County Museum of Art, 1993.

Los Angeles Museum of Contemporary Art, *Individuals: A Selected History of Contemporary Art 1945–1986*, Los Angeles, Los Angeles Museum of Contemporary Art, 1993.

Los Angeles Museum of Contemporary Art, *Reconsidering the Object of Art 1965–1975*, Cambridge, Mass., and London, MIT Press, 1995.

McNay, M., 'When Attitudes Become Form', *Guardian* (1 September 1969), 6.

Marcuse, Herbert, *Eros and Civilisation*, London, Routledge, 1998.

Masheck, Joseph, 'Editing *Artforum*', *Art Monthly*, 13 (December 1977–January 1978), 11–12.

Mayor Gallery, *Eva Hesse 1936–70*, London, Mayor Gallery, 1974.

Melkonian, N., 'Art in a Multicultural America: An Interview with Lucy R. Lippard', *Artspace*, 14:6 (September–October 1990), 56–9.

Meyer, Ursula, 'The De–Objectification of the Object', *Arts Magazine*, 43:8 (Summer 1969), 20–2.

Michelson, Annette, '10 x 10: Concrete Reasonableness', *Artforum*, 5:5 (January 1967), 30–1.

Michelson, Annette, 'La Pensée Sculpturale de Robert Morris', Press Release for Sonnabend Gallery, Paris, 1968.

Michelson, Annette, 'An Aesthetics of Transgression', in Corcoran Gallery, *Robert Morris*, Washington DC, Corcoran Gallery of Art, 1969, 7–79.

Michelson, Annette, 'Contemporary Art and the Plight of the Public: A View From the New York Hilton Book Review', *Artforum*, 13:1 (September 1974), 68–70.

Michelson, Annette (ed.), *October: The First Decade 1976–1986*, Cambridge, Mass., and London, MIT Press, 1987.

Millet, C., 'Michael Fried: La Place du Spectateur', *Art Press*, 155 (February 1991), 49–53.

Mitchell, W. J. T., 'Golden Memories', *Artforum*, 32:8 (April 1994), 86–91.

Morgan, R. C., 'Eccentric Abstraction and Postminimalism: From Biomorphic Sensualism to Hard-Edged Concreteness', *Flash Art*, 144 (January–February 1989), 73–81.

Morris, Robert, 'Notes on Sculpture Part 1', *Artforum*, 4:6 (February 1966), 42–6.

Morris, Robert, 'Notes on Sculpture Part 2', *Artforum*, 5:2 (October 1966), 20–3.

Morris, Robert, 'Notes on Sculpture Part 3: Notes and Nonsequiturs', *Artforum*, 5:10 (June 1967), 24–9.

Morris, Robert, 'Anti Form', *Artforum*, 6:8 (April 1968), 33–5.

Morris, Robert, 'Notes on Sculpture Part 4: Beyond Objects', *Artforum*, 7:8 (April 1969), 50–4.

Morris, Robert, 'Some Notes on the Phenomenology of Making: The Search For the Motivated', *Artforum*, 8:8 (April 1970), 33–5.

Morris, Robert, 'The Art of Existence. Three Extra-Visual Artists: Works in Process', *Artforum*, 9:5 (January 1971), 28–33.

Morris, Robert, *Continuous Project Altered Daily: The Writings of Robert Morris*, Cambridge, Mass., and London, MIT Press, 1993.

Morris, Robert, 'Professional Rules', *Critical Inquiry*, 23:2 (Winter 1997), 298–321.

Müller, Gregoire, 'Robert Morris Presents Anti–Form: The Castelli Warehouse Show', *Arts Magazine*, 43:4 (February 1969), 29–30.

Müller, J., M. Lee, and I. Graw, 'Three Statements on the Recent Reception of Bruce Nauman', *October*, 74 (Fall 1995), 123–38.

Museo Nacional Reina Sofia, *Peter Halley*, Madrid, Museo Nacional Reina Sofia, 1992.

Nauman, Bruce, 'Paroles d'Artiste', *Art Press*, 184 (October 1993), 21–3.

Museum of Modern Art, New York, *Richard Serra, Sculpture*, New York, Museum of Modern Art, 1986.

Museum of Modern Art, *Bruce Nauman*, New York, Museum of Modern Art, 1995.

Nemser, Cindy, 'An Interview with Eva Hesse', *Artforum*, 8:9 (May 1970), 59–63.

Nemser, Cindy, 'Interview with Steve Kaltenbach', *Artforum*, 9:3 (November 1970), 47–53.

New Jersey State Museum of Art, *Soft Art*, Trenton, New Jersey State Museum of Art, 1969.

Obrist, Hans-Ulrich, 'Mind over Matter: Hans-Ulrich Obrist talks with Harald Szeeman', *Artforum*, 35:3 (November 1996), 74–9, 111–12, 119, 125.

O'Doherty, Brian, *Inside the White Cube and other Essays*, Santa Monica, Lapis Press, 1976.

Orton, Fred, and Griselda Pollock, *Avant-Gardes and Partisans Reviewed*, Manchester, Manchester University Press, 1996.

Owens, Craig, 'Earthwords', *October*, 10 (Fall 1979), 121–30.

Owens, Craig, 'The Allegorical Impulse: Toward a Theory of Postmodernism', *October* 12 (Spring 1980), 67–86, and 13 (Summer 1980), 59–80.

Centre Georges Pompidou, *Robert Morris*, Paris, Centre Georges Pompidou, 1995.

Peckham, Morse, *Man's Rage for Chaos*, New York, 1976.

Perrault, John, ' Pulling Out the Rug', *Village Voice* (16 May 1968), 15.

Perrault, John, 'Robert Morris', *Art News*, 67:5 (September 1968), 13.

Perrault, John, 'Long Live Earth!', *Village Voice* (17 October 1968), 17.

Perrault, John, 'Dump, Drop, Drape', *Village Voice* (14 November 1968), 17–18.

Perrault, John, 'A Test', *Village Voice* (19 December 1968), 19–20.

Perrault, John, 'Art – Down to Earth', *Village Voice* (13 February 1969), 18, 20.

Perrault, John, 'Nonsites in the News', *New York* (24 February 1969), 44–5.

Perrault, John, 'Earth Show', *Village Voice* (27 February 1969), 16, 18–19.

Perrault, John, 'Art', *Village Voice* (29 May 1969), 16.

Perrault, John, 'First Person Criticism', *Art Criticism*, 1:2 (1979), 3–12.

Philadelphia Institute of Contemporary Art, *1967: At The Crossroads*, Philadelphia, Philadelphia Institute of Contemporary Art, 1987.

Piene, Nan R., 'How to Stay Home and Help the Balance of Payments', *Art In America*, 56:3 (May–June 1968), 108.

Pincus-Witten, Robert, 'New York', *Artforum*, 6:8 (April 1968), 63–5.

Pincus-Witten, Robert, 'Keith Sonnier, Materials and Pictorialism', *Artforum*, 8:2 (October 1969), 39–45.

Pincus-Witten, Robert, 'Eva Hesse: Postminimalism into Sublime', *Artforum*, 10:3 (November 1971), 32–43.

Pincus-Witten, Robert, 'Last Words', *Artforum*, 11:3 (November 1972), 74–6.

Pincus-Witten, R., 'Barry Le Va: The Invisibility of Content', *Arts Magazine*, 50:2 (October 1975), 66–7.

Pincus-Witten, R., *Postminimalism*, New York, Out of London Press, 1977.

Pincus-Witten, R., *Eye To Eye: 20 Years of Art Criticism*, New York, 1984.

Pincus-Witten, R., *Postminimalism to Maximalism 1966–1986*, New York, 1987.

Plagens, Peter, '557,087 at the Seattle Art Museum', *Artforum*, 8:3 (November 1969), 64–7.

Plagens, Peter, 'A Short, Amazing, Life', *Newsweek* (25 May 1992), 88.

Prinz, Jessica, *Art Discourse/Discourse in Art*, New Brunswick, Rutgers University Press, 1991.

Raffaele, J., and E. Baker, 'The Way-Out West: Interviews with 4 San Francisco Artists', *Art News*, 66:4 (Summer 1967), 38–41, 75–6.

Roberts, J. (ed.), *Art Has No History! The Making and Unmaking of Modern Art*, London, Routledge, 1994.

Royal Academy of Arts, *American Art in the Twentieth Century*, London, Royal Academy of Arts, 1993.

Runkel Hue Williams, *Robert Morris, Sculpture 1962–1984*, London, Runkel Hue Williams, 1990.

Sagan, Carl, *Broca's Brain*, London, Paladin, 1980.

Sedowsky, Laura, 'Down and Dirty: Lauren Sedowsky Talks with Rosalind Krauss and Yve-Alain Bois', *Artforum*, 34:10 (Summer 1996), 90–5, 126, 131, 136.

Serra, Richard, 'Play It Again, Sam', *Arts Magazine*, 44:4 (February 1970), 24–7.

Serra, Richard, *Writings, Interviews*, Chicago, University of Chicago Press, 1994.

Shapiro, Gary, *Earthwards: Robert Smithson and Art after Babel*, Berkeley and Los Angeles, University of California Press, 1995.

Sharp, Willoughby, 'Interview with Joseph Beuys', *Artforum*, 8:3 (November 1969), 40–7.

Sharp, Willoughby, 'Nauman Interview', *Arts Magazine*, 44:5 (March 1970), 22–7.

Sharp, Willoughby, 'Carl Andre', *Avalanche*, 1 (Fall 1970), 18–27.

Sharp, Willoughby, 'A Continuous Flow of Fairly Aimless Movement', *Avalanche*, 3 (Fall 1971), 64–75.

Sharp, Willoughby, 'Bruce Nauman', *Avalanche*, 2 (Winter 1971), 23–5.

Sharp, Willoughby, 'Alan Saret: Installation for Man – A Conversation with Willoughby Sharp', *Avalanche*, 11 (Summer 1975), 7–11.

Shirey, David L., 'Venetian Carnival', *Newsweek* (1 July 1968), 93.

Shirey, David L., 'Impossible Art: What It Is', *Art In America*, 57:3 (May–June 1969), 33–4.

Siegel, Jeanne, 'Documenta IV – Homage to the Americans?', *Arts Magazine*, 43:1 (September–October 1968), 37–41.

Siegel, Jeanne (ed.), *Artwords: Discourse of the 60s and 70s*, New York, 1985.

Siegelaub, Seth, and Charles Harrison, 'On Exhibitions and the World at Large', *Studio International*, 178:917 (December 1969), 202–3.

Smith, Roberta, 'A Hypersensitive Nose for the Next New Thing', *New York Times* (20 January 1991), II, 33.

Smithson, Robert, 'Entropy and the New Monuments', *Artforum*, 5:10 (June 1966), 26–31.

Smithson, Robert, 'Quasi Infinities and the Waning of Space', *Arts Magazine*, 41:1 (November 1966), 28–31.

Smithson, Robert, 'Letter to the Editor', *Arts Magazine*, 41:4 (February 1967), 8.

Smithson, Robert, 'Towards the Development of an Air Terminal Site', *Artforum*, 5:10 (June 1967), 36–40.

Smithson, Robert, 'Letter to the Editor', *Artforum*, 6:2 (October 1967), 4.

Smithson, Robert, 'The Monuments of Passaic', *Artforum*, 7:4 (December 1967), 48–51.

Smithson, Robert, 'A Sedimentation of the Mind', *Artforum*, 8:1 (September 1968), 44–50.

Solomon R. Guggenheim Museum, *Eva Hesse: A Memorial Exhibition*, New York, Solomon R. Guggenheim Museum, 1972.

Solomon R. Guggenheim Museum, *Robert Morris: The Mind/Body Problem*, New York, Solomon R. Guggenheim Museum, 1994.

Stedelijk Museum, *Op Losse Schroeven: Situaties en Cryptostructuren*, Stedelijk Museum, Amsterdam, 1969.

Stockholm Moderna Museet, *Flykpunkter*, Stockholm Moderna Museet, 1984.

Stoekl, Allan (ed.), *George Bataille, Visions of Excess: Selected Writings 1927–1939*, Minneapolis, University of Minnesota Press, 1985.

Sylvester, D., and M. Compton, 'Robert Morris: A Dialogue Between David Sylvester and Michael Compton', *Tatextra* (1997).

Tate Gallery, *Robert Morris*, London, Tate Gallery, 1971.

Tate Gallery *Minimalism*, London, Tate Gallery, 1989.

Tiberghien, Gilles A., *Land Art*, Princeton, Princeton University Press, 1995.

Time Magazine, 'The Earth Movers', *Time* (11 October 1968), 52.

Time Magazine, 'Art: The Avant–Garde: Subtle, Cerebral, Elusive', *Time* (22 November 1968), 36–41.

Trini, Tomasso, 'Trilogia del Creator Prodigio', *Domus*, 478 (September 1969), 47–54.

Trini, Tomasso, 'Un Libro', Domus, 599 (October 1979), 52–3.

Tsai, Eugenie, Robert Smithson Unearthed, New York, Columbia University Press, 1991.

Tuchman, Phyllis, 'American Art in Germany: The History of a Phenomenon', Artforum, 9:3 (November 1970), 58–69.

Tucker, Marcia, 'PheNAUMANology', Artforum, 9:4 (December 1970), 38–43.

Velikowsky, Immanuel, Earth in Upheaval [1956], London, Abacus, 1973.

Von Meier, Kurt, 'Los Angeles: American Sculpture of the Sixties', Art International, 11:6 (Summer 1967), 64–8.

Wagner, Anne M., 'Another Hesse', October, 69 (Summer 1994), 49–84.

Wallach, A., 'Overrun, SoHo's Art World Shifts Ground', New York Times (12 May 1996), 51, 54.

Wallis, Brian (ed.), Art After Modernism: Rethinking Representation, Boston, Godine, 1984.

Washington University Gallery of Art, Here and Now, St. Louis, Washington University Gallery of Art, 1969.

Whitechapel Art Gallery, Eva Hesse 1936–1970, London, Whitechapel Art Gallery, 1979.

Whitechapel Art Gallery, Bruce Nauman, London, Whitechapel Art Gallery, 1986.

Whitney Museum of American Art, Anti–Illusion: Procedures/Materials, New York, Whitney Museum of American Art, 1969.

Whitney Museum of American Art, Robert Morris, New York, Whitney Museum of American Art, 1970.

Whitney Museum of American Art, The New Sculpture 1965–1975, New York, Whitney Museum of American Art, 1990.

Whitney Museum of American Art, Abject Art: Repulsion and Desire in American Art, New York, Whitney Museum of American Art, 1993.

Williams, Richard J., 'The Krazy Kat Problem', Art History, 20:1 (March 1997), 168–74.

Williams, Richard J., 'Cut Felt: Robert Morris interviewed by Richard J. Williams', Art Monthly, 208 (July–August 1997), 7–10.

Unpublished sources

Bracker, A., 'A Critical History of the International Art Journal "Artforum"', Ph.D. thesis, University of Leeds, 1995.

Burnham, Jack, Letter to Robert Morris, 12 March 1969, Robert Morris Archive, New York, Solomon R. Guggenheim Museum.

Burnham, Jack, Interview with Robert Morris, 21 November 1975, Robert Morris Archive, New York, Solomon R. Guggenheim Museum.

Butler, E., Letter to Robert Morris, 20 January 1969, Robert Morris Archive, New York, Solomon R. Guggenheim Museum.

Cummings, Paul, Interview with Robert Morris for the Archives of American Art, 10 March 1968, New York, Archives of American Art.

Cummings, Paul, Interview with Robert Smithson for the Archives of American Art, 14 and 19 July 1972, New York, Archives of American Art.

Cummings, Paul, Interview with Keith Sonnier for the Archives of American Art, 3 August 1972, New York, Archives of American Art.

De Angelus, M., Interview with Bruce Nauman for the Archives of American Art, 27 and 30 May 1980, New York, Archives of American Art.

Fischbach, Marylin, Card to Eva Hesse, Eva Hesse Papers, New York, Archives of American Art.
Fitzsimmons, James, Correspondence with Lucy R. Lippard, 10 November 1967, 1 January 1968, Lucy R. Lippard Papers, Washington, D.C., Archives of American Art.

Gibson, John, Interview with the author, New York, 7 May 1996.
Glaser, S. M., Letter to Eva Hesse, 10 October 1966, Eva Hesse Papers, New York, Archives of American Art.

Harrison, Charles, Letter to Robert Smithson, 24 July 1969, Robert Smithson Papers, New York, Archives of American Art.
Harrison, Charles, Interview with the author, Milton Keynes, 14 June 1995.

Kaltenbach, Stephen J., Letter to Lucy R. Lippard (no date), Lucy R. Lippard Papers, Washington, D.C., Archives of American Art.
Krens, Thomas, Interview with Robert Morris (no date), Robert Morris Archive, New York, Solomon R. Guggenheim Museum.

Leering, J., Letter to Robert Morris, 10 April 1968, Robert Morris Archive, New York, Solomon R. Guggenheim Museum.
Leider, Philip, Letter to the author, 22 March 1996.
Le Va, Barry, Interview with the author, New York, 2 May 1995.
Lippard, Lucy R., Letter to Philip Johnson, 21 August 1966, Lucy R. Lippard Papers, Washington, D.C., Archives of American Art.
Lippard, Lucy R., Letter to Harald Szeeman, 22 January 1969, Lucy R. Lippard Papers, Washington, D.C., Archives of American Art.

Martin, Timothy D., Interview with Robert Morris, Henry Moore Institutes, Leeds, 1997.
Monte, James, Interview with the author, New York, 16 May 1996.
Morris, Robert, 'Form Classes in the Work of Constantin Brancusi', Master's thesis, Hunter College, New York, 1966.
Morris, Robert, Letter to Aegis Fabricators, 30 October 1966, Robert Morris Archive, New York, Solomon R. Guggenheim Museum.
Morris, Robert, Installation instructions for *Untitled (254 Pieces of Felt)*, 1968, Robert Morris Archive, New York, Solomon R.Guggenheim Museum
Morris, Robert, Letter to David Sylvester, 1 March 1969, Robert Morris Archive, New York, Solomon R. Guggenheim Museum.
Morris, Robert, Letter to John Coplans, 29 October 1969, Robert Morris Archive, New York, Solomon R. Guggenheim Museum.
Morris, Robert, Letter to Willoughby Sharp, December 1969, Robert Morris Archive, New York, Solomon R. Guggenheim Museum.
Morris, Robert, Letter to Ursula Meyer, 5 June 1970, Robert Morris Archive, New York, Solomon R. Guggenheim Museum.

Morris, Robert, Letter to Fine Arts Gallery, UMBC, Baltimore, 1991, Robert Morris
 Archive, New York, Solomon R. Guggenheim Museum.
Morris, Robert, Letter to the author, undated [1995].
Morris, Robert, Letter to the author, 10 March 1996.
Morris, Robert, Letter to the author, 25 March 1996.
Morris, Robert, Letter to the author, 28 May 1996.
Morris, Robert, Conversation with the author, Leeds, 20 May 1997.

Rose, Barbara, Interview with Leo Castelli for the Archives of American Art, July 1969,
 New York, Archives of American Art.

Saret, Alan, Letter to James Monte, 20 April 1969, New York, Whitney Museum of
 American Art Archive.
Sharp, Willoughby, 'Earth Art: The Untold Story', Lecture, New York, City College,
 5 May 1995.
Sharp, Willoughby, Interview with the author, New York, 17 May 1996.
Sharp, Willougby, Conversation with the author, 28 April 1997.
Smithson, Robert, 'Art and the Political Whirlpool or the Politics of Dissent (1st draft)' (no
 date), Robert Smithson Papers, New York, Archives of American Art.
Sonnabend, Ileana, Letter to Robert Morris (no date), Robert Morris Archive, New York,
 Solomon R. Guggenheim Museum.
Sonnier, Keith, Interview with the author, New York, 27 April 1995.
Stuckey, Charles, Interview with Virginia Dwan for the Archives of American Art,
 21 March–7 June 1984, New York, Archives of American Art.
Szeeman, Harald, Letter to Eva Hesse, 28 November 1968, Eva Hesse Papers, New York,
 Archives of American Art.
Szeeman, Harald, Letter to Lucy R. Lippard, 22 January 1969, Lucy R. Lippard Papers,
 Washington, D.C., Archives of American Art.
Szeeman, Harald, Letter to Bruce Altshuler, 11 May 1992.

Tucker, Marcia, Interview with the author, New York, 8 May 1996.

Williams, D., Letter to Lucy R. Lippard, 25 October 1967, Lucy R. Lippard Papers,
 Washington, D.C., Archives of American Art.

Index

Note: page references in *italics* refer to an illustration; 'n.' after a page reference indicates a note number on that page.

10, 28–30, 44
2001: A Space Odyssey, 66
557,087, 95
955,000, 95, 120
2,972,453, 95

Adorno, Theodor, 92–3
Aegis, 7–8, 82
Air Art, 130, 131, 138n.66
Aldiss, Brian, 66
Alloway, Lawrence, 4, 121
Altshuler, Bruce, 83, 98n.1, 150
American Sculpture of the Sixties, 2, 3–8, 9,
 10–11, 100–1, 102
Amman, Jean-Christophe, 143
Anderson, Wayne, 4
Andre, Carl, 6, 27, 52, 53, 59, 64
 Earth Art, 133
 Equivalent VIII, 27
 Log Piece, 126
 Rock Pile, 126
Anselmo, Giovanni, 11, 86, 89–90
 Le Cotton Blanc qui Mange l'Eau, *149*
 Structure that Eats Salad, 145, *145*
Anti Form, 20, 30–4, 39, 68, 73, 86, 149
 earth art, 125, 127, 128, 129, 133, 135
 Smithson, 120, 121, 122, 123–4
 work, 106–7
Anti Form exhibition, 147
Anti-Illusion, 83–4, 113, 147, 155, 156
Antin, David, 41
Antonakos, Stephen, 4
Arnatt, Keith, 92
Arte Povera, 11, 140–9
Arte Povera e Azioni Povere, 146–7

Arte Povera exhibition, 142–3, 146
Artforum, 1, 4, 9, 40, 125
 American Sculpture of the Sixties, 5,
 6–7, 8
 Summer 1967 issue, 8, 9, 26
Art International, 4, 5, 41–3
Arts, 28
Art Workers Coalition (AWC), 59
Ashton, Dore, 4
Avalanche, 130

Bachelard, Gaston, 25, 29, 46
Barry, Robert, 83
Barthes, Roland, 93
Battcock, Gregory, 2, 43, 71, 130
Bayer, Herbert, 126
Benedikt, Michael, 28–9, 30
Benjamin, Walter, 102
Berger, Maurice, 71, 73
Berlant, Tony, 5
Beuys, Joseph, 3, 13–15, 96–7, 119, 130,
 159
Bladen, Ronald, 5
Bliss, Lillie P., 115n.9
Bochner, Mel, 28, 55
bodily ego, 46
Boetti, Alighiero, 152
Bois, Yve-Alain, 14
Bollinger, Bill, 64, 86, 89
Bourgeois, Louise, 41, 45
Breuer, Marcel, 103

Calder, Alexander, 24
Cameron, Dan, 140
Canaday, John, 123

Caro, Anthony, 2, 6, 10, 19–20, 33
 Fried on, 9, 20–2, 24–5, 39
 Midday, 25, *25*
 Prairie, 18, 18, 19, 20–2
 Sculpture Seven, 25, *26*
Caute, David, 71
Celant, Germano, 11, 135, 140, 141–9, 159
Chadwick, Helen, 40
Chandler, John, 8, 11, 81–2, 98
Chave, Anna, 51–2, 53
Childs, Lucinda, 73
Christov-Bakargiev, Carolyn, 140
Chryssa, 5
Colpitt, Frances, 7
Conceptual Art, 8, 81, 82, 85
Cooper, Paula, 106
Coplans, John, 4
Crimp, Douglas, 11, 86, 107
Cummings, Paul, 98

Dallas–Fort Worth airport, 66, 122
Danieli, Fideli, 48
Dayton, Robert, 96
dedifferentiation, 63–4, 67–8, 70
de Kooning, Willem, 82
de Maria, Walter, 11, 76, 92, 147
 earth art, 118, 126, 127, 131, 133
dematerialization, 81–5
 myth, 92–8
 Nine at Leo Castelli, 50, 85–92, 93
desublimation, 72–3
Dibbets, Jan, 131
Documenta, 140–1, 155
Doyle, Tom, 52, 54
Duchamp, Marcel, 143
Dwan, Virginia, 120, 124, 125–6, 128, 137n.
 41

earth art, 12, 59, 118–19
 Earth Art exhibition, 70, 124–5, 129–35
 Earthworks, 124–9
 Smithson's works, 8, 66–7, 79n.22,
 119–25
eccentic abstraction, 12, 40–7, 55–6
Eccentric Abstraction exhibition, 40–1, *41*, 43,
 44–7, 53–4, 55–6
ego, bodily, 46
Ehrenzweig, Anton, 11, 60–3, 64–6, 67–8, 70,
 77
entropy, 66–7, 68, 70

Fabro, Luciano, 142–3, 145
Fer, Briony, 43, 58n.43
Ferrer, Rafael, 82–3, 86
Fitzsimmons, James, 43
Flanagan, Barry, 3, 152
form, 34–5, 36
Foster, Hal, 2, 159
Freud, Sigmund, 46, 47, 56, 59, 93
 influence on Ehrenzweig, 60, 61
 influence on Marcuse, 60, 72
Fried, Michael, 36, 37n.3, 79n.26
 'Art and Objecthood', 8–9, 20, 26–7, 30, 45,
 158
 on Caro, 20–2, 24–5, 39
 Greenberg's influence, 22, 23–4, 26
Friedman, Tom, 40
Fundació Antoni Tapies, 104

galleries, *see* space
Gilardi, Piero, 114, 155–8
Glueck, Grace, 125, 126, 160n.7
Goldsworthy, Andy, 118, 119
Gombrich, Ernst, 61
Goodwin, Philip, 102
Goossen, E. H., 34
Gravity and Grace, 2
Greenberg, Clement, 4, 21, 22–3, 24, 36, 92
 influence on Fried, 22, 23–4, 26
 'The New Sculpture', 22–3, 37n.9
 'Sculpture in Our Time', 22
Greenberg, Reesa, 106, 115n.10
Grosvenor, Robert, 4, 7
Gruen, John, 127
Grunenberg, Christof, 102
Guggenheim Museum, 104, 106

Haacke, Hans, 130, 131
Hamrol, Lloyd, 5
Harrison, Charles, 117n.43, 141, 152
Heizer, Michael, 118, 126, 131, 133, 154
Hengler, Renata, 130
Hesse, Eva, 3, 45, 50–5, 56, 80n.37
 Aegis, 7, 82
 Area, 51
 Aught, 87, 89
 Contingent, 52
 Metronomic Irregularity, 41, *42*, 53–5
 Nine at Leo Castelli, 86, 89
 Tori, 52
Hobbs, Robert, 123, 128

Holt, Nancy, 120
Horkheimer, Max, 92–3
Hudson, Robert, 6
Huebler, Douglas, 83

imagination, 46, 47
Informe: Mode d'Emploi, L', 14, 157
Institute of Contemporary Arts (ICA), 114

January 1–31 1969, 83
Jenney, Neil, 131–2, 133
Jensen, Wilhelm, 47
Johns, Jasper, 143
Johnson, Philip, 83, 103
Johnston, Jill, 134
Judd, Donald, 2, 6, 7, 27, 28
 and Hesse, 54, 89
 'Specific Objects', 27, 44–5

Kafka, Franz, 121
Kaltenbach, Stephen, 15, 86, 89
Kaprow, Allan, 8, 93–4, 95, 108–10, 114, 123
 Assemblages, Environments and Happenings,
 93, 108
 Yard, 94, 108–10, *109*
Karmel, Pepe, 58n.47, 121
Kipp, Lyman, 6
Klein, Yves, 82
Köhler, W., 62
Kohn, Gabriel, 6
Kosuth, Joseph, 82, 83, 144
Kounellis, Jannis, 142, 143, 144–5, 146
Kozloff, Max, 59, 60, 79–80n.36, 141
 American Sculpture of the Sixties, 4
 Earth Art, 129, 134–5
 Nine at Leo Castelli, 90
Kramer, Hilton, 5, 6, 44, 54
Krauss, Rosalind, 2, 14, 43, 77, 120, 158–9
Kubler, George, 34–6
Kubrick, Stanley, 66
Kuehn, Gary, 41, 44

land art, *see* earth art
Latham, John, 92
Leavitt, Tom, 130, 131, 133
Leider, Philip, 50, 90, 112, 125
 American Sculpture of the Sixties, 4–6, 7,
 8
 Morris's 'Anti Form', 34, 112, 121, 122
Leo Castelli Gallery, 103, 104, 111

Leo Castelli warehouse, *105*, 113, 114
 Nine at Leo Castelli, 10, 90, 103–4, 105,
 107–8, 111–13
Le Va, Barry, 64, 78n.18
 *Continuous and Related Activities
 Discontinued by the Art of Dropping*,
 64
 Untitled, 64
LeWitt, Sol, 27, 28, 52, 55, 82, 144
 'Paragraphs on Conceptual Art', 8, 82
 Report on a Cube, 126, 127
 'Sentences on Conceptual Art', 93
Lichtenstein, Dorothy, 89
Lichtenstein, Roy, 5
L'Informe: Mode d'Emploi, 14, 157
Lipke, William C., 65
Lippard, Lucy, 8, 59, 85, 130, 159
 557,087, 95
 955,000, 120
 American Sculpture of the Sixties, 4
 Changing, 43
 'The Dematerialization of Art', 11, 81–2,
 98
 'Eccentric Abstraction' (article), 41–4,
 45–6, 47, 55
 Eccentric Abstraction (exhibition), 40, 41, 43,
 44, 47, 55–6
 Hesse's *Metronomic Irregularity*, 53,
 54–5
 'Eros Presumptive', 43
 Hesse, 51, 53, 54–5
 Minimal Art, 43–4, 59
 Nine at Leo Castelli, 85, 86
 politics, 141, 149
 Primary Structures, 27–8, 44
 Six Years, 2, 11, 81, 82–3, 92, 158
Long, Richard, 118–19, 130, 131, 132, 147
Los Angeles County Museum of Art, 3–8, 9,
 10–11, 100–1, 102
Louis, Morris, 37n.3

McShine, Kynaston, 27
Mao Tse-tung, 157
Marcuse, Herbert, 60, 70–3, 76, 77, 161n.37
Marion Goodman Gallery, 106
Marx, Karl, 72
MC5, 157
Medalla, David, 131, 132
Mellow, James, 127
Merleau–Ponty, Maurice, 24, 25, 39

Merz, Mario
 Città Irreale, 150
 Cone, 146
 Overzicht Tent, 150
Meyer, Ursula, 71, 76, 160n.24
Minimal Art, 2, 6, 7, 27, 46–7, 66
 10, 28–30
 American Sculpture in the Sixties, 5, 7
 Beuys on, 14
 dematerialization, 82, 89
 Fried on, 8–9, 27
 Hesse's works, 50, 54
 Judd on, 44–5
 Lippard on, 43–4, 59
 Morris on, 45
 Nauman's works, 48–9, 50
 Primary Structures, 27–8
 Whiteread's works, 59
modalities, 21, 40
Model A Ford, 69
Modern Art, 2, 22, 26
Monte, James, 4, 83, 147
Morris, Robert, 2, 3, 15
 10, 28
 254 Pieces of Felt, 18–19, *19*, 31, 33–4
 Aegis, 7–8, 82
 Amsterdam Piece, 151, 154
 anecdotes, 55
 'Anti Form', 11, 20, 30–4, 39, 68, 149
 Celant, 147
 earth art, 125
 Kubler's influence, 36
 Lippard on, 43
 Meyer's interest in, 71
 Nine at Leo Castelli, 86, 90, 91, 92
 Smithson's response, 66, 120, 121, 122,
 123–4, 128
 work, 106–7, 112
 Arte Povera, 143
 Artforum, 6
 artistic kleptomania, accusations of, 14, 15,
 79n.30, 96
 'The Art of Existence', 95–6, 97–8
 Art Workers Coalition, 59
 Bern Piece, 154–5
 and Beuys, relationship between, 13, 14, 97
 Continuous Project Altered Daily, 73–6, *74–5*,
 112, 113–14
 critical focus on, 19–20
 Dirt, 113, 126, 127, *127*, 128–9, 155

earth art, 118, 119, 125
Earth Art exhibition, 133, 154
and Ehrenzweig, 11, 63–5
Eindhoven retrospective, 13
felt, 159
financial problems, 7–8
Form-Classes in the Work of Constantin
 Brancusi, 34
Fried's 'Art and Objecthood', 9
Kubler's influence, 34, 36
Litanies, 83
Marcuse's influence, 71, 73, 76
Minimal Art, 27, 30–1, 45, 89
Money, 83–5
myth, 92, 94, 95–6, 97–8
Nauman's interest in, 49
Nine at Leo Castelli, 149
 dematerialization, 85, 86, 91, 92, 94, 96
 space, 111
'Notes on Sculpture', 27, 29, 30, 34, 68
 Part 1, 29, 44, 45
 Part 2, 29–30, 44, 45, 79n.32, 100
 Part 3, 8
 Part 4, 63–5, 68–70, 107
originality and copies, 36
politics, 139
Quarter Horses, 138n.66
and Sharp, relationship between, 131
and Smithson, friendship between, 120–1
Statement of Aesthetic Withdrawal, 83
Steam, 138n.66
steam sculptures, 82, 138n.66
subjectivity, 40
Tangle, 31
Threadwaste, 59, *63*, 63–4, 68, 69–70, 113, 155
 Smithson's influence, 121
 space, 107
Untitled, 133
Waterman Switch, 73
When Attitudes Become Form, 152
Müller, Gregoire, 153
muscular consciousness, 46
Musée d'Orsay, 114
Museum of Modern Art (MoMA), 102, 103
myth, 92–8

Namuth, Hans, 94, 107
Nauman, Bruce, 47–50, 86, 112, 89, 147, 152
 Cast of the Space Underneath My Chair, 49, *50*
 Eccentric Abstraction, 41, 47, 56

Nemser, Cindy, 51, 53
Newman, Barnett, 5
New Museum of Contemporary Art, 104
New York School, The, 5
Nine at Leo Castelli, 13, 50, *85*, 147
 dematerialization, 82–3, 85–92, 93
 space, 10, 90, 103–4, 105, 107–8, 111–13
Noland, Kenneth, 37n.3
nuclear destruction, 68, 70

October, 2
O'Doherty, Brian, 29, 102–3, 105
Oldenburg, Claes, 31, 82, 91, 108, 126
Op Losse Schroeven, 13–14, 95, 114, 149–50,
 153–6
Oppenheim, Dennis, 126, 132
originality, 36
Owens, Craig, 121–2

Pace Gallery, 106
Paolini, Giulio, 142, 144
Pascali, Pino, 142, 144
Paul, David, 30, 38n.25
Perrault, John, 69, 91–2, 112, 113, 127, 134
Petermann, B., 62
phenomenology, 24–5, 29, 30, 39
Philip Morris, 150
Picasso, Pablo, 10
Pincus-Witten, Robert, 51, 53
Plagens, Peter, 8, 95
politics, *see* revolution
Pollock, Jackson, 31, 32, 94, 98, 107, 110
Potts, Don, 41
Primary Structures, 27–8, 44, 47
Prini, Emilio, 142, 143
Prinz, Jessica, 120
psychoanalysis, 46–7, 56, 59, 60, 61–3, 72

Rainer, Yvonne, 73
Rauschenberg, Robert, 82, 140
Reise, Barbara, 8
repression, 47, 56, 72
revolution, 139–40
 Arte Povera, 140–9
 Gilardi's 'Politics and the Avant-Garde',
 156–8
 Op Losse Schroeven, 149–50, 153–6
 When Attitudes Become Form, 149–55, 156
Ricke Gallery, 114
Rickey, George, 6

Rivers, Larry, 5
Rockefeller, Mrs John D., 115n.9
Rose, Barbara, 4
Rose, Gilbert J., 46
Rousseau, Jean-Jacques, 47
Rubin, William, 115n.10

Sagan, Carl, 79n.35
Sandler, Irving, 4
Saret, Alan, 31, 86, 89, 95, 131
Saussure, Ferdinand de, 24
scarcity, 72
Schaffer, Lawrence, 8
science fiction, 66
Scull, Bob, 103
Scull, Ethel, 103
sensual experience, 45–6, 47
Serra, Richard, 32, 52
 Belts, *33*, 152
 Casting, *84*, 84
 Ehrenzweig's influence, 63, 64, 78n.19
 and Morris, 15, 31, 78n.18, 79n.30
 Nine at Leo Castelli, 82, 86, 89, 95, 113
 Op Losse Schroeven, 76, 95, 152
 Scatter Piece, 64, *65*
 Splashing, *10*, 113
 as critique of modern sculpture, 9–12
 Op Losse Schroeven, 76, 152, 153–4
 When Attitudes Become Form, 152, 153
Shapiro, Gary, 78n.20
Sharp, Willoughby
 Air Art, 130, 131, 138n.66
 Beuys interview, 14, 96–7, 130
 Castelli Gallery, 116n.17
 Earth Art, 124, 125, 129, 130, 135
 Nauman interview, 48, 49
Shirey, David L., 125, 139
Shunk, Harry, 152
Situations and Environments, 108
Smith, David, 2, 6, 10, 22, 33
 Home of the Welder, 22–3, *23*
Smith, Roberta, 15, 79n.30, 96
Smith, Tony, 1, 4, 6, 67
Smithson, Robert
 Asphalt Rundown, 76, *76*, 77, 119–20
 Closed Mirror Square, 132
 earth art, 8, 66–7, 79n.22, 118–26, 132, 133
 Ehrenzweig's influence, 61, 63, 64, 65–6, 67,
 77
 'Entropy and the New Monuments', 66

Fountain Monument, 67
Fried's 'Art and Objecthood', 8
Glue Pour, 76, *76*, 77, 120
 and Hesse, relationship between, 52
 Kubler's influence, 34
 Marcuse's influence, 76, 77
Mirror Displacement, 70, 121, 132
Mirror Trail, 65
'The Monuments of Passaic', 34, 66, 122–3
 and Morris, 120–1
 'Anti Form', 66, 77, 120, 121, 122,
 123–4, 128
 myth, 98
Non-Site, Franklin, New Jersey, 126, 127–8
Non-Sites, 120, 123, 124–5, 128, 132
 originality and copies, 36
Rock Salt and Mirror Square, 132, *132*
'A Sedimentation of the Mind', 65, 66–8,
 70, 121, 123–4, 125
Slant Piece, 132
Spiral Jetty, 12, 36, 66, 98
'Towards the Development of an Air
 Terminal Site', 8, 122
Snelson, Kenneth, 4
Sonnabend Gallery, 104
Sonnier, Keith, 13, 41, 56, 82, 86
 Mustee, 86–9, *87*
 Neon and Cloth, 88
 Untitled, 42
space, 7, 100–7, 113–15
 Kaprow's work, 108–10
 Leo Castelli warehouse, 10, 90, 103–5, *105*,
 107–8, 111–14
 Los Angeles County Museum of Art, 7,
 100–1, 102
 Warhol's Factory, 110–11
Stone, Edward, 102
Stuckey, Charles, 120, 125–6
subjectivity, 39–40, 55–6
 eccentric abstraction, 40–7
 Hesse, 50–5
 Nauman, 48–50
sublimation, 72–3
Sugarman, George, 6
Sullivan, Mrs Cornelius J., 115n.9
Sylvester, David, 76
syntax, 24
Systemic Painting, 4
Szeeman, Harald, 141, 149, 152–3, 155,
 160n.26

Tate Gallery Liverpool, 104, 114
Tate Gallery London, 104, 105, 114
technological triumphalism, 7
theatricality, 8–9, 30, 45
Thompson, Jon, 2, 140
Tiberghien, Gilles A., 133
Transamerica Building, 101
Trini, Tomasso, 152, 153
Tuchman, Maurice, 3, 4–5, 6, 8
Tuchman, Phyllis, 13, 114
Tucker, Marcia, 83, 147
Tuten, Frederick, 5
Tuttle, Richard, 4

Üecker, Gunter, 131, 132
'undifferentiation' concept, 11

'Varga Girl', 69
Velikowsky, Immanuel, 70
Venice Biennale (1968), 139
Viner, Frank Lincoln, 41
Von Meier, Kurt, 5, 6, 9, 100, 115n.6
von Schlegell, David, 4

Wagner, Anne, 46, 52–3
Warhol, Andy, 14, 110–11
Weiner, Lawrence, 83, 154
When Attitudes Become Form, 13, 14, 95, 97,
 117n.43, 149–56
Whiteread, Rachel, 1, 40, 59
Whitney, David, 48
Whitney Annual Exhibition 1966, 4
Whitney Museum of American Art, 103
William Pereira Associates, 4, 101
work, 101, 102–3, 106–7, 110–11, 112, 113–14

Zorio, Gilberto, 3, 11, 86, 90, 145
 Lampe avec Amianto, 151

DATE D